Romantik

...VAL FOR THE STUDY OF ROMANTICISMS

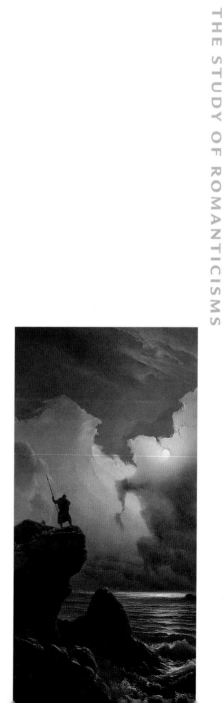

Editors

Robert W. Rix (Aalborg University), Lis Møller (Aarhus University), Karina Lykke Grand (Aarhus University), Anna Lena Sandberg (University of Copenhagen)

Editorial Board

Elisabeth Oxfeldt (University of Oslo), Gunilla Hermansson (University of Gothenburg), Tomas Björk (Stockholm University), Lauri Suurpää (Sibelius Academy, Helsinki), Leena Eilittä (University of Helsinki)

Advisory Board

Charles Armstrong (University of Bergen), Paula Henrikson (Uppsala University), Jacob Bøggild (Aarhus University), David Fairer (University of Leeds), Karin Hoff (Georg-August-Universität Göttingen), Stephan Michael Schröder (University of Cologne)

Nordic Co-Editor (first issue)

Leena Eilittä (University of Helsinki)

Main editorial contact

Robert W. Rix [rix@cgs.aau.dk]

Editorial Secretary

Kasper Rueskov Guldberg

Subscription services

Aarhus University Press [unipress@au.dk]

The cover illustration is *Scene from the Era of Norwegian Sagas* (1850), a painting by the Norwegian artist Knud Baade (1808-1879). The depiction of the lonely Viking by the sea reflects the artist's interest in Norse themes. It also demonstrates how he combined such subject matters with one of his other favourite genres, the Romantic moonlit landscape. This was a genre Baade knew well from Dresden, where he belonged to the circle of German Romantics that included Caspar David Friedrich and the Norwegian painter Johan Christian Dahl, who for a period was Baade's teacher. Later, Baade settled in Munich, where his work became quite popular. In 1851, King Ludwig I purchased one of his works, *Phantasibild aus der norwegischen Sagazeit*, for the collection of the Neue Pinakothek. This is very likely identical with the painting illustrated on this cover. It was sold in 1918, and was rediscovered in the collection of Mr. Asbjørn Lunde of New York only a few years ago. The history of the painting may be said to reflect the reception history of Romantic ideals: thrown out at the beginning of Modernism, neglected during large parts of the 20th century, only to be appreciated again in our time – as in the periodical *Romantik*.

(Knut Ljøgodt)

Content
01

On behalf of the Nordic Association for Romantic Studies, we are delighted to announce the publication of the inaugural issue of *Romantik: Journal for the Study of Romanticisms.*

The journal is a natural outgrowth of a series of papers that the Association has published since 1996. This series consisted of contributions from a number of renowned Scandinavian and international scholars. We felt that a peer-reviewed journal would be the ideal vehicle to take the success of these papers a step further.

Romantik is a multi-disciplinary journal dedicated to the study of both the cultural productions and the concept of Romanticism. The articles range over a variety of cultural practices from the period (c. 1780–1860), including the written word, visual arts, history, philosophy, religion and theatre. The journal is interested in the plurality of European romanticisms, as well as the connections between them.

We aim to publish articles of relevance to both a Nordic and an international community. When accepting articles for the journal, we focus on the innovativeness and presentation of the material, and we aim to publish articles only of the highest academic quality.

Romantik is published once a year. There will be special issues on different themes of current critical interest. Each issue contains a review section, in which we draw special attention to works published in the Nordic countries, as well as exhibitions with relevance to Romanticism.

The journal is published first as a printed edition and will then be available as an open access source after a one-year embargo period; we hope that this will increase the research impact of the articles.

This issue contains articles that cover a broad range of disciplines, utilizing a wide range of methodological approaches. But, in stimulatingly diverse ways, they all address the connection between Romanticism and politics, which is a reflection of the call for papers that was sent out over a year ago. It is a particular pleasure to publish some of the cutting-edge research that is carried out among Scandinavian and German scholars, some of whom have had their articles translated.

FOREWORD

The website and research forum *www.romantikstudier.dk* is closely connected with the journal. In addition to scanned texts of the issues published in the original series of papers, the website will also feature the most extensive listing of conference alerts, news, exhibitions etc. in the Nordic countries.

We would like to thank our editorial secretary Kasper Rueskov Guldberg, who suffered patiently through our teething process, as we put our workflows in place. We also extend our thanks to Aarhus University Press for their professionalism, which has made the printed version of this journal a reality.

This inaugural issue owes its existence to the generous funding we have received from NOP-HS (the Nordic Board for Periodicals in the Humanities and Social Sciences). We would also like to extend our thanks to AU Ideas, who made possible the publication of the many illustrations included within these pages.

Welcome to *Romantik*!
The editors

The Politics
of Dream

THE POLITICS OF DREAMING – FROM DIDEROT TO KEATS AND SHELLEY

ALAN RICHARDSON

[ABSTRACT]

Dreaming, seemingly a private activity, can exhibit political and ideological dimensions. The first part of this article looks at the ideological significance, within late Enlightenment and Romantic-era culture, of the very activity of dreaming, with particular reference to Diderot's *Le Rêve de d'Alembert*. Nocturnal dreaming and the somnambulistic behaviors closely associated with dreaming can and did challenge orthodox notions of the integral subject, of volition, of an immaterial soul, and even of the distinction between humans and animals. The second half of the article looks at two literary dreams, from the poetry of Shelley and Keats, considering how represented dreams can have pronounced ideological and political valences. The article as a whole illustrates the claims and methods of cognitive historicist literary critique.

.

KEYWORDS Poetry, dreams, neurology, John Keats, P. B. Shelley.

'In Dreams Begin Responsibilities', Delmore Schwartz's oblique and compact coming of age narrative, remains one of the most compelling American short stories of the last century. Its coolly seductive hold on the reader begins with its title, which Schwartz borrowed from an epigraph to W. B. Yeats's poetic volume *Responsibilities*, 'in dreams begins responsibility', attributed by Yeats in turn to an 'Old Play' (98). Whatever the title's ultimate provenance, its juxtaposition of dream and responsibility instantly sets us pondering: how could dreams, involuntary, cryptic and unpredictable, generate anything like duties and obligations?

The juxtaposition of politics and dreaming in this essay's title seeks to provoke a similar unsettling of categories and rethinking of conceptual boundaries. What could dreaming, perhaps our most private activity, have to do with politics, a set of inherently social practices? What might the political implications be of dreams themselves, with their strange transformations, their rambling story lines, their seemingly random jumps from one image or event to the next? In what follows, I will explore the politics of dreaming in two different but related ways. First, I will consider the ideological significance of the very activity of dreaming, as it was newly understood and represented in late enlightenment and early Romantic culture. I will then consider the political and ideological valence

ALAN RICHARDSON, Professor of English, Boston College
Aarhus University Press, *Romantik,* 01, vol. 01, 2012, pages 9-26

of the specific dreams represented in two important Romantic poems, P. B. Shelley's *Alastor* and John Keats' 'The Eve of St. Agnes'. In both parts of this essay, my reinterpretation of earlier discourses and texts has been partly inspired by my awareness of key developments in the cognitive neuroscience of dreaming. As such, the analyses that follow may be considered examples of what has been termed 'cognitive historicism' (Spolsky; Richardson, *Neural Sublime* 1-16).

Developments in the experimental study of sleep and dreaming, for example, first prompted scholars to look with serious interest at Romantic-era understandings of dreaming that could be seen to 'anticipate' not Freud's 'dream work' but a distinctively post-Freudian, neuroscientific account of dream formation (Lavie and Hobson). Moreover, the differences as well as the resonances between Romantic-era and neuroscientific understandings can prove instructive. For instance, the cognitive neuroscience of dreaming shows relatively little interest in what scientists now term the 'parasomnias', such as sleepwalking or talking during sleep; the preeminent dream researcher J. Allan Hobson devotes only three of the 153 pages of his highly useful *Dreaming: A Very Short Introduction* to the topic (82-84). For Hobson, as for most of his colleagues today, REM (rapid eye movement) dreaming garners most attention and serves as the paradigmatic example; parasomniac activities belong to non-REM (NREM) sleep, as do sleep onset dreams and the thought-like dreaming that occurs in 'slow wave' sleep (8). To the contrary, influential Romantic (and late Enlightenment) accounts of dreaming show a pronounced interest in somnambulism and similar behaviors, and view them as continuous with the vivid, hallucinatory dreaming now connected with REM sleep. Indeed, this connection helped give certain Romantic-era theories and representations of dreams their radical ideological valence.

Dreaming, Somnambulism and the Corporeal Mind

We might start with a glance at John William Polidori's 1815 medical thesis on 'Oneirodynia', his term for somnambulism and other parasomnias, as presented in an important recent article by Anne Stiles, Stanley Finger and John Bulevich. Polidori's thesis, composed in Latin, long remained nearly invisible to Romantic scholarship, although Polidori himself was well known: as Lord Byron's friend and physician, as a participant in the famed ghost story contest that generated both Mary Shelley's *Frankenstein* and Byron's fragmentary vampire tale, and as the author of *The Vampyre* (1819), the first widely popular vampire story in English. As Stiles and her co-authors explain, sleepwalking and other parasomnias suggested how the 'human body and brain could function mechanically', independent of a guiding soul or of conscious volition (790). If so, might the soul and will themselves prove epiphenomenal or altogether fictive? Small wonder that sleepwalking and related unconscious behaviors became closely associated with the vampire, that notoriously soulless and deeply unsettling figure.

Simply noting how the mind remained active during sleep could prove 'controversial' during the Romantic era, implicitly challenging as it did both ratio-

nalist and religious notions of a unitary subjectivity guided by conscious voli-
tion (790). But Polidori's interest in 'oneirodynia' went much further. Not only
did dreaming suggest a mind (or brain) that stayed active in the absence of con-
sciousness, but this unconsciously active mind could also engage in a number
of seemingly guided actions with no rational subject awake to guide them. Poli-
dori's broad definition of somnambulism includes 'not only someone who walks
while in a dream, but also someone who appears to wake up while still asleep, and
who performs actions or speaks as if he were awake' (Polidori 776). He describes
sleepers who 'respond to friends' questions and discourse ably', who dress them-
selves and 'guzzle' wine, who (endowed with 'vivid imagination') compose poems
or essays or even edit them (776-777). We are not far here from 'Kubla Khan' and
its famous headnote, which S. T. Coleridge would first publish the year after Poli-
dori completed his medical thesis (Richardson, 'Coleridge').

Polidori borrowed the anecdote of a priest correcting sermons in his sleep
from the *Encyclopédie*, which included an article entitled 'SOMNAMBULE, &
SOMNAMBULISME' by the French physician Jean-Joseph Ménuret de Cham-
baud. The *Encyclopédie* also proffers a generous definition of somnambulism,
embracing the same range of activities covered by Polidori, who apparently mod-
eled his definition on that of Ménuret de Chambaud. The latter places special
emphasis on the seeming directedness and rationality that these unconscious be-
haviors can manifest, 'quelquefois même avec plus d'intelligence & d'exactitude'
['at times with even more intelligence and precision', my translation] than or-
dinarily (vol. 15: 340). Given the leading role in the *Encyclopédie* project taken by
Denis Diderot and Jean-Baptiste le Rond d'Alembert, it comes as no surprise that
Diderot's great fictional account of an elaborate dream attributed to d'Alembert,
Le Rêve de d'Alembert [*D'Alembert's Dream*], should feature a comparably broad
range of parasomniac activities, some of which exhibit an unexpectedly high de-
gree of rational sense.

Not that coherent, connected thought and the sort of non-sense we normally
associate with dreaming can be differentiated too readily or too definitively in
this series of dialogues. Initially Mlle. de L'Espinasse, d'Alembert's housemate
though not his bedmate, has called in Dr. Bordeu precisely because d'Alembert
seems to be raving in his uncharacteristically troubled sleep: he thrashes about,
throws off the covers, and talks like a 'crazy person' (113) ['tout l'air du délire'
(359)].[1] Bordeu, however, who shares some of d'Alembert's crazier ideas, can turn
his 'nonsense of vibrating strings and sensitive fibers' (113) ['galimatias de cordes
vibrantes et de fibres sensibles' (359)] into a penetrating and corrosive discourse
on the mind's instantiation in the body and its nervous system, the necessary
illusion of the self, the secret workings of sensibility and more. Later in the dia-
logue, d'Alembert resumes talking, sometimes in his sleep and sometimes awake
– the line between sleeping and waking, unconscious cognition and conscious
thought, never entirely clear. In addition, during his earlier period of somniloquy
(which Mlle. de L'Espinasse has providentially taken down), d'Alembert at times
addresses his present friend and at times an absent and purely hallucinated in-
terlocutor, the '*Philosophe*', that is, Diderot himself, who features in a waking dia-

logue that precedes the *Rêve* proper (120). Although d'Alembert never walks in his sleep, he does exhibit several of the parasomnias, including one only delineated quite recently though apparently well known to Diderot: 'sexsomnia' or 'sleep sex' (Andersen et al.). D'Alembert masturbates in his sleep, achieving orgasm, after hopefully asking his lovely companion to approach more nearly. If we can even fondle ourselves while attempting to seduce our beloved in our sleep, what *can't* we do without the benefit of conscious awareness?

The striking overlaps between *Le Rêve de d'Alembert* and Polidori's medical thesis (not to mention Coleridge's dream-generated, sexually charged 'Kubla Khan') cannot be attributed to something called 'influence', especially because, though composed in 1769, Diderot's text remained unpublished until 1830. Rather, key concerns impelling these dream writings – with the brain's activity during sleep, with unconscious mental and bodily behaviors, with the fragility of a unified self and the potential for connected discourse in the absence of conscious volition – all attest to the powerful contemporary appeal of what I have termed the 'corporeal psychologies' of the Romantic era (Richardson, *British Romanticism* 1-38). In France, the main expositor of a corporeal approach to mind and mental behaviors was the French Revolutionary physiologist and physician Pierre-Jean-Georges Cabanis. Cabanis drew inspiration for his corporeal approach to mind both from the *philosophes* generally and from the Montpellier School of Medicine in particular, not least the medical practitioner and theorist Théophile Bordeu (Moravia 52-60; Williams 32-41, 85-90) – the same Dr. Bordeu that Diderot fictionalizes in *Le Rêve de d'Alembert*.

Simply the fact of dreaming holds, as we have seen, potentially subversive implications for any philosophical or religious orthodoxy presupposing an integral, self-determined subject. More than this, the form that dreaming takes in 'somnambulistic' texts further provokes skepticism toward reigning orthodoxies, in underscoring how an unconscious yet active brain-mind can direct quite complex behaviors, including everything from dressing and walking out of the house to coherent conversation to poetic composition, without any waking supervision or conscious volition. Furthermore, in *Le Rêve de d'Alembert*, the content of d'Alembert's dream monologues, along with the dialogues that surround them, make the radical implications of dreaming explicit. The dreaming intellectual's 'nonsense' about vibrations and fibers broaches a materialist theory of mind that jettisons the soul, dissolves the unity of the self, exposes conscious volition as an illusion, instantiates cognition and character in the brain and nervous system, and erodes any firm line between humans and other animals. In short, *Le Rêve de d'Alembert* ushers in a number of the most important and most radical postulates of the Romantic-era corporeal psychologies soon to come.

In and of itself, dreaming challenged orthodox conceptions of a unitary self, since dreams (and the parasomniac activities closely associated with them) implied an agency independent of and even foreign to conscious subjectivity. But d'Alembert's dream goes further, incorporating an explicit critique of the integral subject in the manifest content of the dream (shaped to some extent by the waking dialogue between d'Alembert and Diderot that immediately precedes it in

the text). D'Alembert, seconded by Bordeu and Mlle. de L'Espinasse, advances a series of analogies that suggest that the self is in fact an aggregate, held together provisionally, subject to change over time and continuous with biological processes that antedate the singular human subject. As Andrew Curran puts it in an essay on 'Monsters and the Self' in the *Rêve*, Diderot exposes the self or *moi* as a 'spurious abstraction temporarily attached to dynamic processes that extend beyond the confines of a given lifetime' (59). Diderot owes the most striking (and most famous) of these analogies, the human organism as a 'swarm of bees' (115) ['essaim d'abeilles' (361)], to the historical Bordeu himself, who had advanced the same metaphor in his 1767 treatise *Recherches sur le tissue muqueax* (Williams 37). Huddled together on a branch, a colony of bees seems to act as a single, unified organism, moving together and reacting together, and yet the 'cluster' ['grappe'] is in fact composed of multiple agents. Fuse the bees together, d'Alembert tells Mlle. de L'Espinasse in his dream, and the cluster becomes, in the eyes of a given perceiver, a single individual, and yet the multiplicity remains. Each human individual can be understood as just such a cluster, not of bees but of 'organs' ['organes'], which at bottom are 'only distinct animals held together by the law of continuity in a general bond of sympathy, unity, or identity' (117) ['Ne sont que des animaux distincts que la loi de continuité tient dans une sympathie, une unité, une identité générale' (362)].

If the seeming individual can better be seen as a hive of bees or, in another striking analogy, a colony of 'polyps' (119) ['polypes' (363)], then what becomes of personal volition? Predictably, it vanishes, yielding instead to a vision of multiple agents with diverse needs and conflicting wills. 'While there is only one center of consciousness in an animal', Bordeu explains, there are 'many different impulses. Each organ has impulses peculiar to itself' (151) ['S'il n'y a qu'une conscience dans l'animal, il y a une infinité de volontés; chaque organe a la sienne' (387)]. So the stomach, for example, may desire food while the palate does not. What we experience as conscious volition in fact reflects the outcome of a contest among contending impulses that largely fly under the radar of consciousness. Bordeu goes on to expose 'free will' ['volunté'] as an illusion, a given volitional act reflecting merely the 'most recent impulse of desire and aversion' ['la dernière impulsion du désir et de l'aversion'], or at least the most recent one to register in conscious awareness, since we perform countless acts in an 'involuntary' ['sans vouloir'] manner (166-7/397). Even when awake, that is, we often act somnambulistically.

Notice that in some of these exchanges Diderot moves between the 'animal' and the human seamlessly. This reflects yet another radical and, at the time, highly unorthodox move: the implicit denial of any definitive boundary between human beings and other animals. The opening (waking) dialogue between Diderot and d'Alembert, in fact, has made this denial explicit: 'there is no difference between you and the animals except in degree of organization' (106) ['qu'entre l'animal et vous, il n'y a de différence que dans l'organisation' (353)] – in degree and, therefore, not in kind. It follows that there is no uniquely human soul; what makes us human consists in a more highly organized 'sensibility' ['sensibilité'], shared with other life forms and potential even in inorganic matter (95-6/345).

In human beings, as in other animals, organization (as its root word, *organ*, implies) must ultimately be understood in purely bodily, corporeal terms. The material organization of the nervous system and brain (of the 'fibers' and their neural 'center') subtends cognition, character, emotion, behavior – everything. After a snatch of dialogue recounting instances of profound changes in intelligence, personality and behavior following head injuries and other assorted neural insults, Bordeu summarizes: 'If you disturb the center of the bundle of fibers [the brain], you change the whole creature whose entire being seems to be concentrated there' (153) ['Dérangez l'origine du faisceau, vou changez l'animal' (388-9)]. Toward the end of the dialogue, Mlle. de L'Espinasse offers her own summary, noting that 'memory, judgment, desires, aversions, passions, will, power, self-awareness' ['la mémoire, le jugement, lés désirs, les aversions, les passions, la volunté, la conscience du soi'] all depend on the precise 'structure of the brain' (169) ['l'organisation du cerveau' (400)]. These statements exemplify corporeal psychology at its most subversive and unorthodox: small wonder that the dialogue remained unpublished until well after Diderot's death.

Summing up recent advances in the cognitive neuroscience of dreaming, Hobson describes its 'most radical assertion' in this way: 'our so-called minds are functional states of our brains'. That is, the mind is 'not something else': not a 'spirit', not an autonomous 'entity' of any sort. Simply, mind *'is* the self-activated brain' (58). As we have seen, the late Enlightenment-to-Romantic science of dreaming and 'somnambulism' arrived at much the same conclusion two centuries ago. Diderot, in fact, advances his own analogy for how the altered functional state of the brain significantly changes our experience of mind and self in dreaming. Because the brain remains active in sleep while the center of consciousness, where the network of fibers converges, has become temporarily weakened, the 'master is thrown on the mercy of his vassals or, one might say, is abandoned to the energy of his own uninhibited activity' (164) ['Le maître est abandonné à la discrétion de ses vassaux, et à l'énergie effrénée de sa propre activité' (396)]. The whole neural 'network', according to Diderot's fictionalized Bordeu, 'relaxes', and each individual fiber (the 'threads' responsible for neural transmission) 'moves, vibrates, and so transmits to the center a whole series of sensations', self-generated from memories, associations, and dimly perceived external prompts (164) ['tout le réseau se relâche et ... chaque filet du réseau s'agite, se meut, transmet a l'origine commune une foule de sensations' (396)]. Trains of association proliferate, as each neural vibration can activate, on analogy with the harmonic vibrations of a clavichord, other fibers that have become connected with it through experience or innate predisposition (170-1/400). An example within the text concerns d'Alembert's episode of what would now be termed sexsomnia: the vibrations ascending from one of his 'voluptuary fibers' (165) ['le brin voluptueaux' (396)], uninhibited by central control, trigger the alluring image of Mlle. de L'Espinasse, who is thus both hallucinated and really present at the same time.

The simultaneous loosening and incitement of association networks becomes a key aspect of the Romantic dream theories soon to come. William Hazlitt, in his essay 'On Dreams', writes that in dreaming, the 'bundles of thought' formed

by association 'are, as it were, untied, loosened from a common center, and drift along the stream of fancy as it happens' (vol. 12: 20). Coleridge famously remarks on the '*streamy* Nature of Association' in dreams, 'streamy' evoking both the heightened flow ('Fancy and Sleep *stream* on') and the meandering pathways of dream association (Coleridge, vol. 1: 1770, vol. 2: 2542). Coleridge draws in part on David Hartley, an 18th-century associationist philosopher important to a number of Romantic writers, who noted the 'great wildness and inconsistency' of dreams and attributed this to a recuperative disruption or 'breaking' of 'accidental association' (vol. 1: 385, 389). Hobson highlights this passage in Hartley as an early recognition of the 'hyperassociative' character of REM dreams (27). Recent neuroscience understands dream hyperassociation rather differently, however: less as the creative destruction of 'accidental' and potentially misleading associations than as the formation of loose associations and integration of new information into existing association networks (what Hartley calls 'trains of ideas' [vol. 1: 385]). According to Hobson, writing with co-researchers Robert Stickgold, Laurie Scott and Cynthia Rittenhouse, REM dreaming enhances the formation of 'weak' associations (such as *thief / wrong*) but not 'strong' associations (such as *right / wrong*), facilitating the connection of ideas, images, and remembered events that waking consciousness might never group together. Stickgold, Scott, Rittenhouse and Hobson conclude that 'this alteration in normal cognitive processing provides part of the explanation for the bizarre and hyperassociative nature of REM-sleep dreaming' (188), its 'wildness', as Hartley puts it. The work of another group of dream researchers suggests that, in enhancing the 'formation of association networks and the integration of [previously] unassociated information', REM dreaming also facilitates the sort of creativity seen in problem solving – or, one might add, in famously associative poems like 'Kubla Khan' (Cai et al. 10130). Finally, it is worth noting that Hartley too attributes the bizarre inconsistency of dreams to changes in functional brain states: 'for the brain, during sleep, is in a state so different from that in which the usual associations were formed, that they can by no means take place during vigilance' (vol. 1: 385).

Dreams, the Default Mode and the Poetical (Political) Imagination

Brain-based, corporeal approaches to dreaming – in Diderot's time as in our own – may strike some as reductive, especially in relation to the content of dreams. The tradition of mining dreams for revelatory, richly symbolic material goes back at least to the Old Testament and found its great modern expositor in Sigmund Freud, a tradition that Hobson still feels required to combat on occasion (15-17, 134). Empirical research on dreaming simply will not support the claims of Freud – or of Joseph – to uncovering the 'true' meaning behind the disconnected narratives and bizarre imagery characteristic of REM dreams. It does not follow, however, that cognitive neuroscience has nothing of moment to say about the relation of dreaming to such topics as creativity, imagination or meaningfulness. Rather, 21st-century developments in dream research have elicited surprising new

ways to approach such connections. I will turn now to consider recent work by Hobson's colleague Stickgold, a research psychiatrist specializing in the cognitive neuroscience of dreaming, that could hardly be termed reductive, save in the sense that Stickgold (in common with virtually all prominent brain researchers today) does assume the fundamental identity of mind and brain.

Pursuing interconnections among 'sleep, memory, dreams, meaning, and literature' (91), Stickgold provides the outlines of a scientific *and* broadly humanistic approach to dreaming, imagination and what neuroscientists term the brain's 'default mode' that considers a broad range of human imaginative activity, beginning with the wildly imaginative creativity experienced in dreams. For Stickgold, dreaming and other imaginative activities involve nothing less than the 'construction of meaning', a fundamental human activity involving such processes as forming 'associations, relationships, regularities, and rules' and constantly reordering both the remembered 'context of an individual's life to date' and the 'imaginal space' of his or her personal future (76-77). These meaning-making processes can take place both consciously and unconsciously and can proceed in a 'bottom-up' manner – building meaning up from detached images, experiences, ideas – or coalesce in a 'top-down' manner instead (89). According to Stickgold, the bottom-up mode is typified by dreams, the top-down mode by literature.

Indeed, for Stickgold dreams, which he reasonably assumes preceded even simple oral narratives in human mental and cultural evolution, constitute our true 'ur-literature' (88). Both dreaming and imaginative literature involve 'narrative, emotionality, bizarreness, sudden shifts in time and place, metaphor, and meaning' (88). And REM dreaming recruits many of the same brain areas as well as performing some of the key functions of the brain's default mode: a set of cognitive processes active when the brain-mind is not otherwise engaged, including episodic memory, prospective thinking about the future, 'theory of mind' or thinking about other people's mental states and daydreaming or wandering thoughts (90). All this leads Stickgold to a tantalizing conclusion: 'a major function of the brain is not all that different from the function of literature' (90). Stickgold's dream research exemplifies how cognitive neuroscience has circuitously returned to a notion of imagination that would have been familiar to the writers of high Romanticism, one that credits imagining with such fundamental aims as meaning-making, pattern construction, novel discrimination of resemblances and 'similes', intuition and creative invention (76, 81).

According to Stickgold, dreams provide a window into the workings of the brain-mind as it engages in a bottom-up process of meaning construction with little or nothing in the way of executive control. REM sleep 'represents a brain state in which novel and unexpected associations are more readily identified, enhancing creativity, the discovery of insight, and the construction of meaning' (87). This 'enhanced associative activity' is facilitated by the unique neurochemistry of REM dreaming, characterized by high levels of acetylcholine and low levels of norepinephrine and serotonin, greatly reducing cognitive accuracy and reliability while increasing the forming of the sort of loose associations that may well subtend insight and creativity (80-81). In terms of the activation of local-

ized brain areas, those linked to reasoning and executive function barely register, while emotion areas such as the limbic system show high levels of activity.

The larger pattern of neural activation also overlaps with brain areas that neuroimaging studies have identified as constituting the brain's default network (Buckner, Andrews-Hanna and Schacter; Spreng, Mar and Kim; Richardson, 'Defaulting' 672, 685-689). This, Stickgold argues, helps us understand the narrative construction of dreams, since narrative forms a common thread among various cognitive activities implicated in the brain's default mode, notably including episodic memory or 'recall of autobiographical memories', theory of mind or 'divining the thoughts and intents of others' and prospection, 'imagining future worlds and scenarios'. In the default mode, Stickgold continues, the brain's 'greater purpose', like that of literature, is 'both to create a personal understanding of the world in which we live and to expand its boundaries' – to give meaning to experience encoded and stored as information and to construct new orderings and possibilities (90-91). These functions may be seen writ large in the activity of the 'dreaming brain' (91).

The connections posed here by Stickgold between dreaming, meaning making, literature and various 'default' functions had been previously explored, though in markedly different ways, during the Romantic era: a time of intense and in many ways unprecedented interest in dreaming and other mental phenomena associated with unconscious or spontaneous brain activity. An early 'default mode' approach to dreaming can in fact be traced in two celebrated and notoriously complex dreams represented in the poetry of Shelley (the poet's dream of the 'veiléd maid' in *Alastor* [Shelley 73-75]) and Keats (Madeline's dream of Porphyro in 'The Eve of St. Agnes' [Keats 312-315]). Both Keats and Shelley, as is now well known, took a pronounced interest in their era's pioneering brain science, which both established the ground for and resonates in remarkable ways with the cognitive neuroscience of our own time (Richardson, *British Romanticism* 114-150; Ruston 74-101).

To begin with, each of the invented dreams in question draws on images stored in memory in the process of envisioning a personal future – precisely the relation that neuroscientific studies of the 'default system' pose between episodic memory and 'prospective thinking' or, more colloquially, 'imagining the future' (Schacter, Rose and Buckner). The poet protagonist of *Alastor*, having glimpsed but consciously slighted a love-struck 'Arab maiden' not two dozen lines earlier in the poem, now dreams of a similarly dark-haired, exotic 'veiléd maid' who embodies 'hopes that never yet / Had flushed his cheek'. Madeline, for her part, goes to sleep anticipating (following traditional ritual practices) 'visions of delight', specifically (according to a variant text) of 'her future lord'; she fills in these visions with remembered images of her forbidden lover, Porphyro. Both dreams also feature another key function of the brain's default mode, 'theory of mind' (or 'mindreading') activities: Madeline is attempting to determine magically the marital intentions of her beloved, while the *Alastor* poet extrapolates an entire character from the amorous looks, seductive tones, flushing skin and revealing gestures of his dream girl. Each dream, in other words, centrally involves personal

meaning-making, with Madeline literally putting a face on her deepest and most secret hopes, and the poet-hero of *Alastor* embodying the poetic practices, the political hopes and the thoughts 'most dear to him' in the form of an idealized female counterpart.

In both poems, the psychological status of the represented dream proves difficult to pin down with any great precision: is it a dream proper, a reverie or a visionary experience? Here the literary works notably depart from neuroscientific paradigms, muddying the very distinctions that science thrives by – much as dreaming, waking and reverie bleed into one another in *Le Rêve de d'Alembert*. *Alastor* seems initially to present a straightforward case of nocturnal dreaming: 'He dreamed a veiléd maid / Sate near him'. Yet the dream is introduced as a visionary experience – 'a vision on his sleep there came' – suggesting that some internal or even external agency has produced a vision marked by greater coherence and memorability than dreaming would ordinarily produce. ('The spirit of sweet human love has sent / A vision to the sleep of him who spurned / Her choicest gifts'.) And although the dream or vision enters 'on his sleep', at its conclusion the poet seems to fall *back* to sleep at its anticlimactic climax: 'Now blackness veiled his dizzy eyes … sleep … rolled back its impulse on his vacant brain'. The reader is left with all too many intriguing questions: does the 'spirit of sweet human love' represent the poet's deep, inarticulate and repressed passions or a form of supernatural agency or both? And has he been fully asleep, experiencing what would now be called REM dreaming, or lulled into a receptive state of waking reverie? Or does Shelley, like Hobson, Stickgold and other 21st-century dream researchers, understand nocturnal dreaming as a type of conscious experience (Hobson, Pace-Schott and Stickgold)?

Determining the status of Madeline's dream in 'The Eve of St. Agnes' proves if anything more perplexing and can be seen as a crux, perhaps an unresolvable one, for literary interpretation of the poem, at least in its published form.[2] Some elements are clear: Madeline has fallen into an 'azure-lidded sleep', primed to dream of her future beloved and duly dreaming of Porphyro. That same Porphyro has cleverly, or treacherously, take your pick, managed to ensconce himself in Madeline's chamber and attempts to wake her up. He fails – her dream proves 'Impossible to melt' – and then Porphyro himself falls into a profound, dreamlike reverie, 'entoil'd in woofed phantasies'. When he comes to, he tries singing to Madeline, which finally has an effect: 'she panted quick – and suddenly / Her blue affrayéd eyes wide open shone'. And then the poem continues, teasingly: 'Her eyes were open, but she still beheld, / Now wide awake, the vision of her sleep'. Of course, since she was just dreaming of Porphyro and is now looking into his face, the dream may simply have ended and a waking experience of Porphyro taken its place. Yet the poem suggests, with such details as 'she look'd so dreamingly', that Madeline, though awake, remains in a dreamlike state. Moreover, the dream itself, even before she wakes, has incorporated Porphyro's actual presence and movements: 'even now / Thy voice was at sweet tremble at mine ear'. The lines between dreaming and sense perception, sleeping and waking, virtual and real image grow increasingly blurry, suggesting that Keats, like Diderot

and Polidori, sees dreaming through the lens of 'somnambulism' as it was then understood.

The poem even broaches the possibility of sexsomnia, as Porphyro, now thoroughly aroused, somehow begins to participate in Madeline's 'dream': 'Into her dream he melted'. Again, the reader is left with unresolvable questions: does this line imply that Madeline has been dreaming all along? Or that 'dream' has moved from a literal to a metaphoric sense? Or, perhaps, that nocturnal dreaming has shaded imperceptibly into daydreaming, a half-conscious erotic reverie? In any case, Porphyro feels required to say, at the end of their dreamy, passionate encounter, 'This is no dream, my bride, my Madeline'. A statement that Madeline by no means takes as obvious: 'No dream, alas! alas! and woe is mine!'. If one takes this to mean that Madeline, at least, has up to then remained in or (alternatively) subsided back into a dream state, then sexsomnia, at least on her part, becomes a tempting resolution for the crux. On the other hand, if Madeline has more than half woken up, does she willingly engage in an erotic encounter under cover of somnambulism, or, more than half asleep, has she been a victim (as students sometimes assume) of what would now be called 'date rape' (Marcus 375)?

Notice how both dream passages, in Shelley as well as in Keats, end woefully: the poet in *Alastor* also cries, or the narrator cries out for him, 'Alas! Alas!'. In each case a process including (but perhaps not coterminous with) dreaming has drawn on memories to image forth a possible future, giving form to intimate hopes and desires, and yet produced a profound dissatisfaction with the quotidian world of waking experience. Madeline cannot reconcile Porphyro's actual appearance with the 'looks immortal' beheld in her dream: 'How chang'd thou art! how pallid, chill, and drear!'. The *Alastor* poet has no present image to compare with the exotic maid's imagined one: she has no existence outside his dream world, evacuating the everyday world of all meaning: 'His wan eyes / Gaze on the empty scene as vacantly / As ocean's moon looks on the moon in heaven'. This world of pale, watery reflections proves painfully inadequate to the visionary world of dream and reverie. Both poems imply that the imaginative construction of meaning can backfire, and end by draining meaning from ordinary life.

Finally, both dreams are highly allusive and self-consciously literary, suggesting both poets' awareness that dreaming, seemingly a private activity, in fact participates in public discourses; that, like other narrative acts, dreaming must draw on a collective storehouse of images and on shared cultural codes. At the individual human level, meaning and meaningfulness must be understood, as Stickgold stresses, as 'personal': each mind-brain (or, if one prefers, each subject) uniquely situated in time and space, situated, moreover, in a unique body, and with its own distinctive array of memories and other information traces, will develop its own idiosyncratic set of meanings. And yet these meanings interact pervasively with and are largely constructed from larger social networks of meaning – including those complex networks we gesture toward with terms like *culture*, *ideology*, *habitus* and *background*.

Nothing could be more personal to Madeline than her romantic hopes and erotic feelings for Porphyro, and yet these feelings are worked out along the lines

of the cultural expectations and social scripts to which she is exposed. It is no accident that this romance begins in an institutional setting, a Catholic church. The St. Agnes' Eve ritual that Madeline must follow in order to dream of her husband-to-be is one performed by countless other Madelines before, since, and no doubt on that same chilly evening. The fifth stanza of the poem, heralding the entrance of Madeline and the rest of the local gentry into the church, could hardly be more emphatic on how each developing mind (Keats actually says 'brain') gets 'stuff'd' with established cultural scripts (299):

> At length burst in the argent revelry,
> With plume, tiara, and all rich array,
> Numerous as shadows haunting fairily
> The brain, new stuff'd, in youth, with triumphs gay
> Of old romance.

Porphyro too acts out a script from 'old romance', though just what script precisely remains under debate. Porphyro himself calls it 'La belle dame sans mercy' (the song he sings to dreaming Madeline); others see Porphyro less as a love-struck, despairing knight than a predatory figure related to the conventional demon lover or even to the vampire (Stillinger, 'The Hoodwinking of Madeline' 539-540; Stillinger, *Reading* 46-47). Either way, Porphyro hijacks the St. Agnes' Eve ritual not to disrupt it but to insert himself into the 'future lord' slot, and his singing of an 'ancient ditty' to a sleeping Madeline may well reflect his attempt to channel her dreaming into a stereotypical romantic narrative of his own choosing.

The ill-fated dream date in *Alastor* rehearses a basic scenario endemic to Orientalist writing of the long 18th century: the adventurous male European finding his ultimate erotic partner in an exotic, idealized, Oriental woman. (This scenario is sometimes termed, in cultural studies shorthand, 'the exotic is the erotic', a formula that goes back as far as Praz [207].) More specifically, Shelley borrows heavily here from an earlier Romantic-era narrative describing just such a culturally fraught and erotically overcharged encounter: Sydney Owenson's Orientalist novel *The Missionary*. Although Shelley's Orientalized singer departs in certain important ways from Owenson's Luxima – the veiléd maid, for example, chants of 'divine liberty' while Luxima devotes her songs to *Camdeo, the god of mystic love* (99) – Shelley consciously and overtly models his exotic poetess on Owenson's (then) celebrated Hindu vestal (Judson). Most saliently, the *Alastor* poet encounters his visionary maid in the 'vale of Cashmire', Luxima's home in *The Missionary* and a setting already made famous for its lushness and pristine 'Indian' character by the great Orientalist Sir William Jones. Like Luxima, Shelley's visionary maid ineffectively screens a 'lovely and luxuriant' person behind a diaphanous veil, sings inspired verses in a hauntingly beautiful voice, combines 'purity' with an irresistibly erotic manner, sports 'long dark hair' that 'floated in the wind' and reveals her passionate nature in a fit of 'soft and unrepressed transport' (Owenson 97, 109, 147-148; cf. *Alastor* lines 163, 178-180). Readers of *The Missionary* cannot

miss the veiléd maid's pronounced resemblance to Luxima (who also appears 'like the tender vision which descends upon Passion's dream' [162]) and Shelley does not want them to. The *Alastor* poet's dream represents at one and the same time 'Thoughts the most dear to him' *and* a stock cultural script already well established in British Orientalist literature.

Each dream participates in larger-scale ideological discourses, particularly in relation to gender and empire. In rehearsing the stock Orientalist fantasy scenario of an exceptional European male overcoming the resistance ('she drew back awhile') of an exotic beauty, *Alastor* implicitly endorses the 'Western=male=dominant / Asian=female=subordinate' equation endemic to Orientalist discourse. This equation is unabashedly spelled out in Shelley's primary source for this encounter, the meeting of Hilarion and Luxima in Owenson's *Missionary*: 'they stood finely opposed, the noblest specimens of the human species, as it appears in the most opposite regions of the earth: she, like the East, lovely and luxuriant; he, like the West, lofty and commanding'. Owenson only intensifies this fundamental contrast and the power differential it implies as the passage goes on: 'she, looking like a creature formed to feel and to submit; he, like a being created to resist and to command' (109). Shelley seeks to qualify this opposition by making the veiled maid both poetically inspired and politically informed, and indeed Owenson's narrative sometimes puts into question the same contrast it so blatantly poses, yet in each case the basic scenario confirms an deeply unequal social relation between European and Oriental, male and female.

'The Eve of St. Agnes', in its own uneasy manner, gives literary form to key aspects of the bourgeois domestic ideology of the era: Madeline is associated with domestic interiors, with passive positions (supine in bed) and with romantic fantasy, while Porphyro has the freedom to come and go (even on enemy territory), takes active roles, and proves capable of manipulating romance patterns to his own (however dubious) ends. The St. Agnes' Eve ritual in itself implies that the chief business of bourgeois women like Madeline must be to marry; the dream reveals not whether to marry, but whom. More than that, the very prophetic character of the dream implies a lack of agency: Madeline will not choose Porphyro, but hopes to be chosen by him. Porphyro's singing of 'La Belle Dame Sans Merci' might seem to subtly undermine this formula, implying that it is the woman who chooses, who decides whether to pity her beseeching lover or not, yet (especially in context) the allusion to courtly romance traditions does not so much overturn the domestic ideology of Keats's time as obscure or disavow its ineluctable force.

Conclusion

Are dreams ever to be considered 'private', do they ever reflect solely the preoccupation and movements of an individual mind? In an important consideration of *Le Rêve de d'Alembert* in the broader context of Diderot's 'dynamic materialism', Wilda Anderson suggests that d'Alembert's dream itself may be viewed as a kind of 'polyp', as much an aggregate as the fragmented self that dreams it and the

disintegral subject that receives it (1, 65). The dream incorporates ideas suggested by the fictional Diderot in the preliminary dialogue no less than the sleeping d'Alembert's reactions and elaborations, these in turn shaped by the contributions of Mlle. de L'Espinasse (who writes out the first part of the dream and whose presence clearly shapes it) and Bordeu, who at times fills out the lacunae in Mlle.'s transcription and whose own suggestions and elaborations become in turn drawn into d'Alembert's somniloquy. The participants in the dialogue, in Anderson's reading, resemble the 'bee swarm' in the dialogue itself: 'Our interlocutors ... have not lost their own identities, but they have managed to construct a larger identity that includes them all—all four of them' (66). And, as we have noticed, this exemplary dialogical dream also incorporates any number of contemporary physiological and ideological discourses, sometimes (as in the borrowing of that same bee swarm image from a prior text of Bordeu's) in a manifestly knowing manner. Like the dreams represented by Keats and Shelley, d'Alembert's dream includes intertextual as well as dialogical and ideological dimensions that extend well beyond the dreamer's individual subjectivity, or rather, expose the corporate and interdependent nature of all human subjectivity.

Over the course of this essay, I have made two complementary arguments, reflecting the dual focus informing the practice of cognitive historicism. In relation to historical literary interpretation, I hope to have shown that informed attention to cognitive neuroscience in the present can elicit unnoticed or undervalued aspects of past literary artifacts and discourses. Lessons from the cognitive neuroscience of dreaming, for example, can help us appreciate the ideological challenge posed by Enlightenment and Romantic accounts and representations both of dreams and of the very activity of dreaming. The work of Stickgold in particular can help us to new appreciations of old connections between dreaming and literary creativity, as well as to views of dreaming in relation to a whole suite of activities – including remembering the past, imagining a possible future and speculating on the emotions and intentions of others – newly grouped together as aspects of the brain's default system.

Cognitive historicist literary investigation can, in turn, reveal some of the biases and potential blind spots of scientific research agendas. The emphasis placed by current scientific dream researchers on REM dreaming, for example, may downplay some of the more unorthodox implications of the brain's activity during sleep. It seems notable that dream science should have 'discovered' sexsomnia only quite recently, although Diderot represented it over two centuries ago and it arguably features in one of Keats's best known poems. Sleep sex brings out quite graphically the disturbing (not to say titillating) aspects of a brain unshackled from conscious supervision and cultural norms, troubling notions of agency and volition, in an especially salient manner. Earlier theories and representations of dreaming also serve to remind us that at least some of the lines drawn by scientific investigators – say, between dreaming and reverie, or waking and sleeping consciousness, which in Diderot, Shelley and Keats seamlessly blend into one another – may ultimately prove overstated, however useful for the purposes of study design: statistical differences presented as hard categorical distinctions.

Most importantly, the literary texts examined here remind us that dreams reveal ideological as well as emotional investments, construct personal meanings out of public discourses and confound any firm division between private and political. All three texts break down any sense of private ownership of a given dream, suggesting instead that dreams (at least invented, literary dreams) exhibit, like other discursive forms, dialogical features: in the corporate subjectivity informing 'd'Alembert's' dream, in the ways that Porphyro helps shape and even enters into Madeline's dream ('into her dream he melted'), and in the patent rehearsal of an earlier Orientalist text in the Alastor poet's dream of his veiled maid. Each dream also evokes pressing social and ideological issues: Diderot's materialist critique of a whole range of contemporary orthodoxies, Shelley's engagement with a highly gendered version of Orientalist discourse, Keats's underscoring, critical or not, of the domestic ideology recently challenged by Mary Wollstonecraft and other pioneering feminists. And yet all three of these fictional dreams harbors utopian tendencies as well, not least in the way they unleash erotic energies in defiance of social and literary notions of decorum. The dreamer never ceases to function as a political and ideological subject, even as discrete individual subjectivity itself is exposed as an ephemeral dream.

Literature

Andersen, Monica L., Dalva Poyares, Rosana S. C. Alves, Robert Skomro and Sergio Tufik. 'Sexsomnia: Abnormal Sexual Behavior During Sleep'. *Brain Research Reviews* 56 (2007): 271-282.

Anderson, Wilda. *Diderot's Dream*. Baltimore: Johns Hopkins UP, 1990.

Buckner, Randy L., Jessica R. Andrews-Hanna and Daniel L. Schacter. 'The Brain's Default Network: Anatomy, Function, and Relevance to Disease'. *Annals of the New York Academy of Sciences* 1124 (2008): 1-38.

Cai, Denise J., Sarnoff A. Mednick, Elizabeth M. Harrison, Jennifer C. Kanaday and Sara C. Mednick. 'REM, Not Incubation, Improves Creativity by Priming Association Networks'. *PNAS* 106.25 (June 23, 2009): 10130-10134.

Coleridge, Samuel Taylor. *The Notebooks of Samuel Taylor Coleridge*. Ed. Kathleen Coburn. 5 vols. London: Routledge and Kegan Paul, 1957-2002.

Curran, Andrew. 'Monsters and the Self in the *Rêve de d'Alembert*'. *Eighteenth-Century Life* 21.2 (1997): 48-69.

Diderot, Denis. *D'Alembert's Dream*. In *Rameau's Nephew and Other Works*. Ed. Jacques Barzun and Ralph H. Bowen. Garden City, NY: Doubleday, 1956. 95-182.

Diderot, Denis. *Le Rêve de d'Alembert*. In *Oeuvres Philosophiques*. Ed. Michel Delon and Barbara Negroni. Paris: Gallimard, 2010. 344-409.

Hartley, David. *Observations on Man*. 2 vols. 1791. Poole, England: Woodstock, 1998.

Hazlitt, William. *The Complete Works of William Hazlitt*. Ed. P. P. Howe. 21 vols. London: Dent, 1930-1934.

Hobson, J. Allan. *Dreaming: A Very Short Introduction*. Oxford: Oxford University Press, 2005.

Hobson, Edward F. Pace-Schott and Robert Stickgold. 'Consciousness: Its Vicissitudes in Waking and Sleep'. *The New Cognitive Neurosciences*. Ed. Michael S. Gazzaniga. 2nd ed. Cambridge, MA: MIT P, 2000. 1341-1354.

Judson, Barbara. 'Under the Influence: Owenson, Shelley, and the Religion of Dreams'. *Modern Philology* 104.2 (November 2006): 202-223.

Keats, John. *The Poems of John Keats*. Ed. Jack Stillinger. Cambridge: Harvard University Press, 1978.

Lavie, Peretz and J. Allan Hobson. 'Origin of Dreams: Anticipations of Modern Theories in the Philosophy and Physiology of the Eighteenth and Nineteenth Centuries'. *Psychological Bulletin* 100.2 (1986): 229-240.

Marcus, Steven. 'Soft Totalitarianism'. *A Partisan Century: Political Writings from Partisan Review*. Ed. Edith Kurzweil. New York: Columbia UP, 1996. 370-376.

[Ménuret de Chambaud, Jean-Joseph]. 'SOMNAMBULE, & SOMNAMBULISME'. *Encyclopédie, ou dictionnaire raisonné des sciences, des arts et des métiers, etc.* Ed. Denis Diderot and Jean le Rond D'Alembert. Vol. 15. University of Chicago: ARTFL Encyclopédie Project (Spring 2011 Edition), Robert Morrissey (ed.), http://encyclopedie.uchicago.edu/. 340-342.

Moravia, Sergio. 'From *Homme Machine* to *Homme Sensible*: Changing Eighteenth-Century Models of Man's Image'. *Journal of the History of Ideas* 39.1 (Jan.-March 1978): 45-60.

Owenson, Sidney (Lady Morgan). *The Missionary: An Indian Tale*. Ed. Julia M. Wright. Peterborough, ONT: Broadview, 2002.

Polidori, John William. 'An English Translation of John William Polidori's (1815) Medical Dissertation on Oneirodynia (Somnambulism)'. Trans. and with notes by David Petrain. *European Romantic Review* 21:6 (2010): 775-788.

Praz, Mario. *The Romantic Agony*. Trans. Angus Davidson. 2nd ed. London: Oxford University Press, 1970.

Richardson, Alan. *British Romanticism and the Science of the Mind*. Cambridge: Cambridge University Press, 2001.

Richardson, Alan. 'Coleridge and the Dream of an Embodied Mind'. *Romanticism* 5.1 (1999): 1-25.

Richardson, Alan. 'Defaulting to Fiction: Neuroscience Rediscovers the Romantic Imagination'. *Poetics Today* 32:4 (Winter, 2011): 663-692.

Richardson, Alan. *The Neural Sublime: Cognitive Theories and Romantic Texts*. Baltimore: Johns Hopkins University Press, 2010.

Ruston, Sharon. *Shelley and Vitality*. Houndsmills: Palgrave Macmillan, 2005.

Schacter, Daniel L., Donna Rose Addis and Randy L. Buckner. 'Remembering the Past to Imagine the Future: The Prospective Brain'. *Nature Reviews: Neuroscience* 8 (September 2007): 657-661.

Schwartz, Delmore. 'In Dreams Begin Responsibilities'. 1937. *In Dreams Begin Responsibilities and Other Stories*. Ed. James Atlas. New York: New Directions, 1978. 1-9.

Shelley, Percy Bysshe. *Shelley's Poetry and Prose*. Ed. Donald H. Reiman and Sharon B. Powers. New York: Norton, 1977.

Spolsky, Ellen. 'Cognitive Literary Historicism: A Response to Adler and Gross'. *Poetics Today* 24.2 (2003): 161-183.

Spreng, R. Nathan, Raymond A. Mar and Alice S. N. Kim. 'The Common Neural Basis of Autobiographical Memory, Prospection, Navigation, Theory of Mind, and the Default Mode: A Quantitative Meta-analysis'. *Journal of Cognitive Neuroscience* 21.3 (2008): 489-510.

Stickgold, Robert. 'Memory in Sleep and Dreams: The Construction of Meaning'. *The Memory Process: Neuroscientific and Humanistic Perspectives*. Ed. Suzanne Nalbantian, Paul Matthews and James L. McLelland. Cambridge, MA: MIT Press, 2011. 73-95.

Stickgold, Laurie Scott, Cynthia Rittenhouse and J. Allan Hobson. 'Sleep-Induced Changes in Associative Memory'. *Journal of Cognitive Neuroscience* 11.2 (1999): 182-193.

Stiles, Anne, Stanley Finger and John Bulevich. 'Somnambulism and Trance States in the Works of John William Polidori, Author of The Vampyre'. *European Romantic Review* 21:6 (2010): 789-807.

Stillinger, Jack. 'The Hoodwinking of Madeline: Scepticism in *The Eve of St. Agnes*'. *Studies in Philology* 58.3 (July 1961): 533-555.

Williams, Elizabeth A. *The Physical and the Moral: Anthropology, Physiology, and Philosophical Medicine in France, 1750-1850*. Cambridge: Cambridge University Press, 1994.

Yeats, William Butler. *The Complete Poems of W. B. Yeats*. New York: MacMillan, 1956.

Notes

1 Quotations from Diderot are given first in English, from the translation in Barzun and Bowen's edition, and then in the French original, following the 2010 Gallimard edition by Michel Delon. Where two page numbers are given separated by a slash, the second refers to the French edition.

2 Keats produced a revision of lines 314-322, which his publishers refused to accept, that included the phrase 'Still, still she dreams' (Stillinger, 1999 26-27). For Stillinger, this version 'makes clearer that Madeline is still dreaming' (Stillinger, 'The Hoodwinking of Madeline' 545), but what then do we make of the phrase, in the previous stanza, 'now wide awake'? To me, the passage remains highly ambiguous.

'LET'S BE HUMAN!' – ON THE POLITICS OF THE INANIMATE

KARIN SANDERS

[ABSTRACT]

To Romantics the principle of life, its mystery and power, propelled a desire to 'see into the life of things' as William Wordsworth articulated it. This article examines how the relationship between life and non-life, the animate and the inanimate, humans and things, took on a new inflection in Romanticism, which differed in radical ways from the pragmatic and economic relationship between persons and things in the 18th century. In Romanticism, the threshold between living and dead matter came to linger between divinity and monstrosity. In Denmark, Hans Christian Andersen had few rivals when it came to articulating associations between humans and things. This article narrows the scope of Andersen's vivifications to one specific subset: marionettes, dolls and automatons, asking how his surrogates operated vis-à-vis Heinrich von Kleist's, E. T. A. Hoffman's and Mary Shelley's. Each of these authors drew on the hyper-mimetic relationship that dolls, marionettes and automatons have to humans: Kleist used marionettes to examine consciousness through unconsciousness; Hoffmann used automatons to articulate the uncanny; and Shelley used a golem-like monster to ponder the ethics of man's quests for generative powers. Andersen, in contrast, used dolls, marionettes and automatons in order to speak about *social* beings.'[1]

.

KEYWORDS *Hans Christian Andersen, humans and things, animate-inanimate, conscious-unconscious, the uncanny, monstrosity.*

'The result of aesthetic concentration is the animation of the soul,
the part of us that rises from corporeal slumber to penetrate the *life* of things.'
 Denise Gigante, *Life: Organic Form and Romanticism* 2

'Nej, lad os nu være Mennesker!' [Now, let's be human!], a caged parrot repeatedly cries out in Hans Christian Andersen's fairy tale 'Lykkens Kalosher' [The Magic Galoshes 481] from 1838.[2] A tiny lark repeats the command, 'Let's be human!' in a mimicry that would be innocuous were it not for the fact that the reader recognizes that the lark is *already* human; namely a copyist who had wished to be a poet, and who in turn had wished to be a bird in order to escape the misery of the human condition. Repeating the wish to be human brings the bird/poet back to his former shape as copyist. Although the narrator remarks that the lark

KARIN SANDERS, Professor in Scandinavian Studies, Berkeley University
Aarhus University Press, *Romantik*, 01, vol. 01, 2012, pages 29-47

repeated the words 'uden selv at tænke paa hvad han sagde' [without reflecting on what he said] ('Lykkens Kalosher' 482) when it repeated what the parrot said (and thus presumably did not wish himself back in the human shape from which he had escaped), the copyist is returned to his wretched humanness precisely because he, in the form of a lark, must act like a lark. That is, it must act like its species, 'parrot' the parrot, and hence repeat the fateful words: 'Now, let's be human!' ('Lykkens Kalosher' 482).

The instructive irony at play here speaks not only to Andersen's clever use of copying and repetition but also to his constant examinations of humans (their customs and characteristics) by way of that which is not human.[3] In 'Pengegrisen' [The Piggy Bank], from 1855, we find a slightly different combination of the inanimate and the human. The story is set in a nursery full of toys. It is night, the moon is shining and an old doll with a patched-up neck peeks out of a chest and calls out to her fellow toys, 'Skal vi nu lege Mennesker, det er jo altid Noget!' [Let's play humans, that's always something] ('Pengegrisen' 114). The change from the existential 'to *be* human' to the performative 'to *play* human' is tied to the detail that the doll (unlike the lark) already looks like a human and therefore simply needs to play out this mimicry. Yet to look human is not to *be* human; and to *play* at being human may not be much, but as the doll acknowledges, it is 'always something' ('Pengegrisen' 114).

These instances of escaping the human condition (wishing to be an innocent lark) and playing at being a human (the toy doll's desire for movement) should be seen as part of Andersen's overall investigation of the mores and distinctiveness of humanity. His use of non-humans (things, animals) is important precisely because they allow him freedom to articulate the follies of human vanity and expose humankind's fraught social behaviors. When Andersen focuses our attention on naïve desires, as is the case in 'Lykkens Kalosher' and 'Pengegrisen', he also offers his readers a way to consider what it means to be human in a broader sense of the word, as a social and psychological being.

The banalities of the everyday are observed by Andersen via the lure of material objects: pencils and paper and ink, bottle necks, a wooden spoon, matchsticks, peas, shoes, coins, and many other material things are used as tropes that play out some kind of relation with humans. Yet he never conflates humans and things. That is to say, when Andersen parses specific properties of given material objects and assigns human attributes to them, he rarely violates their unique form or functionality (the pen-ness of a pen, the ink-ness of an inkwell, the bottle-ness of a bottle, the steadfastness of a toy soldier and so on).[4] Likewise, he personifies animals according to their perceived characteristics: talkativeness (parrots), aloofness (cats), loyalty (dogs), dignity (swans) and so forth. This sensitivity to the specificity of physical objects or animals resonates far beyond his fairy tales and can be seen in his many travel descriptions, novels and poems. Yet it is in the fairy tales that Andersen's relationship to non-human forms (things, animals) comes into its own; in fairy tales the humanized actions of non-humans seem 'natural'.[5]

The threshold between the 18th and 19th centuries had yielded a plethora of 'things' for cultural and literary theorists.[6] In the 18th century, as Barbara M. Benedicts writes, things were seen as 'the devils of the empirical age'. She continues:

Especially in their mutability and fungibility, they possess supernatural power over individual meanings and identities; they can make and unmake themselves; they can even take over conscience and consciousness. Because of their replicability and fundamental indifference to human possession or loss, things embody the terrible hazards of living in a world of soulless material powers. They are absolute material: bodies without souls. (39)

To Romantics, however, the principle of life, its mystery and power, propelled a desire to 'see into the life of things' as William Wordsworth articulated it. Indeed, since the beginning of Romanticism, as Larry H. Peer notes, 'we have been "thing-ing" in Western culture: taking a word, concept, or object out of its natural setting and projecting human values, meanings, or explanations on it' (5). Things-as-humans can have distinctive moral inflections that force humans (the readers) to see their own self-centered anthropocentricism. That is, readers are made to see themselves *as* humans *by way of* things. But because they are excluded from a human code of ethics, anthropo*morphic* objects can act out more freely, and enunciate more clearly (and sometimes devastatingly), their critiques of the anthropo*centric*.

In Romanticism, the vitality associated with life was implicitly related to the authenticity of the aesthetic. Art and life shared in a dynamism of essential energy, and therefore, as Denise Gigante has recently argued in her study *Life: Organic Form and Romanticism,* 'sparked a preoccupation with self-generating and self-maintaining form' – one that served to cross-pollinate between aesthetics and life sciences (5). The relationship between life and non-life, the animate and the inanimate, humans and things, took on a new inflection, which differed in radical ways from the pragmatic and economic relationship between persons and things that had been articulated in the 18th century (for example in the form of so-called 'it-narratives', also known as circulation novels, in which an inanimate object serves as narrator).[7] In Romanticism, the threshold between living and dead matter came to linger between divinity and monstrosity.

Hans Christian Andersen had few if any rivals when it came to articulating associations between humans and things. For the purpose of this essay, however, I want to narrow the scope from the plethora of anthropomorphisms, personifications and vivifications of material things or animals in his oeuvre to one specific subset: marionettes, dolls and automatons. I do so, first, because Andersen ties these surrogates to a larger vision shared by several other Romantics, most notably Heinrich von Kleist, E. T. A. Hoffman and Mary Shelley; and, second, because marionettes, dolls and automatons already *look the part* of humans and therefore bring the distinction between human/non-human and human/ahuman to the fore in remarkable ways. *When the something* that is brought to life already resembles a human, we are afforded a particularly clear view into the relation

between living bodies and inanimate ones that is contingent on similitude. A few exceptions, an anthropomorphized book and a vivification of a machine, will be used along the way to underscore Andersen's engagement with the dynamics of humans and non-humans.

Hoffman had a direct influence on Andersen; this was not the case with Kleist and Shelley. But Kleist and Shelley were part of the Romantic *Zeitgeist* and they helped form the cultural conversation that shaped Andersen's aesthetics. Each of these authors, albeit in fundamentally different ways, drew on the hyper-mimetic relationship that dolls, marionettes and automatons have to humans: Kleist used marionettes to examine consciousness through unconsciousness; Hoffmann used automatons as a way to articulate the uncanny; and Shelley used a golem-like monster in order to ponder the ethics of man's quests for creative powers. Andersen, in contrast, used dolls, marionettes and automatons in order to speak about *social* beings.

Conscious Unconsciousness

Playing with puppet theaters was a formative childhood experience for many Romantics and pre-Romantics, Andersen amongst them: 'Min største Glæde var at sye Dukkeklæder' as he writes in his autobiography *Mit Eget Eventyr uden Digtning* (183).[8] Goethe, who famously drew inspiration from his puppet theater, expressed a more sinister fascination in one of his *Withheld Venetian Epigrams*:

> In ein Puppenspiel hatt ich mich Knabe verliebet,
> Lange zog es mich an, bis ich es endlich zerschlug.
> So griff Lavater jung nach der gekreuzigten Puppe:
> Herz' er betrogen sie noch, wenn ihm der Atem antgeht![9]
> (136-7)

His childhood puppets are here implicitly conflated with the 'puppet' of the crucified Christ that Goethe's former friend, the physiognomist and poet Johann Kaspar Lavater (whom Goethe came to see as being too superstitious), grabs at. It is unsurprising perhaps that these profanely demolished puppets did not make it past the censor into the original rendering of Goethe's Venetian epigrams.

While puppet theaters enjoyed great popularity in the 18th century, in the 19th century they were seen mostly as second-order entertainment. As Victoria Nelson explains in *The Secret Life of Puppets*:

The simulacrum has always travelled both a high road and a low road in human culture – as highest form of worship and as lowest form of entertainment – but it is the peculiarity of Western culture of the last three hundred years that the two have joined into one that runs, as it were, below sea level. Once the human likeness was no longer worshipped, it became an idea, not an idol, partaking of the insensible territory 'imaginary' instead of the insensible territory 'holy'. (60)

This shift from the holy to the imaginary can be found in Kleist's enigmatic treatise 'Über das Marionettentheater' from 1810. Here a ballet dancer finds ultimate grace in wooden marionettes, contingent upon the loss of self-consciousness. As is illustrated by two side-stories on un-self-consciousness (the story of a young man losing his grace by looking in a mirror) and animal-like intuitiveness (the story of a fencing duel with a bear), primal innocence is lost to humans. To Kleist's dancer, whose manner of argument has an eccentric mathematical-demiurgic inflection, grace appears only in puppets that lack consciousness or in gods who possess infinite consciousness. Being neither puppets nor gods, human bodies are virtually excluded from the art of graceful aesthetics.

Some forty years after Kleist, in 1851, Andersen published an allegory called 'Marionettespilleren' [The Puppeteer]. The story is as follows. On a steamer, sailing through the canals of Sweden, our narrator meets an older gentleman, a traveling puppeteer and a fellow Dane, who carries his entire troupe of actors on his back – in a wooden box. His facial expression of exuberance suggests to our narrator that this man must be the happiest human on earth. Indeed, as the two travelers strike up a conversation, the puppeteer not only confirms that he was born with a joyful disposition but that his positive outlook had been strengthened after a meeting with an unusual spectator, a student of science. The puppeteer tells the story of their meeting: one day a man dressed in black, from the Polytechnic Institute, sits down amidst an audience of children. He responds to the performance in ways that are fully appropriate; he 'leer aldeles paa de rigtige Steder, klapper aldeles rigtigt, det var en usædvanlig Tilskuer!' ('Marionettespilleren' 190).[10]

Whether the new spectator's response is 'unusual' because it mimics that of children (a naïve response) or because he comprehends the show at a level beyond that of the usual audience, is left unsaid. In either case, the puppeteer decides to attend the student's scientific demonstration: 'nu var jeg hans Tilhører' [now I became his spectator] ('Marionettespilleren' 191). They strike up a friendship. But unlike the science student's implicit understanding of the nature of puppeteering, our puppeteer seems unable to comprehend fully the scientific experiments of his new friend. Enthralled nevertheless by the perceived magic of electromagnetism (a favorite theme of Andersen's) the puppeteer persuades the scientist to help him complete his happiness by making him a real theater director with living actors: 'at blive Theaterdirecteur for en levende Trup, et rigtigt Menneske-selskab' ('Marionettespilleren' 191).[11] Inspired by a night of drinking, the student hurls the puppeteer (along with his box of marionettes strapped on his back) through an electromagnetic spiral and the marionettes stumble out of the box, as alive as real humans. Predictably this transformation of dumb lifeless things into real speaking humans turns nightmarish:

Det var ligesom Fluer i en Flaske, og jeg var midt i Flasken, jeg var Directeur. Veiret gik fra mig, Hovedet gik fra mig, jeg var saa elendig, som et Menneske kan blive, det var en ny Menneskeslægt jeg var kommen imellem, jeg ønskede, at jeg havde dem Allesammen i Kassen igjen, og at jeg aldrig var bleven Directeur.[12] ('Marionettespilleren' 192)

The marionettes-as-real-actors unleash a plethora of unattractive characteristics in the form of self-promotion and overblown egos. Each 'actor' now insists on special treatment and full attention from their director: The ballerina claims that the success of the entire performance stands or falls with her ability to balance on pointed toes, the hero wants new lines that guarantee the greatest exit applause, the actress playing an empress demands to be treated like one both on and off the stage, and so forth. Thus the transformation from marionette to human consti-tutes a fall from grace on two fronts: The marionettes turn from gentle dummies to maliciously self-centered avatars; and the puppeteer loses his much-professed happiness. Alive, the marionettes are neither demonic nor divine, but hideously pedestrian and all too human – plain, greedy, attention-seeking and nitpicky. Succumbing to misery over this precipitous fall into utter triviality, the puppe-teer finally informs his actors straight to their faces that 'de igrunden dog alle vare Marionetter og saa sloge de mig ihjel!' ('Marionettespilleren' 192).[13] At this very moment, the puppeteer wakes up from the 'electromagnetic dream' to find the science student gone and the marionettes scattered on the floor, once again lifeless.

Dolls can connote madness, but the puppeteer's marionettes perform only one mad act, which is one of anger ('and then they killed me'). With this act the order of things is restored: The puppeteer wakes up, alive, and his marionettes are once again dead. Humans are humans – things are things. But with this re-instated order the ability to reason is also gone: 'mit Personale raisonnerer ikke – og heller ikke publikum' ('Marionettespilleren' 192).[14] 'Lutret' [purified] by the quasi-scientific experiment, Andersen's puppeteer has regained complete sover-eignty, but appears strangely nonsensical as he repeatedly professes to a bliss so complete (the word 'lykkelig', 'happy', is mentioned no less than nine times) that it forces the reader to be suspicious. Has the puppeteer gone mad?

In 'Über das Marionettentheater', as Karl Heinz Bohrer has suggested, the 'quasi-phenomenological precision' that grows from marionettes illustrates how 'happiness (charm, grace) is ... retained or achieved precisely through an act of the unconscious conscious' (208). But does Andersen's tale reflect such a state of the unconscious consciousness? Will his puppeteer's almost delirious happiness lead to unreflective bliss? The answer is no. Instead, I would argue, Andersen of-fers a corrective to the aesthetic and philosophical questions parsed in 'Über das Marionettentheater'.

Unlike Kleist, whose puppeteer embodies a divine principle (in the form of the hand that guides), Andersen lacks sympathy for his self-proclaimed 'happi-est' puppeteer; *his* puppeteer is a buffoon. And unlike Kleist's utopia, Andersen's marionettes cannot elevate art to the highest potency; rather, as soon as they are given agency they plunge into mediocrity. And when they return to thingness (as wooden shapes), they are merely dull 'dolls'. Their inability to reflect and reason – the very thing that is celebrated by Kleist – is tranformed by Andersen from an aesthetic possibility to a critique of human behavior. He effectively breaks down the Kleistian model of unconscious consciousness in favor of a social model that speaks to human characteristics in a more pessimistic manner than the philo-

sophical and aesthetic optimism and utopian vision we find in Kleist. What these authors do agree on, however, is that if marionettes present second-order theater (they are not the *real* thing), as *things* (inanimate, speechless, emotionless) they offer the possibility of absolute freedom. Andersen's puppeteer uses this freedom and power over his once again inanimate minions to maintain the status quo and to stage performances from the vault of forgotten plays. The stabs at real-life theater life are palpable:

Jeg er en lykkelig Directeur, mit Personale raisonerer ikke, Publicum ikke heller, det fornøier sig af Hjertens Grund; frit kan jeg selv lave alle mine Stykker sammen. Jeg tager af alle Comedier det Bedste jeg vil, og Ingen ærgrer sig derover. Stykker, som nu ere foragtede paa de store Theatre, men som Publicum for tredive Aar siden løb efter og tvinede over, dem tager jeg nu til mig, nu giver jeg dem til de Smaa, og de Smaa de tvine ligesom Fader og Moder tvinede; jeg giver »Johanna Montfaucon« og »Dyveke,« men i Forkortning, for de Smaa holde ikke af langt Kjærligheds-Vrøvl, de ville: ulykkeligt, men gesvindt. Nu har jeg bereist Danmark paa Retten og paa Vrangen, kjender alle Mennesker og kjendes igjen[15] ('Marionettespilleren' 192-193)

Andersen's allegory, it should be mentioned, was originally published in the travel book *I Sverrig* [In Sweden] and later slightly revised as a freestanding tale in *Samlede Skrifter*, 1868. This provenance is important because *I Sverrig*, a rich and complicated engagement with modernity, introduces us to another breed of 'puppet', one that is infinitely larger than those in 'The Puppeteer' story, and that redefines in radical ways the threshold between the inanimate and the animate. Its name is 'Master Bloodless'.[16] But before I turn to this remarkable incarnation of puppetry there is more to be said about Andersen's early puppeteer stories, and in particular how they engage with the uncanny and, consequently, with E. T. A. Hoffmann.

Circumscribing the Uncanny

If we look back at Andersen's first attempt writing a fairy tale, in a variation of the folktale on the grateful dead called 'Dødningen' [The Dead] published in 1830, we find an inserted marionette scenario.[17] Here a puppeteer is giving a performance from the Old Testament (Queen Esther's story) when an audience member's bulldog flies up on the stage and breaks the Queen: 'Knik, knak! hvor gik hun i Stykker, og den arme Marionetspiller jamrede sig gyseligt, thi det var jo hans første Prima-Donna, Hunden havde bidt Hovedet af' ('Dødningen' 61).[18] The sharp clatter of the decapitation ('[k]nik knak') mimics the sound of wood breaking. We cannot doubt that the doll is a thing made out of hard and stiff material. Andersen may have taken inspiration here from Cervantes' *Don Quixote*, in which Quixote, in full accordance with his inability to distinguish between illusion and reality, throws himself on the puppets when an army of other puppets endangers the show's hero. In Andersen's version, however, a stranger (the grateful dead man) rubs salve on the cracked marionette and not only heals and

repairs its broken shape but also gives it the ability to move its limbs. Alive, the only thing 'she' lacks is 'Mælet' – a voice. Ironically, while 'she' remains soundless, the other, inanimate marionettes can sigh, very audibly in fact:

Alle Træukkerne laae imellem hinanden, Kongen og alle Drabanterne, og det var dem, som sukkede saa ynkeligt og stirrede med deres store Glas-Øine, for de vilde saa gjerne blive smurt lidt ligesom Dronningen, at de ogsaa kunde komme til at røre sig af sig selv.[19] ('Dødningen' 61)

The large glass eyes of the wooden dolls, capable of eloquence far beyond their assumed deadness, are positively eerie, and the collective sigh from the wooden box creates uneasiness about the textual logic: How can the dead marionettes utter sounds when the living doll cannot? The question, Sigmund Freud might answer, is moot. There may be nothing uncannier than hearing sounds from something dead, yet because fairy tales, as Freud maintains in 'Das Unheimliche', defy logic, they are exempt from uncanniness. Freud is in fact specific on this point and insists that while fairy tales (and he singles out Andersen as an example) make striking uses of animation, they are 'not in the least uncanny':

Das Märchen stellt sich überhaupt ganz offen auf den animistischen Standpunkt der Allmacht von Gedanken und Wünschen, und ich wüßte doch kein echtes Märchen zu nennen, in dem irgendetwas Unheimliches vorkäme. Wir haben gehört, daß es in hohem Grade unheimlich wirkt, wenn leblose Dinge, Bilder, Puppen, sich beleben, aber in den Andersenschen Märchen leben die Hausgeräte, die Möbel, der Zinnsoldat, und nichts ist vielleicht vom Unheimlichen entfernter. Auch die Belebung der schönen Statue des Pygmalion wird man kaum als unheimlich empfinden.[20] ('Das Unheimliche' 268)

Even so we instinctively expect an experience of the uncanny when confronted with scenes in which the dead return. In 'Dødningen' the magic life-giving salve comes from an 'undead' man. The tale's hero, Johannes, had secured the man's grave-peace and the 'grateful dead man' now returns as a traveling companion, paying back his debt by securing Johannes' fortune in wondrous ways (Johannes will ultimately marry a princess and gain a kingdom). Yet, as Freud reiterates, re-animation of the dead 'ist aber wiederum im Märchen sehr gewöhnlich; wer wagte es unheimlich zu nennen, wenn z. B. Schneewittchen die Augen wieder aufschlägt? Auch die Erweckung von Toten in den Wundergeschichten, z. B. des Neuen Testaments, ruft Gefühle hervor, die nichts mit dem Unheimlichen zu tun haben' ('Das Unheimliche' 269).[21]

Freud's remarks are perhaps too perfunctory. But unlike Hoffman's fantastic tales (and we might remember that Freud used Hoffmann's 'Der Sandmann' as a prime example of the uncanny), Andersen's fairy tales rarely if ever ask his readers to imagine or experience the uncanny feeling that inanimate objects can produce if mistaken for humans. Andersen may be a student of Hoffmann, but he is not a follower. Hoffmann's famous automata Olympia in 'Der Sandmann', mute and elusive but deceptively close to being human and thus decidedly uncanny, is of

a type that is not to be found anywhere in Andersen's oeuvre. A speaking doll or pen or jackhammer in Andersen's world is never uncanny in this overt way. Even his use of marionettes navigates free of the bewilderment (is it real, or is it not?) of the uncanny – the reader is never in doubt.

In the fictional travelogue *Fodreise fra Holmens Canal til Østpynten af Amager i Aarene 1828 og 1829* [*Journey on foot from Holmens Canal to the East Point of Amager*], in which Andersen first sharpened his pen on the concept of unnatural life, a scene with automatons (a key Hoffmann trope) will help clarify this. Here we find a futuristic vision of aristocrats inhabiting a castle in the year 2129 (three hundred years after the publication of *Fodreise*). The narrator finds himself in the company of a host of mechanical beings:

En Mængde pyntede Herrer bevægede sig mechanisk op og ned ad Gulvet. De saae ud, som de vare dreiede. Enhver Fold i Klæderne syntes udstuderet. Jeg tiltalte den som kom mig nærmest, men han svarede ikke et Ord, vendte mig Ryggen, og gik med stolte Miner sin sædvanlige Gang. Jeg tiltalte en Anden, men han var ikke mere høflig end den Første. - Da nu den Tredie ogsaa vilde vende mig Ryggen, tabte jeg Taalmodigheden og holdt ham fast ved Armen. Han var slem at holde og gjorde uhyre mange Bevægelser med alle Lemmer, i det han tillige snerrede ganske underligt ad mig. Tilsidst mærkede jeg da, at hele Selskabet bestod af lutter Træmænd, fyldte med Damp; et Slags kunstige Automater, Aarhundredet havde opfunden til at udpynte Forgemakkerne med²² (*Fodreise* 180)

The automatons in this passage are wooden, but, once again, not uncanny. Andersen uses them to expose the social characteristics of the castle inhabitants (the aristocracy): boorishness, artificiality and deceitfulness. They are stiff wooden automatons: 'affected' [udstuderet], 'arrogant' [stolte], 'sneering' [snerrende] and 'impolite' [ikke ... høflig(e)] (*Fodreise* 180), all of which is far from the uncanniness brought on by a Hofmannesque ambiguity and liminality. In *Fodreise*, then, the work in which Andersen most clearly demonstrated his mastery of Romantic irony, using a plethora of tropes and genres favored by Romanticism's darker modalities, he remains implicitly critical of the Romantic project. His brand of Romanticism, even his use of Romantic irony, is more overtly political than Hoffmann's. Let us, for example, observe how Andersen appropriates a Hoffmann text and demolishes its content.

Fodreise's perambulating narrator happens to walk around with a copy of *Elixiere des Teufels* [The Devil's Elixir] in his pocket, and at the stroke of midnight the novel unsurprisingly starts to 'spøge' and 'fortælle' [spook and speak]. Unable to read, because of the darkness of the night, the narrator decides to 'høre' [listen] to its story:

Mine første Erindringer – begyndte den – strække sig fra Bogtrykkeriet, hvor jeg først saae Lyset Som en Drøm husker jeg endnu fra denne Tid, en lille Mand med et underligt Katte-Ansigt, der en Dag traadte ind i Stuen, hvor jeg hang i al Uskyldighed paa en Snoer for at tørres. Min Moder, – saaledes tør jeg vel nok benævne det Manuscript, jeg skylder min Tilværelse – fortalte os Børn om Natten, at det var vor Fader, Hofraad *Hoffmann*, uden

hvem hun endnu havde været et reent ubeskrevet Papiir, og vi aldrig seet Lyset – Nysgjær-
rigt hørte vi Alt hvad hun fortalte os om ham, hvorledes de Syner, der bevægede sig i vort
Indre, viste sig lyslevende for ham, naar han i de lange Vinter-Nætter sad og arbeidede, og
at han da ofte maatte kalde sin Kone op af Sengen, der satte sig hos ham med sin Strik-
kestrømpe, og nikkede venligt over til den underlige Mand, naar Phantasien tog sig altfor
meget Herredømme.[23] (*Fodreise* 195)

As we listen along with our narrator, we are presented with a rather unusual
homage to Hoffmann. *Elixiere des Teufels* has become a tangible artifact: paper,
print, binding. It has morphed into an object-biography emptied of the meaning
it had as a dark Romantic story full of madness and doppelgängers. There are
no signs left of a monk succumbing to the seductive powers of the devil's elixir
and so forth. Instead we are taken on its journey from manuscript to bookbind-
ing and from a life in bookstores to the humiliation of being placed in a lending
library. Hoffraad Hoffmann, as is suggested by the alliteration, the doubling of
'Hoff' and the implicit linking of 'raad' with 'man' (*rådmand* in Danish translates
to alderman), is pulled apart, reassembled and in the process strangely neutered
even as he exhibits his potency and 'impregnates' the blank page into a manu-
script. His fecundity becomes explicit when the anthropomorphic 'words' that
narrate their life story make a paternity claim. Andersen plays knowingly with
the fact that when 'a Hofmann automaton comes to life, it contains the essence
of its creator in a true father-child relation and is often passed off as biological
child', as Victoria Nelson astutely observes (see Nelson 65). The anthropomor-
phized 'words' in Andersen's tale claim precisely such a genetic link to Hoffmann
because their mother, the manuscript, has told them that without him she would
still be 'reent ubeskrevet Papiir' [a pure unwritten page] (*Fodreise* 195). Yet, besides
his paper-mistress, Hoffmann also has a (house)wife, who knits while she brings
her fanciful spouse back to reality from his rampant imagination (and his virile
impregnation of virgin paper).

 With this rather humorous if impertinent domestication of his German idol,
Andersen not only flaunts his own literary historical knowledge (in this case of
the circulating stories about Hoffmann's propensity to scare himself during the
writing process) but also offers his readers a remarkably poignant (if indirect)
criticism of the kind of literature that he claims to want to imitate. Clearly, An-
dersen's tribute to Hoffmann is ironically couched and should be seen as a way
in which he could distance himself, in a roundabout manner, from Hoffmann's
brand of the fantastic. On the one hand *Fodreise*, an arabesque with strong strokes
of Romantic irony, is full of Hoffmann pastiches, from the devil taking hold of
the narrator and enticing him to become an author (a devilish enterprise in-
deed), to doppelgänger motifs and talking objects. On the other hand, as can
be seen in the audacious incorporation of *Elixiere des Teufels* within the covers of
Andersen's own book, 'Hoffraad Hofmann' is embraced – only to be kept at arm's
length. Andersen has transcribed Hoffmann's novel into the kind of 'it-narrative'
that, as mentioned above, was favored during the 18th century, in which the lives
of things became narratives about commoditization and circulation. In his own

brand of ingenious puppetry, Andersen essentially rewrites the script and 'plays' with Hoffmann's text (as a master puppeteer with his puppet) to expose the prosaic (and non-Romantic) politics of book markets.

Monstrous Machines

Far more morbid than Hoffmann's uncanny automatons or Kleist's aloof marionettes, Mary Shelley's *Frankenstein; or, The Modern Prometheus* (1818) subscribed to a version of Romantic monstrosity that was alien to Andersen. Her avatar is sutured to human beings in an explicitly psychical way, a golem created from dead body parts. Andersen never seems to have commented directly on Shelley's novel, but we know from his response to his close friend B. S. Ingemann, who had used cadavers in one of his fantastic stories, that morbidity did not appeal to Andersen.[24] In *Frankenstein*, Romanticism's fixation with the power of life is forcefully articulated, and Shelley's interest in natural philosophy and animation via galvanism (*and* her suggestion that her husband Percy Bysshe Shelley was portrayed in Victor Frankenstein; a point that is important because it suggests a monstrosity of a particular kind, one associated with the creative forces of poets) is a 'distinctly Romantic version of monstrosity', to borrow Gigante's words. If the sublime object in Romanticism 'threatened to exceed formal constraints, when it slid from theory into praxis, from imagined into actual, animated power, it could slide out of the sublime and into a distinctly Romantic version of monstrosity' (5). Science was a source of wonder and astonishment for Andersen and its aesthetic potential was a constant inspiration. But to him, such science-fuelled aesthetics looked less monstrous and more like small miracles.

To illustrate this, let me return briefly to what appeared to be a paradoxical quotidian-Promethean effort in 'Marionettespilleren'. Here we learned that the science student's experiments could have brought him glory during the time of Moses, and thus brought him into concord with the gods. It would have burned him on the stake during the Middle Ages, and brought him into concord with devils. Yet in the present (the mid-19th century) these 'Underværker' [wonders] are but 'Hverdagsting' [everyday occurrences], setting him amongst mere mortal humans. Subsequently, the workings of electromagnetism, even as they 'blew the mind' of the puppeteer ('løftede Hjerneskallen paa mig' [lifted my skull]), remain exactly that: everyday miracles, never fully explained. Andersen notoriously missed H. C. Ørsted's lectures at Copenhagen University on electromagnetism only to use the phenomenon for aesthetic purposes later – though he would never fully grasp the science behind it. Nevertheless, his interest in the vitality of electromagnetism, the very force field used to animate the marionettes in 'Marionettespilleren', dovetails with a universal Romantic interest in the vitality of creative forces. 'Neither electricity nor magnetism constituted life exactly', as Gigante has argued, 'but they were both considered aspects of a polar, dynamic equilibrium thought to characterize the living world' (190). These creative forces, as seen in Shelley's monster, can become uncontainable and hence monstrous, the flipside of the Romantic Promethean dream. To steal fire from the gods or,

as in the case of 'Marionettespilleren', from science, and give it to humans, or to ask for life in inanimate objects, is, indeed, playing with fire. This fire, so imaginatively 'played with' throughout Romanticism, and with the most devastating consequences in *Frankenstein*, speaks to deep ethical concerns about human/non-human thresholds and responsibilities. To Andersen, being twirled through the experimental electromagnetic spiral did not transform his puppeteer into a god or a devil. Instead, the whole exercise turned out to be edifying: The puppeteer stopped dreaming about vivifications. After all, his avatars turned out to merely mimic ordinary human behavior.

Surely, not every ostentatious Romantic trope is cut to size in Andersen's oeuvre. We do, to finally return to the aforementioned 'Master Bloodless', find elements of grandiose vitality of a sublime nature and monstrous proportions in this figure. But it is of a rather different sort than those we have so far encountered. 'Bloodless' is located within *I Sverrig*'s calculated intermingling of nature and technology, imagination and science. As early as his first stop into Sweden at Trollhättan, by the great manufactory in Motala, our traveling narrator draws us into the sublime life of machinery:

Hvad der dikker i Uhret, slaaer her med stærke Hammerslag. Det er »Blodløs,« der drak Liv af Mennesketanken, og ved den fik Lemmer af Metaller, af Steen og Træ; det er *Blodløs*, der ved Mennesketanken vandt Kræfter, som ikke Mennesket selv physisk eier. I Motala sidder *Blodløs* og gjennem de store Haller og Stuer strækker han sine haarde Lemmer, hvis Led og Dele ere Hjul ved Hjul, Kjæder, Stænger og tykke Jerntraade. – Træd herind og see hvor de gloende Jernstykker presses til lange Jernstænger, *Blodløs* spinder den gloende Stang. See hvor Saxen klipper i de tunge Metalplader, klipper saa stille og saa blødt, som var det i Papir; hør hvor han hamrer, Gnisterne flyve fra Ambolten! see hvor han knækker de tykke Jernstænger, knækker efter Længde-Maal, det gaaer, som var det en Stang Lak der brødes. Foran dine Fødder rasle de lange Jernstykker, Jernplader høvles i Spaaner; foran dig dreie sig de store Hjul, og hen over dit Hoved løbe levende Jerntraade, svære, tunge Jernsnore, det hamrer, det surrer, og søger du ud i den aabne Gaard, mellem store omkastede Kjædler til Dampskibe og Bane-Vogne, da strækker ogsaa *Blodløs* her ud en af sine favnelange Fingre og haler afsted. Alt er levende, Mennesket staaer kun og stiller af og stopper! Vandet springer En ud af Fingerspidserne ved at see derpaa, man dreier sig, man vender sig, staaer stille, bukker og veed ikke selv hvad man skal sige af bare Ærbødighed for den menneskelige Tanke, der her har Jernlemmer[25] (*I Sverrig* 18)

Bloodless has limbs and fingers that spring from 'human thought', and the vitality described is so forceful that the single 'man' who 'stands alone' is positively dwarfed. 'Everything is living' – that is, the machine is alive as a giant marionette, directed by the human mind even as it silences 'man', who stands confused, dizzy and in awe of 'his' own creature. The passage celebrates man-made technology. *Bloodless*, then, is not a monster run rampant and there is no 'uncontrollable vitality' here. In fact, this giant machine-marionette's transition from 'imagined into actual, animated power' (Gigante 5) is not *really* monstrous. To Andersen, the puppetry of modernity is enchanted in its own way.[26]

The Sway of Travesty

Fascination with puppets, as Harold Segel has suggested in *Pinocchio's Progeny: Puppets, Marionettes, Automatons, and Robots in Modernist and Avant-Garde Drama* (1995), can be a response to a deep need to see ourselves as a

projection of the obsession of human beings with their own image, with their own likeness, the obsession that underlies artistic portraiture, the building of statues, and the extraordinary and enduring popularity of photography. More profoundly, it reveals a yearning to play god, to master life. (4)

Humans do in fact see themselves reflected in Andersen's marionettes, but often in the form of travesty. He downplays the element of wonder. Unlike Kleist, and unlike George Bernard Shaw, who generations later would contend that 'there is nothing wonderful in a living actor moving and speaking, but that wooden headed dolls should do so is a marvel that never palls' (qtd. in Segel 4), but also unlike the avant-garde in the early twentieth century that celebrated Kleist (such as Edward Gordon Craig's 'The Actor and the Über-Marionette' or Oskar Schlemmer's *Triadisches Ballett*), Andersen's marionettes become instruments of illusion used to unveil the complicated, yet ultimately mundane, reality that surrounded him.

Less philosophical than Kleist, less daemonic than Hoffmann and less morose than Shelley, Andersen in effect disenchanted the very enchantment we have come to expect from Romanticism. When Andersen bestows personhood on his marionettes, he makes them recognizable as individuals, with all the ordinariness of everyday persons. If readers do not easily recognize themselves in Kleist's abstract ideal (even if they aspire to reach such an ideal in art-making), and if they cannot see themselves in Hoffmann's automaton (even if they fear that such a demonic possibility may be a veiled possibility in their neighbor), and if Shelley's creation (in spite of the very human emotions it articulates) is too monstrous to resonate with readers' real familiarity, they are hard-pressed *not* to see Andersen's avatars as 'something' that behaves and acts out like us. Yet this does not reduce Andersen's use of marionettes to mere mirrors. Things-as-persons also speak about persons-as-things. The terrifying utterance used to silence his unruly actors, 'You are just marionettes', turns out to be a double-sided critique that not only unveils a fall from grace but also shows how people can be treated like things in the real world. This, in turn, is an *unheimlich* [uncanny] prospect, albeit of a different order than the variety we know from Hoffmann; it might even be seen as a corrective to Freud's prescriptive pre-empting of fairy tales as uncanny.

If divine or daemonic potentials seem to evaporate in Andersen's various marionettes and automatons, and if at first sight they become surprisingly ordinary, this ordinariness, as I hope to have shown, is certainly out of the ordinary. In other words, Andersen uses the fantastic to articulate a critique of the mundane. His marionette stories may not have the mathematical sophistication of Kleist's, whose lines and curves and spatial calculations constitute an aesthetic principle, nor the power of Hoffmann's articulation of psychic and material liminality, nor,

for that matter, the impact of Shelley's Frankensteinian, monstrous freakishness. Yet there is a kind of buoyancy in Andersen's use of marionettes and puppets as surrogates for humans that points to an aesthetic that not only bridges Romanticism and modernity (a point that is frequently made about Andersen) but also points back to elements of rationalism.

The early Romantics challenged the empiricism and scientific advances of the 18th century. This challenge, as well as the reactions against 'cold' secularism and consumer culture, is complicated in Andersen's work. In some respects, he picked up a thread from the empiricism of the 18th century that had been overruled by the Romantics in favor of a more metaphysical model. Andersen's ideas about humans and non-humans, and his specific kind of empirical attitude, serve as an important key to our understanding of his negotiation of human versus non-human and also allows us to appreciate how he is positioned on various historical and literary thresholds. We have become accustomed to seeing an inherent disenchantment and suspicion about material objects in modernity, based on the hypothesis that objects that once had a particular meaning in a society with firmly established hierarchal patterns are broken down by the individualism and multiplicity that marks the age. With one foot in Romanticism and the other stretched out (leaping, it seems) into modernity, Andersen saw no threat of disenchantment in this new age – modernity to him was enchanted in its own right. Similarly, as I have suggested, he seems to draw instinctively on a mindset that, to borrow from Barbara M. Benedict's examination of the 18th century, 'reestablish[es] the importance of the very relationship in which things intervene, and urge[s] the role of moral conviction and social responsibility in personal identity' (21).

There is, then, an important and pervasive paradox in Andersen's work. He makes use of tropes favored by the Romantics but for a purpose that extends, or at least complicates, that of any variant of the Romantic program. In an eccentric maneuver he pays homage to Romanticism while simultaneously leaving many of Romanticism's claims behind. Barbara Johnson notes in *Persons and Things* that

It seems that puppets do for some observers resemble divinities in contrast to fallen, self-aggrandizing human beings. The aura of contact with a transcendent dimension, in fact, is what renders puppets eerie. (85)

But Andersen's marionettes, as I have shown, seem to have escaped both uncanny associations and demiurgic control with its latent sacred associations; his marionettes are essentially de-sacralized. Andersen instead found the potential for a decidedly more social agenda than those offered by metaphysical schema. What is more, Andersen offers a counter-story in advance to the tragic-doll concept that Mikhail Bakhtin would later articulate when he noted that

in Romanticism the accent is placed on *the puppet as the victim of alien inhuman force*, which rules over men by turning them into marionettes. This is completely unknown in folk culture. Moreover, only in Romanticism do we find the peculiar grotesque theme of the *tragic doll*.[27] (40; my italics)

He also seems to have implicitly countered the gloomy prognosis that occupied Charles Baudelaire in his 1853 essay 'A Philosophy of Toys', in which the child's desire to break open toys is seen as a need to 'to get at and see [its] soul', only to find a sad and empty soullessness. Destruction of dolls, then (recalling Goethe's Venetian epigram) becomes the child's 'first metaphysical tendency' (202-203).

Andersen gives his readers a different kind of epistemological insight. Playing at being human, as the doll proposed to do in 'Pengegrisen', is no trivial matter for Andersen even if it permits him to expose human triviality. His demystification of Romanticism's more fantastic injection of life, vitality, grace, uncanniness or monstrosity into inanimate forms that resemble humans, and his insistence on an almost naïvely pragmatic observation of materiality, comes to sound very much like the sharp '[k]nik, knak!' clatter of broken puppets. But his broken forms are never empty; they are filled with 'sociability' and speak volumes about the (human) 'lives of things'.

Literature

Andersen, Hans Christian. *Samlede Værker*. [*SV*]. 18 vols. Ed. Klaus P. Mortensen. Det Danske Sprog-
og Litteraturselskab. Copenhagen: Gyldendal, 2003-2007.

Andersen, Hans Christian. *Fodreise fra Holmens Canal til Østpynten af Amager i Aarene 1828 og 1829*.
(1829). *SV*. Vol. 9. 165-257.

Andersen, Hans Christian. 'Dødningen'. (1830). *SV*. Vol. 1. 52-71.

Andersen, Hans Christian. 'Lykkens Kalosher'. (1838). *SV*. Vol. 1. 460-485.

Andersen, Hans Christian. *Mit Eget Eventyr uden Digtning*. (1846) *SV*. Vol. 16. 177-333.

Andersen, Hans Christian. *I Sverrig*. (1851). *SV*. Vol. 15. 11-133.

Andersen, Hans Christian. 'Marionettespilleren'. (1851/68). *SV*. Vol 3. 190-193.

Andersen, Hans Christian. 'Pengegrisen'. (1855) *SV*. Vol. 2. 114-115.

Bakhtin, Mikhail. *Rabelais and His World*. Trans. Helene Iswolsky. Bloomington: Indiana University
Press, 1984.

Baudelaire, Charles. 'A Philosophy of Toys'. *The Painter of Modern Life and Other Essays*. Trans. Jona-
than Mayne. London: Phaidon Press, 1964.

Benedict, Barbara M. 'The Spirit of Things'. *The Secret Life of Things. Animals, Objects, and It-Narratives
in Eighteenth-Century England*. Ed. Mark Blackwell. Lewisburg: Bucknell UP, 2007. 19-42.

Bohrer, Karl Heinz. *Suddenness: On the Moment of Aesthetic Appearance*. (1981) Trans. Ruth Crowley.
New York: Columbia University Press, 1994.

Brown, Bill. 'Thing Theory'. *Things*. Ed. Bill Brown. Chicago and London: Chicago UP, 2004. 1-16.

Flint, Christopher. 'Speaking Objects'. *The Secret Life of Things. Animals, Objects, and It-Narratives in
Eighteenth-Century England*. Ed. Mark Blackwell. Lewisburg: Bucknell UP, 2007. 162-186.

Freud, Sigmund. 'Das Unheimliche'. *Studienausgabe, Band IV*. Frankfurt am Main: S Fischer Verlag,
1970. 241-282.

Freud, Sigmund. 'The Uncanny'. *The Uncanny*. Trans. David McLintock. London: Penguin Books.
121-162.

Gigante, Denise. *Life: Organic Form and Romanticism*. New Haven and London: Yale UP, 2009.

Goethe, Johann Wolfgang von. *Roman Elegies and Venetian Epigrams. A Bilingual Text*. Trans. L. R. Lind.
Manhattan and Wichita: The University Press of Kansas, Lawrence, 1974.

Gross, Kenneth. *Puppets. An Essay on Uncanny Life*. Chicago: University of Chicago Press, 2011.

Hoffmann, E. T. A. 'Der Sandmann'. (1816). *Nachtstücke*. Middlesex: Echo Library, 2006. 4-27.

Johnson, Barbara. *Persons and Things*. Cambridge, Mass.: Harvard University Press, 2008.

Kleist, Heinrich von. 'Über das Marionettentheater'. (1810). Berlin: Streuben Verlag, 1948.

Mylius, Johan de. *Forvaldlingens pris, H. C. Andersen og hans eventyr*. Copenhagen: Høst og søn, 2005.

Müller-Wille, Klaus. 'Hans Christian Andersen und die Dinge'. *Hans Christian Andersen und die Hetero-
genität der Moderne*. Ed. Klaus Müller-Wille. Tübingen and Basel: A Francke Verlag, 2009. 161-178.

Nelson, Victoria. *The Secret Life of Puppets*. Cambridge, Mass.: Harvard University Press, 2001.

Peer, Larry H. 'Introduction. Romanticizing the Object.' *Romanticism and the Object*. Ed. Larry H.
Peer. New York: Palgrave Macmillian, 2009. 1-7.

Sanders, Karin. *Konturer: skulptur og dødsbilleder fra guldalderlitteraturen*. Copenhagen: Museum Tuscu-
lanum Press, 1997.

Segel, Harold B. *Pinocchio's Progeny: Puppets, Marionettes, Automatons, and Robots in Modernist and Avant-
Garde Drama*. Baltimore: The Johns Hopkins University Press, 1995.

Shelley, Mary. *Frankenstein, or the Modern Prometheus*. 3rd ed. (1818). London: Dover Publications, 1994.

Notes

1 This essay is part of a book project in which I investigate H. C. Andersen's use of physical real-
 ity. The working title of the book is *The Lives of Things in Hans Christian Andersen's Material Imagi-
 nation*. Projected publication date is 2014.

2 Unless otherwise noted translations from Danish to English are mine.

3 'The Magic Galoshes' reveals how reckless dreams and desires inevitably trap humans in fan-
 tasies that cause misery rather than pleasure: dreams of living in another time (the good old
 days), flying to the moon, or being someone else.

4 Johan de Mylius notes how dead things are animated in accordance with the material from
 which they are formed. The little tin soldier, for example, is steadfast like the tin of which he is
 made and so on; see Mylius 73.

5 Johan de Mylius, for one, suggests that the reader should interpret Andersen's use of material
 objects as dictated by genre conventions.

6 The nomenclature of 'thing' and 'object' has been discussed in numerous theories in later years,
 and it has become commonplace to follow Bill Brown's definition that 'we begin to confront
 the thingness of objects when they stop working for us The story of objects asserting them-
 selves as things, then, is the story of a changed relationship to the human subject and thus the
 story of how the thing really names less an object than a particular subject-object relationship'
 (Brown 4). For an excellent discussion of thing theory as it concerns H. C. Andersen, see Klaus
 Müller-Wille's article 'Hans Christian Andersen und die Dinge' (2009).

7 During the eighteenth century so-called 'it-narratives' were in vogue. As suggested by the pro-
 noun 'it', these stories used inanimate objects as narrators, often letting the objects recount their
 autobiographies. The speaking object regularly narrates its story to human intermediaries, so
 that the experience of the object is communicated indirectly. Often the agents involved in manu-
 facturing objects, the commodity culture and the spiritualization of commodity culture was
 at stake. In his chapter 'Speaking Objects' in *The Secret Life of Things*, Christopher Flint explains:
 'As items of clothing, jewelry, furniture, transportation, currency, and so on, narrating objects
 invariably evoke physicality, grounding their narratives in the experiences of vulnerable human
 bodies. The speaking objects' effectiveness as a storyteller derives from its proximity to human
 beings' (167-168). In 1781 the British periodical *The Critical Review* complained: 'this mode ... is
 grown so fashionable, that few months pass which do not bring one of them under our inspec-
 tion' (qtd. in Flint 165). In Britain alone, between the early eighteenth century and the late nine-
 teenth century, we find a series of novels that use coins or bank notes as narrators. Many are by
 anonymous or lesser-known women authors and the genre was not regarded as high literature.

8 'My greatest joy was to sew puppet clothes'.

9 'I fell in love as a boy with a puppet show; / It attracted me for a long time until I destroyed it.
 / So Lavater, while young, snatched at the crucified puppet: / May he still hug it, deceived as he
 draws his last breath.'

10 'laughs at all the right places, applauds at the right moment; this was an unusual spectator!'

11 'to be theater director of a live troupe, a real human one'

12 'They were like flies in a bottle, and I was in the midst of the bottle, I was the theater director.
 The air went out of me, my head was spinning, and I was as miserable as any human being
 could ever be. I found myself amongst a new species of humans. I wished they all were back in
 my box and that I had never become director.'

13 'in reality they were only marionettes and then they killed me!'

14 'my staff does not reason, and neither does the audience'

15 'I am a happy director, my staff does not reason, and neither does the audience, it enjoys itself full-heartedly. I can freely make my own plays. I take the best from the comedies, and no one frets about it. Plays that are now despised on the large stages but were a draw some thirty years ago, and then made the audience chortle, I have now taken hold of and now I present them to the little ones, and the little ones chortle like their father and mother chortled; I present 'Johanna Montfaucon' and 'Dyveke', but abbreviated versions, for the little ones do not appreciate lengthy love-nonsense: they want sad, but quickly. Now I have travelled Denmark inside and out, I know all people and I'm known in return'.

16 Andersen appears to have borrowed the name 'Bloodless' from the Swedish Romantic Per Daniel Amadeus Atterbom.

17 In its later incarnation as 'Rejsekammeraten' [The Travelling Companion], the marionette scene has been altered slightly, but in important ways. The biblical story of Ester and Asheverus is changed to a fairy tale of a princess, for example.

18 'Knick, knack! How she broke, and the poor puppeteer moaned so horribly, for it had been his first Prima Donna and the dog had bitten off the head.'

19 'All the wooden dolls were scattered in a heap. The king and all the henchmen, they were the ones that sighed so pitifully and stared with their large glass eyes, for they wished so dearly to be anointed a little, just like the queen, so that they too could move.'

20 'Indeed, the fairy tale is quite openly committed to the animistic view that thoughts and wishes are all-powerful, but I cannot cite one genuine fairy story in which anything uncanny occurs. We are told that it is highly uncanny when inanimate objects – pictures or dolls – come to life, but in Hans Christian Andersen's stories the household utensils, the furniture and the tin soldiers are alive, and perhaps nothing is further removed from the uncanny. Even when Pygmalion's beautiful statue comes to life, this is hardly felt to be uncanny' (Freud, 153).

21 'commonplace in fairy tales. Who would go so far as to call it uncanny when, for instance, Snow White opens her eyes again? And the raising of the dead in miracle stories – those of the New Testament, for example – arouses feelings that have nothing to do with the uncanny' (Freud, 153).

22 'A host of adorned Gentlemen moved mechanically up and down the floor. They looked like they were fabricated. Every fold in their clothes seemed calculated. I addressed the one that came closest to me, but he did not answer one word, turned his back on me and went away with his regular stride and an arrogant manner. I addressed another, but he was no more polite than the first. – When presently the third was also about to turn his back on me, I lost patience and grabbed his arm. He was difficult to hold and made an extraordinary amount of movement with all his limbs, while at the same time he sneered rather peculiarly at me. At last I sensed that the entire company consisted of completely wooden men, filled with steam; a kind of artificial automaton that the century had invented to decorate the antechamber'.

23 'My first memories – it began – reaches back to the printers' shop, where I first saw the light of day. As if in a dream I still remember a little man with a strange catlike face, who one day stepped into the living room where, in all my innocence, I was hung to dry on a string. My mother – as I dare call the aforementioned manuscript to whom I owe my existence – told us children during the night that he was our father, alderman Hoffmann, without whom she would still be pure unwritten paper and we would never have seen the light of day. We listened

with curiosity to what she told us about him, how the specters that moved inside of us showed themselves to him as if alive when he sat and worked during the long winter's nights. And how he often had to call his wife out of bed so she could sit with him with her knitting sock and nod genially to the peculiar man whose imagination was claiming too much power.'

24 For an elaboration on this, see my article 'Left Eye-Right Eye: B. S. Ingemann's Bifocality and Morbid Imagination', forthcoming in *Scandinavian Studies*.

25 'What ticks in the clock, here beats with strong strokes of the hammer. It is *Bloodless* who drank life from human thought and thereby grew limbs of metal, of stone and of wood; it is *Bloodless*, who by human thought gained strength that humans do not physically possess. In Motala, *Bloodless* sits and, through the great halls and rooms, he stretches his hard limbs, each joint is wheels on wheels, chains and thick iron threads. –Step inside and see how the glowing iron pieces are presses into long iron rods. *Bloodless* spins the glowing bar. See how the scissors cut into the hard metal plates, so quietly and softly, as if into paper. Listen how he hammers; the sparks fly from the anvil. See how he breaks the thick iron rods, breaks them to fitted pieces; it looks as if a piece of the seal was broken. The long iron pieces are planed into shreds in front of your feet. In front of you, the great wheels are turning and over your head run iron threads, heavy and large. It hammers and buzzes, and if you venture into the open yard, amongst large scattered boilers for steamboats and railways, then here too *Bloodless* stretches one of his fathom-long fingers and hauls off. Everything is alive, man alone stands still and is silenced and stops. The water springs from one's fingertips just looking at it. One turns, stands still, bows and does not know what to say, in awe of the human thought that here has iron limbs.'

26 Andersen's complex relationship with machines with regards to nature and humans will be investigated in more detail in *The Lives of Things*.

27 In Andersen's statue-stories, on the other hand, such as 'Psychen' [The Psyche], and also in his novel *Improvisatoren* [The Improvisatore], the entire metaphysical apparatus is rolled out in an engagement with concepts of mimesis. For Andersen, statues, unlike puppets, absorb eternity and immortality and resonate with Promethean/Pygmalion powers. This means that the 'tragic doll' is absorbed into the connotations of neoclassical marble. See Sanders.

Schiller
Fairy

H. C. ANDERSEN'S 'SCHILLER FAIRY TALE' AND THE POST-ROMANTIC RELIGION OF ART

HEINRICH DETERING

TRANSLATED BY SABINA FAZLI

[ABSTRACT]

In his story 'Den gamle Kirkeklokke' ['The Old Church Bell'], Andersen transforms, rein-terprets, and dissolves Schiller's popular poem 'Das Lied von der Glocke' ['The Song of the Bell'] into prose. Written for the Schiller celebrations in 1859, it re-establishes the Roman-tic cult of the artist under profoundly changed cultural conditions. The article examines Andersen's complex relationship with the Weimar culture and reveals the hidden autobio-graphical patterns in his Schiller narrative. By adopting Schiller's role for himself and at the same time linking it to the biography of Thorvaldsen, Andersen manages to bridge the only recently developed national gap between Danish and German culture. He simultane-ously arranges the story as a critical commentary on his own Romantic tale 'Klokken' ('The Bell'). Thus, 'my Schiller fairy tale' turns out to be a post-Romantic legend that succeeds Wackenroder's and Tieck's outdated 'religion of art' in a decidedly 'prosaic' mode.

· · · · · · · · ·

KEYWORDS *Hans Christian Andersen, art religion (Kunstreligion), Schiller reception, Romanti-cism vs Biedermeier, fairy tale postromantic religion of art, Schiller, Hans Christian Andersen.*

Because of Friedrich Schiller, Hans Christian Andersen even wanted to change the course of a river. On March 29, 1860, his friend Adolph Drewsen recounts:

A few days ago, Andersen asked me where Schiller's city of birth, Marbach, was actually situated, namely, whether it might not perhaps be on the Danube, and when he heard that it was on the Neckar, he wished to know into which river the Neckar flows. We got hold of a map, and I showed him the course of the river to its discharging into the Rhine. He didn't like that; he badly wanted the Neckar to flow into the Danube.

Why might that be? Drewsen elaborates:

Because he had received the invitation to write something for the Schiller Album which will be published on the occasion of the 100th anniversary of his birth in November, and after thinking about this for a long time, he struck on his idea which he had taken from Schiller's *Bell*; namely, he imagined that the church bell in Marbach was ringing while

HEINRICH DETERING, Professor of Modern German and Comparative Literature, Göttingen University

Schiller's mother was giving birth, – that this same bell would then fall down and break and then lie in the church yard until it was used in casting the same sculpture in which its ore happened to be used in the head and chest.[1] (Andersen, *Eventyr* 7: 310 et seq.)

When Drewsen gave him this devastating geographical information about the Neckar, for better or worse, Andersen seems to have abandoned the plan of shipping the old church bell from Marbach to Munich where it would have been molten down. Drewsen concludes his account: 'Today, ... he came in and said that he had finished writing the story, and of course, on his demand, I had to drop everything and follow him to my room so that he could read it to me. He wanted to call it "The old church bell"' (ibid.).

In 1859, inspired by the national Schiller celebrations, Major Friedrich Anton Serre of Maxen Manor, near Dresden (1789-1863), one of Andersen's friends and patrons, had asked the poet to write a contribution to the *Schiller Album* which Serre intended to publish in the context of his Schiller lottery.[2] In 1860, the short tale appeared in German; at the end of 1861, it was published in Danish in the *Dansk Folkekalender 1862*, together with an illustration of the Stuttgart monument. In 1868, Andersen included the story in the 26th volume of his *Samlede Skrifter*. Andersen himself called it 'my Schiller fairy tale'.[3]

From the beginning, Andersen's concept aimed at transforming, reinterpreting, and dissolving Schiller's most popular poem into prose. This change of genre is highly symptomatic of the transformation of literary models from the age of Goethe to the period which, in German literature, bears such different names as *Biedermeier*, *Restauration*, and *Vormärz* and is known as the *Guldalder*, the golden age of national literature, in Denmark. While the expansive and, at the same time, narrative and didactic contemplative poem (*Gedankengedicht*) harmonizes narratives and reflections on the philosophy of history, anthropology and political morality, Andersen refashions it into the miniature form of the 'fairy tale'. Only in the widest sense does the tale comply with the Romantic conception of the genre. For Andersen's tale, the genre does not imply anything other than a sequence of complaisantly intertwined set pieces, openly governed by poetic imagination. Andersen's text is no longer about models of history and moral didacticism, middle-class concepts of ethical autonomy, the control of one's emotions, models of family life and craftsmanship, but about the celebration of the artist who has formulated all of this through his authority, which is implicitly accepted and in no need of reflection.

The cult of the artist, which takes the place of the imagined world articulated and mediated in the work of art, also strives to establish harmony. In the Schiller celebrations, this cult is supposed to celebrate national unity as something already achieved on an intellectual level and, at the same time, to mark it as politically imminent. However, from the perspective of Andersen, the Danish poet, this marks the juncture from which the crumbling cultural symbiosis of German and Danish culture should be restored. But to highlight this transnational context, which is informed by the pathos of national unity in Germany and a new national spirit in Denmark defined by anti-German sentiment, Schiller has to

be 'Danified' to the same extent that he figures as a German poet – an extremely difficult balancing act, which the affectedly harmless text does not easily betray.

In any case, the expansive and solemn form of Schiller's poem does not suit Andersen's difficult project. Neither his Danish nor his German middle-class audiences appreciated regular alternating lines and complex stanzas, preferring the small form of the decidedly modest 'Albumblatt' which aims for innocence and preciosity. The prose is chatty and colloquial and has the coherence of a plain and uninterrupted narration. And it adds up to a memorable verbalized genre painting suitable for reading out aloud – a painting which is, in the end, *identical* to the Schiller monument which the Danish sculptor Thorvaldsen had erected in German Stuttgart. The 'Schiller fairy tale' establishes itself as the monument's Romanticized and narrativized etiology. In the course of the narrative however, the original writer, who embodies the authoritative herald of an encompassing conciliatory middle-class moral, takes on traits of Andersen himself – *Quod erit demonstrandum*.

'If I were a Schiller': Andersen in Weimar

Andersen was the only non-German artist whom Major Serre asked to contribute to the *Schiller Album* – and not without reason. The *Guldalder*, in which Andersen grew up and his unprecedented literary career developed, was a partly late Romantic, partly early realist relative of *Biedermeier*, and in many aspects it constituted a Danish continuation of the age of Goethe. Copenhagen of Danish cultural history was, in this exact form, a 'cultural centre of the age of Goethe'.[4] Thus, even Andersen's autobiography, initially written for German readers and published in German, obviously refers to Goethe's *Dichtung und Wahrheit*: Its title is *Das Märchen meines Lebens ohne Dichtung* [The Fairy Tale of My Life], and Andersen fashioned it as a self-assured balancing act between documentation and stylized self-fictionalization. I shall return to this later.

For a talented and ambitious outsider like Andersen, emulating such a model was not only a question of inclination, but also of self-fashioning in the literary marketplace. On 18 July 1832, Andersen wrote to his friend Chamisso, the German-French poet: 'Denmark lies somewhat in a corner which is why its poets have to remain unknown unless they are able to intellectually emigrate to neighboring countries' (Andersen, 'Breve').[5] This sentence summarizes his (not unique) attitude towards Germany at the time. Indeed, Andersen determinedly took his literary success in Germany in hand early on, not the least for the sake of his fame in his home country. Appropriately framing and presenting his texts for a German *Biedermeier* audience, he subtly sought to allow for their demand for unpolitical and comforting literature that contrasted with the rebellious *Zeitgeist* of *Vormärz* activists. It was part of his marketing strategy to blur the borders between Andersen-the-poet and his protagonists so that the stories told in the novels were supplemented by the story of their author. His plan worked brilliantly. With a middle-class reading audience concerned about losing social status and

the threat of revolution, the alleged authentication of his stories by the life of their writer laid the foundation for the poet's continuing fame.[6] In its most productive consequences, motivated by the outsider's literary and social ambition and the economic aspirations of a child of poor parents, this search for a secure position in the market brought about the cross-fertilization of two national literatures which would largely become the tool of two contesting nationalisms, even during Andersen's lifetime. In this, it turned out to be a piece of luck that, early on in his search for German connections, Andersen chanced upon a place which had been central during the age of Goethe and played an almost mythical role in the consciousness of Danish intellectuals. While he had shyly avoided the obvious opportunity to visit Goethe when he first traveled in Germany, on a journey which had followed Romantic models, he gladly accepted the personal invitation extended by the Hereditary Grand Duke Carl Alexander of Saxe-Weimar-Eisenach in June 1844.[7] Andersen was universally admired and securely accepted as a novelist and thus seemed to be an ideal candidate for the envisioned re-establishment of Weimar's *Musenhof*. Many passages in the two men's extensive correspondence read like a satyr play, reminiscent of operetta. Once again they re-enacted the pattern of sentimental friendship while, ironically, neither was entirely confident in German (one of them being a Dane, the other an aristocrat educated in French).[8] During the unrest of the *Vormärz*, it seems that they wanted to prove that the growing national differences could be overcome through idealism, humanity and the love of friends, with their friendship as a biographical extension of the texts they had read.

For Andersen, the friendship gained social, emotional, and perhaps even erotic meaning so that, occasionally, he not only dreamed of his imminent fame as a German-Danish poet, but also considered moving to live permanently in Weimar. (In a greater age but less successfully, Jens Baggesen and Adam Oehlenschläger had already tried to gain entrance to the Weimar *république des lettres*.) However, the same national tensions which should have been overcome by the sentimental and purposely constructed new friendship between the prince and poet finally destroyed the artful structure with the onset of the German-Danish war.

In June 1844, this catastrophe lay in an indefinite future. As soon as Andersen had arrived in Weimar, he went to visit the great dead poets in the Ducal Vault:

In the chapel, the coffins are now switched, Göthe and Schiller sitting side by side, and I wanted Göthe's coffin, but I was bending over Schiller's. I stood between the two, said the Lord's Prayer, asked God to make me a poet who would be worthy of them, and for all the rest, his will be done in evil and in good.

And then he adds a phrase typical of himself and the contemporary cult of poets: 'on the coffins, there were laurel leaves, I took some from each' (Andersen, *Dagbøger* 2: 402).[9]

On the way to the Hereditary Duke's birthday celebration at Weimar Theater, he sees 'Schiller's house' (ibid. 398), which he also records in his diary. From the beginning, he speaks highly of Carl Alexander, describing him as a 'young

26-year-old, well-built man' and as his born friend: 'he is the first of all the princes whom I really like, the first of whom I would wish that he was not a prince, or that I was a prince, too' (ibid. 400). In the course of the budding friendship, Andersen becomes a permanent guest in the town, which he has for years called 'meine zweite Heimat' ['my second home']. Never before had he been closer to the German Parnassus. He tried to evade the Duke's expectations, albeit not without coquetry. As he laments in a letter dated 14 February 1846: 'Alas, I won't be a Göthe.' (Andersen, *Briefwechsel* 42). No, surely not. But whose coffin had he bent over and whose laurel leaves had he providently pocketed?

Admittedly, Schiller's person and works had meant less to him than Goethe's, and the former had never been as naturally close to Andersen's writing. But he had been as familiar with Schiller's works since his school days as might be expected from an assiduous and educated Danish reader of the *Guldalder*.[10] School essays on Schiller have been preserved (cf. Høeg). Whenever, during his almost continuous traveling, he had the opportunity to see a performance of a Schiller play, he seized it. In 1834 he saw Donizetti's opera adaptation of *Maria Stuart* in Naples and *Wallenstein* in Prague; in 1843 *Maria Stuart* in Paris; in 1852 *Piccolomini* in Munich; in July 1857 the *Räuber* in Dresden, and in August of the same year *Die Jungfrau von Orléans* in Dresden ('left during act five') (Andersen, *Dagbøger* 1: 349, 491; 2: 348; 4: 103, 272, 277).

In January 1856, he met Caroline von Wolzogen, Schiller's sister-in-law, for the first time – and found that she was an admirer of his writings: 'she was really taken with my *Bilderbuch*' (ibid. 3: 58).[11] She asks him to read three fairy tales to her and promises a piece of Schiller's manuscript of *Wilhelm Tell* in return. (Later, in June 1852, Andersen would again receive 'a beautiful page in Schiller's hand', as he notes in his diary, this time from Franz Liszt in Weimar [ibid. 3: 60; 4: 87].) Like taking the laurel leaves from the tomb, this small gesture shows Andersen consciously participating in the kind of Schiller cult which transforms practices of catholic veneration of relics into a secular cult of the artist. He does not cherish the manuscript as a philological document but as a contact relic.[12]

Retrospectively, it is strange to see how the motives were already slowly accumulating in Andersen's letters and diary entries which would much later constitute the tale for the *Schiller Album*. When, during the same stay in Weimar, on 27 January, he again went to visit the Ducal Vault, this time in the company of chancellor von Müller and Swedish soprano Jenny Lind, he suddenly and for the first time remembers a congenial fellow Dane. Had he not visited the tomb of sculptor Bertel Thorvalden, also accompanied by Jenny Lind? For the moment, this is nothing but a casual association; in the Schiller tale, it will come to define the whole plot.

On 1 September 1846, Carl Alexander says goodbye to Andersen using a sentence implying succession and identification, at least in its retelling in Andersen's diary entry: 'The Hereditary Grand Duke very much against my leaving! where Schiller and Göthe could work, he said, I could, too.' (ibid. 3: 375). Half a year later, in June 1847, Andersen again explicitly refers to this in a letter from The Hague. Writing to Carl Alexander, he describes how he had been received in the

Netherlands in slightly wobbly German and showing much greater awareness of his own role: 'If I were a "Schiller", one could not receive me more honorably than I am! It is like a dream!' (Andersen, *Briefwechsel* 21).

From now on, the dream of taking, if not Goethe's, then Schiller's place beside a new *Musenfürst* [prince of the muses], turns into a continually recurring association, an *idée fixe*. And as German and Danish national positions became more entrenched, the idea became more 'fixed'. He articulated it most clearly when he was invited to the inauguration of the Goethe-Schiller monument. However, as he resentfully notes in his diary, he was not allowed to follow the ceremony from the Grand Ducal stand. Three days earlier, he had prowled the town in anticipation, writing in his diary on 1 September: 'Saw the Schiller-Goethe monument erected on the theater square, both were tightly draped, but you could still see the shape and their feet. The whole town is busy'. He then adds a casual and ambiguous remark: 'Goethe has booked a room for me' – he is of course talking about Walther von Goethe.[13]

On 4 September, the 100th birthday of Goethe's Grand Duke Carl August (among the guests of honor filling the stand, Andersen discovers 'Mrs. Goethe and her sons' Wolfgang and Walther, 'and Schiller', namely, his son Walther), Ernst Rietschel's monument is unveiled. 'It was', Andersen writes, 'a great moment when the veil fell from the group of poets, Schiller and Goethe.' And then, in three succinct words, the surprised, exhilarating realization: 'Schiller ligner mig' ['Schiller resembles me'] (ibid. 4: 286). It is important to note that it is not Andersen whom Schiller resembles: it is Schiller *in whom Andersen recognizes himself*.

Rietschel's double monument was not the first Schiller memorial Andersen had seen. On 9 August 1855, when he was traveling, he had seen the Schiller monument in Stuttgart made by Thorvaldsen, whom he had suddenly remembered in the Ducal Vault (ibid. 4: 175). (On 25 September 1869, in Stuttgart for the second and last time, he would again look on 'Thorvaldsen's sculpture of Schiller'; by then, however, his Schiller tale would already have been completed [ibid. 4: 439].) In his extremely popular poem 'Danmark, mit Fædreland' of 1850, he suggests that Thorvaldsen's sculptures have spread Denmark's fame in the world like Andersen's own novels, fairy tales and poems: 'A small country – and yet, around the world / resound your song now and the blow of your chisel' (Andersen, *Landschaft mit Poet* 65; my translation). The song also suggests Andersen's own poetry; the blow of the chisel is Thorvaldsen's. The same Thorvaldsen, then, has made the memorial of Schiller in whom Andersen recognizes himself when looking at Rietschel's Weimar sculpture group.

Suffering, Aspiration and Apotheosis: The Legend of an Artist

This was more or less Andersen's mindset when, in 1860, he accepted Serre's offer to write a story for the planned *Schiller Album* and casually asked about the course of the Neckar. The story's explicit basic notion is to combine the memory

of Schiller with that of Thorvaldsen. This warrants closer scrutiny. In a letter to Carl Alexander dated 3 May 3 1860 and written in German, Andersen explains the outline of his story.

I have written a new fairy tale for Schiller's Album. It is called: 'The old church bell'. When Schiller was born, his mother heard the sound of the old church bell in Marbach: in the end, this bell will be turned into the head and the chest of Thorwaldsen's Schiller monument in Stuttgart. Here, Schiller's life resonates with 'Song of The Bell', and through Thorwaldsen, I introduce an element from my homeland; I hope that you will be pleased with my little tale, dear Grand Duke. ... Please graciously remember me. / I am your Royal Highness' humble servant / H. C. Andersen. (Andersen, *Briefwechsel* 241 et seq.)

The idea of illustrating Schiller's life and the history of his works through 'The Song of The Bell' came to him naturally, since Andersen knew the poem from his youth. He had encountered it everywhere in different versions during this period of widespread enthusiasm for Schiller. He would have learned about the poem during his time at grammar school in Slagelse. As a twenty-year-old in 1825 (Andersen, *Dagbøger* 1: 49) he heard it as a song, and he twice saw it adapted in the form of *tableaux vivants* at the Vienna Burgtheater, first in June 1834 (ibid. 1: 455), then again in May 1854 during an evening entertainment dedicated to Schiller: 'Schiller's Bell with living pictures and Wal[l]enstein's camp' (ibid. 4: 138).

Andersen's Schiller story displays little of the imaginative wealth or satirical spirit of his other *Eventyr og Historier* [*Fairy-tales and Stories*], neither in the slightly dull basic theme nor in its execution.[14] On the contrary, this seems to be the *Biedermeier* Andersen, *par excellence*. In almost shocking conventionality, the text reinforces and illustrates an image of Schiller which corresponds to the ideal current among the German and Danish educated middle classes. Schiller's life is idealized as a sentimental lower-middle-class rags-to-riches story which leaves out no clichés. In a poor but idyllic small town, Friedrich is born to a humble family whose members are, first and foremost, 'honest and hard-working' and 'also with the fear of God in the treasury of the heart'. Praying devoutly, mother Schiller gives birth to her child while the old church bell rings solemnly. The birth of the genius unmistakably evokes Christmas and the basic model of the Romantic religion of art reduced to middle-class interiority shows right from the beginning.[15] Schiller not only seems to be a saint, but the virtual Christ Child of the religion of art:

Our Father wanted to give them a child; it was the hour when the mother was confined in great pain that she heard the sound of The Bell from the belfry wafting into her room, so deep, so solemn, it was a holiday, and the sound of The Bell filled the praying people with devout faith; their heartfelt thoughts raising themselves to God, and in the same hour she gave birth to her little son ... the child's bright eyes looked at her, and the little one's hair was glossy as if made of gold; the child was received into the world by the sound of The Bell on that dark day in November ...

The adolescent child is pious and good; when listening to verses from Klopstock's *Messias*, he sheds 'hot tears'. In the Marbach churchyard, he 'almost devoutly' gazes at the old church bell which had fallen down, and his mother tells him

how The Bell had done its duty for centuries, it had rung for baptisms, weddings, and funerals; it had told of happy celebrations and the horror of fires; yes, The Bell sang the whole of a man's life. And the child never forgot what the mother had told him, it sounded in his breast until he had to sing about it as a man.

The second maker: In the end, everything goes back to his mother.

At the 'military school'– to use Andersen's exact words – the adolescent suffers under the drill and instead of letting himself be deformed into a 'cog ... in the big wheel, to which all of us belong' he lets the song 'in his breast' resound wide over the land. As a 'pale-faced refugee' he escapes across the state border and sets out on his path of glory, which the text only briefly summarizes. In this, like his life, his works, too, are reduced to the canonical texts of the educated middle classes. Along with the eponymous bell, the text also mentions *Fiesko*, *Tell*, *The Maid of Orleans* and, *nota bene*, *Dignity of Women*, which had already been mocked by the Romantics.

Schiller's life runs parallel to the fate of the old Marbach church bell, which is first broken, demeaned and forgotten and then raised as the material of the memorial which is finally erected in honor of the poet. Religion, too, which had lost its footing, is reinstated with new brilliance in the cult of the artist. Under the Danish sculptor's masterful hands, whose art is admired all over the world, the molten ore of the bell is transformed into the 'head and chest of the sculpture which today stands revealed in front of the old palace in Stuttgart, on the square in which he, whom the memorial depicts, used to walk as a living person.'

Young Friedrich had so reverentially listened to his mother's memories that he kissed the now useless bell, and 'The Bell' would then sound 'within his young breast'. '[I]n it there was ore that boomed out and needed to resound in the wide world'. These are the same verbs that have also been used for Schiller's poetry: to sing, sound and resound. 'The Song of The Bell' takes the place of 'The Bell', art is substituted for the church – yet, in art and with the work of Schiller (the art Messiah) and Thorvaldsen (his evangelist), struggling religion is granted new life.

Here, at the last, Andersen's tale proves to be a post-Romantic transformation of the type of Romantic legend of the artist which had been developed in Ludwig Tieck and Wilhelm Heinrich Wackenroder's *Herzensergießungen eines kunstlieben-den Klosterbruders* [*Outpourings of an Art-Loving Friar*]. (This also fits with one of the simple collages which Andersen collected in his *Album*: It combined a portrait of Schiller with a painting of the entombment of Christ.[16]) The middle-class virtues of hard work, simple faith and control of one's emotions replaced the model of the genius and poetical inspiration. These middle-class values especially produced (and artistically authenticated) the apotheosis of the artist as an exemplary saint, or even, as in this example, his transformation into a redeemer and savior. However, the core of his salvation is not a divine universal mind but an

ideal which has already been reduced to a rhetorical shadow. As soon as Wacken-roder and Tieck's catholicizing traits in their legends of the artist faded, this ideal shows as the embodiment of protestant middle-class virtues, namely, a strict ethos of work and duty. Merging with this transformation, the mediacy of salvation through art eventually changes, too. The narrative no longer focuses on the saintly artist and his work of art (here Schiller and his poetry) as the mediators between the sacred and its recipients. It focuses on the apotheosis of the artist as saint in a work of art of the second degree (here Thorvaldsen's sculpture), whose legend (here Andersen's tale) is itself a work of art of the third degree.

Traditional institutionalized religion has vanished, symbolized by the muted church bell, which is here physically and literally transformed as Thorvaldsen, the ingenuous sculptor, virtually resurrects the old material in his depiction of Schiller, the artist genius. The established Christian message of the church bell has been changed into the credo of a middle-class cultural protestant cult of the artist. The work of art, which is here praised, depicts a saint-like life of suffering in which external obstacles can be conquered by self-discipline. The artist finally triumphs through 'struggle' and 'work' in preaching 'the immense and beautiful' sung by 'Johann Christoph Friedrich Schiller', who is effectively praised in the last sentence with a full orchestral fortissimo. In his monument, the matter of the old religion and the adoration of his new art merge into one, not in plain historical facts but in Andersen's pious legend, the outpourings of a Schiller-loving friar.

And yet, surprisingly, Andersen manages to sneak into the first degree of the religion of art in an indirect way. By implicitly fashioning himself as a kindred spirit of the saint, the writer of the legend positions himself as close as possible to the object of the legend.

The text not only inscribes more than one Danish version of Goethe's 'Denn er war unser!' ['Because he was ours'] (Goethe 91), but also discreetly adds: And Andersen is like him. In the subtext and between the lines, the text formulates an *imitatio* of Schiller.

Three Songs of The Bell: Romantic and Post-Romantic Religion of Art

Andersen achieves this through a surprising minor motif: young Schiller's ugly appearance. Without this characteristic the text would be smooth enough that even Andersen scholars might be excused for not noticing it.[17] Yet, surprisingly, this detail stands out from the rosy *Biedermeier* picture in that, as far as I can see, it cannot be found in such clarity in any other document of the early Schiller cult.

Indeed, the pious child in Andersen's tale is 'lanky, has reddish hair, a freckled face, yes, that was him'. Andersen had learned about this first-hand, on 13 August 1855, in Stuttgart. The diary records: 'at noon, dinner at the Grand Duke's, with Schiller's oldest son who is a baron, he gave me the portrait of his father which resembled him most, told me that he had had *red* hair' (Andersen, *Dagbøger* 4: 177).[18] It is noteworthy how the Schiller narrative handles this detail: His idealiza-

tion as a golden-blond is limited to the perspective of his loving mother but is actually an obligatory detail in any German artist legend. Schiller's red hair only glows 'as if it were golden' in his mother's eyes, through which the text is looking at the child. The narrator's voice, however, corrects this view and states how, for the rest of his life, the hero cannot shake off his lowly birth, which his red hair epitomizes. Even though Andersen's Schiller goes on to win fame and recognition, he is still 'the poor boy from tiny Marbach'.

One of the central motifs in Andersen's works, both the novels and the fairy tales, is the portrayal of stigmata as secret marks of distinction – from the hero of *O.T.*, who is literally stigmatized through a tattoo, to the one-legged toy soldier, the mermaid caught in the wrong body, and the ugly duckling.[19] And it is one of the central motifs in Andersen's autobiographies, too, starting with the early and only posthumously published *Lesebuch* to *Märchen meines Lebens ohne Dichtung*. Here especially, Andersen's autobiographies and semi-biographical fictions suggest the flipside of his successful fairy-tale career, behind the idealizations. It shows a threefold stigmatization with which he never came to terms: a physical stigmatization due to his clumsy appearance, and his very lanky and disproportional body; an erotic stigmatization in his inability to conform to normative heterosexual roles; and a social stigmatization because he came from a world of poverty, alcoholism and prostitution.

This troubling detail opens up a rift in the text and the closer one reads, the further it goes.

Schiller's story not only resembles the story its author tells about himself in that it is an artist legend turned into a middle-class success story, but also in the exhibition of a stigma that success is supposed to erase. In both respects, the text surprisingly thoroughly aligns *this* hero, too, with its author's autobiographical narrative. While the text's surface only varies the well-known image of Schiller, the subtext amounts to one simple sentence: 'Schiller resembles me'.

The love and piety of Schiller's parents can only appear exemplary because they contrast with a background defined by poverty, which the first paragraph orders into three steps: the poverty of the town, the family home and the family. The house in which Schiller's parents live is one of the poorest and darkest among 'the old, small houses'. It is, with its 'low windows, poor and humble to look at'. Only the dark background of this Bethlehem stable in Marbach lets the love of this holy family shine so brightly – including the father's love of literature, 'pious songs', Kloppstock and Gellert. Andersen fashions the famous beginning of his autobiography *Mit Livs Eventyr* [The Fairy Tale of My Life] in exactly the same way, though here there is a much more drastic social misery that is even more energetically idealized:

In 1805, in a small, poor room in Odense, there lived a newlywed couple who dearly loved each other, a young cobbler and his wife, he, barely twenty-two years old, a strange and talented man, a truly poetical mind, she, a few years older, ignorant about the world and life, but with a warm heart. (Andersen, *Mit Livs Eventyr* 13; my translation)

On closer scrutiny, some characteristics which Andersen depicts in his image of Schiller *only* apply to Andersen's, and not to Schiller's, origins. As is well known, the room in which he was born was small and narrow but the house in which it was situated was not; there can be no talk of low windows, a humble appearance, or even a 'small house'. However, it does apply to Andersen's own 'Barndoms-Hjem', his 'childhood home' in Munkemøllestræde, Odense. Also, Schiller's suffering at the Karlsschule is subtly modified to resemble the humiliations which Andersen had to endure under the pedagogical terror at the grammar school in Slagelse, as he recounts in *The Fairy Tale of My Life*. The turn of phrase alone aligns the two educational institutions when the Karlsschule is initially called a 'military school', which might be interpreted both literally and metaphorically. Told with obvious sarcasm considering the background and the reference to his life, both young poets 'are very graciously admitted to the military school, to the department which the children of high-society attended, and that was an honor, a piece of luck' (Andersen, 'Kirkeklokke'). Thus obliged to kiss the hand that feeds them, both have to choose whether they want to be a bell or a cog in the wheel of middle-class society, either a saint of middle-class religion of art or (as it is explicitly phrased in the text) a 'number'. Consequently, both take flight – to literature and across the state border. In Andersen's self-portrait, it reads thus:

From abroad I have received, as I said, the happiest recognition over the years, which backed me up mentally. If Denmark has a poet in me, no one here has spoiled me to be one. While parents often care for and tend any kind of budding talent and put it in a hot house, the majority of people have done their utmost to stifle mine; but that is how our Lord wanted it for my development, and that is why he sent beams of sun light from abroad, and let that which I have written cut its way. (Andersen, *Mit Livs Eventyr* 175 et seq.)

Thus writes Andersen about himself. And about Schiller:

[T]he more crammed it was behind the walls of the school, … the stronger it sounded in the young fellow's breast and he sang it in the circle of his friends, … and the sound traveled across the borders; but this was not why he had received schooling, clothes, and food … he had to leave his fatherland, his mother, his loved ones, or drown in the flood of mediocre men.

Indeed, neither of them belonged 'among mediocre men' (a phrase which recurs, aimed at Andersen's *alter ego*, in the fairy tale 'The Shadow'). They are both rewarded for their suffering, since they overcame it in the medium and through the means of art. They gain international fame which travels as far as feet can walk, as the phrase goes in the Schiller tale. Like Andersen as the hero of his fairy-tale life who survives only because of his literary works, in his depiction of Schiller, the few 'written pages on the "Fiesco"' are the poet's 'whole wealth and hope for the future'. With the example of the Marbach author, Andersen effectively only varies one of his own maxims: 'the heart has to suffer and try what it shall sing out loud'. Taken together with the sentence 'the poor child had become his nation's

pride', it suggests the underlying construction of Andersen's own *Mit Livs Eventyr* [The Fairy Tale of My Life].

In Andersen's story, both Schiller and Thorvaldsen embody the myth of the poor boy who becomes a great artist. Yet beside these two and between the lines, Andersen is the invisible third man, at least at a superficial glance. Little Thorvaldsen is 'a very poor boy who had been wearing wooden clogs'; the child of poor parents in Odense wrote about himself 'Her løb jeg om med Træsko på / Og gik i Fattigskole' ['Here I ran about in clogs / And went to the charity school'].[20] According to Andersen's text, Thorvaldsen grew up in the idyllic Danish countryside which is similar to Schiller's Swabia: 'on one of the green islands where beeches grow and where there are many barrows'. However, using almost exactly the same words, Andersen had described 'Danmark, *mit Fædreland*' (my emphasis), his extremely popular anthem of 1850: 'Where mighty barrows / stand amidst small cottage gardens'; 'beechy Fatherland'; 'You green Islands, home of my heart here below' (Andersen, *Landschaft mit Poet* 65; 67). Thus, in this picture-puzzle narrative, Andersen paints his idealized self-portrait twice: in the roles of Schiller and of Thorvaldsen. He is the sitter's successor and his portraitist – like those painters who gaze at the onlooker out of the corner of a large painting.

The subtlest and most inconspicuous hint that Andersen has painted Schiller after himself – or that he has stylized his own life as an *imitatio* of the art messiah – can be found in a tiny mistake in the quotation. Significantly, in the Danish text the poor boy is not 'he, who shall later sing the most beautiful "Song of The Bell"' but 'he, who shall later sing the most beautiful song of "The Bell"'. Schiller never sang a song of *this* title; only Andersen himself has. He did so in 1845, in his most consistent framing of a post-Romantic religion of art which conceives of the Romantic *Kunstmärchen* as a variation of myth and only uses the term 'song' as a metaphor for a prose tale. A final glance at the first of Andersen's two bell fairy tales shows why he evokes it in the transformation of Schiller's 'The Song of The Bell', and the consequences this reference engenders.

'Klokken' ['The Bell'] was published in May 1845. The text is written in Andersen's characteristically plain style, which becomes more rhetorically elaborate towards the end of the story. For Andersen, who had started his literary career as a successful poet following Heine, this style is intimately connected with the fairy tale because only prose modelled on colloquial speech could conform to the folkloristic style to which he aspired. Only this kind of prose could gloss over the artificiality of the work of art, contrasting with Andersen's sometimes rather artistic and exalted verse. This kind of folkloristic appeal is at the center of Andersen's prose song of 'The Bell', which unites the poor and the rich, the educated and the uneducated in the spirit of a Romantic philosophy of nature.

The text tells the story of two very different boys, who simultaneously follow a mysterious sound which can be heard one night 'in the narrow streets of a big city'. It is a 'strange sound, like the stroke of a church bell, but you could only hear it for a brief moment because of the clatter of cartwheels and people yelling, and that is annoying' (Andersen, 'Klokken'; my translation).[21] Outside the city gates, however, surrounded by nature, 'the sound of the bell' can be heard 'much

louder; it was as if the sound came from a church deep inside the serene, fragrant forest'. People start to become curious and go looking for it, and even the emperor's scouts are traveling ever further in their search. Yet they cannot discover the source of the mysterious sound. The two boys go farthest, each of them on his own: one 'a son of a king', the other 'a boy in wooden clogs, with a jacket so short it showed his long wrists'. They know each other from home and now they meet again in the open country where they set out independently to find the source of the sound. Only at the end of the world do they meet again, where the sun sets in the endless sea and where the starry sky can be seen above:

The sea ... stretched before them, and the sun stood out there like a shining altar, where sea and sky meet, everything blurred in glowing colors, the forest sang, and the sea sang, and his heart sang with them; all of nature was one holy church in which trees and soaring clouds make up the pillars, flowers and grass the woven velvet, and the sky itself the big dome ... and they ran towards each other and held each other's hand in the huge church of nature and poetry, and the invisible, holy bell chimed above them, blissful spirits floating around it, dancing a jubilant hallelujah.

Like the central motif of 'The Bell', Andersen also adopted from Schiller the 'church of nature' under the starry sky. 'Werden wir Gott in keinem Tempel mehr dienen, so ziehet die Nacht mit begeisternden Schauern auf, der wechselnde Mond predigt uns Buße, und eine andächtige Kirche von Sternen betet mit uns.'[22] The passage can be found in *Kabale und Liebe* [*Love and Intrigue*]; Ferdinand says this to Luise in act 3, scene 4 (Schiller 808). In a school essay, the young Andersen commented on this scene: 'Night covers all of nature which seems to me like a holy church, the sky its vault, and its clear eternal lights are shining down on me. What holy silence! Noble and high feelings awake in my breast, now that the busy life of day is over'.[23] From this passage, Andersen draws the final image of the fairy tale of 'The Bell'. While this fairy tale once again proclaimed the Romantically conceived unity of 'church', 'nature' and 'poetry', 'The Old Church Bell' refers back to this and frames a post-Romantic, educated middle-class cult of art transformed into the cult of the artist. In 'The Bell', the poor boy and the king's son both stand 'in the huge church of nature and poetry'. In 'The Old Church Bell', art only gazes at itself: Andersen at Thorvaldsen and Thorvaldsen at Schiller. The order of this self-reflection can be reversed to reveal the stages of an *imitatio* which integrate the writer of the text into the story told: from Schiller to Thorvaldsen, from Thorvaldsen to Andersen himself.

On 15 January 1846, Andersen wrote in his diary:

I read out loud three fairy tales of which 'The Bell' made the greatest impression, the prince in it, I told him [Carl Alexander], was an allusion to himself: 'Yes, I shall aspire to the noblest and best aims,' he said and pressed my hand. We were at table together and he proposed a toast to me (Andersen, *Dagbøger* 3: 46)

Can it be a coincidence, then, that Vilhelm Pedersen's contemporary illustration depicts the poor boy and the king's son in a way that makes you think you recognize a famous Weimar monument? Yet this is not an idealized friendship between two poets, but the connection of a poet and an art-loving prince. In the Schiller story, which Andersen wove from the lyric 'The Song of the Bell' and the prose fairy tale of 'The Bell', all of these strands converge. Here, the young boy who used to be his friend has inconspicuously identified himself with Schiller. The Danish poet who had sung 'the most beautiful song of "The Bell"' is identified with the German who wrote the most beautiful 'The Song of The Bell'. The Weimar prince, whom he had envisioned earlier, is now the reader to whom the fairy tale writer addresses his text. In his depiction of Schiller, Andersen shows the prince and anyone who is able to see it the story of his own life, suffering and triumph as a post-Romantic variation of an art-religious legend of the artist – wrapped in the plainness of fairy-tale prose in which Schiller's contemplative poetry is nothing but a faint, distant shadow.

Literature

Andersen, Hans Christian. *Eventyr: Kritisk udgivet efter de originale*. Ed. Erik Dal and Erling Nielsen. 7 vols. Copenhagen: Reitzels Forlag, 1963-1990.

Andersen, Hans Christian. 'Klokken'. *Eventyr*. Vol. 2. Copenhagen: Reitzels Forlag, 1964. 204-208.

Andersen, Hans Christian. 'Den gamle Kirkeklokke'. *Eventyr*. Vol. 5. Copenhagen: Reitzels Forlag, 1967. 22-26.

Andersen, Hans Christian. *Almanakker 1833-1873*. Ed. Helga Vang Lauridsen and Kirsten Weber. Copenhagen: Gads Forlag, 1990.

Andersen, Hans Christian. *Dagbøger*. Ed. Kåre Olsen and H. Topsøe-Jensen. 12 vols. 1971-1976. Copenhagen: Gads Forlag, 1995.

Andersen, Hans Christian. *Mein lieber, theurer Erbgroßherzog!: Briefwechsel zwischen Hans Christian Andersen und Großherzog Carl Alexander von Sachsen-Weimar-Eisenach*. Ed. Ivy York Möller-Christensen and Ernst Möller-Christensen. Göttingen: Wallstein, 1998.

Andersen, Hans Christian. 'Breve til, fra og om H. C. Andersen'. Ed. Johan de Mylius and Solveig Brunholm. H. C. Andersen Centret. Web, 15 June 2012. www.andersen.sdu.dk.

Andersen, Hans Christian. *Mit Livs Eventyr, 1855*. *H. C. Andersens Samlede Værker*. Ed. Klaus P. Mortensen. Vol. 17, *Selvbiografier II*. Copenhagen: Gyldendal, 2009. 11-345.

Andersen, Hans Christian. *Landschaft mit Poet: Gedichte*. Trans. Heinrich Detering. Göttingen: Wallstein, 2005.

Andersen, Jens. *Hans Christian Andersen: Eine Biographie*. Trans. Ulrich Sonnenberg. Frankfurt am Main: Insel, 2005.

Detering, Heinrich. 'Religion'. *Handbuch Literaturwissenschaft*. Ed. Thomas Anz. Vol. 1, *Gegenstände und Grundbegriffe*. Stuttgart: Metzler, 2007. 382-395.

Goethe, Johann Wolfgang. 'Epilog zu Schillers Glocke'. *Sämtliche Werke. Münchner Ausgabe*. Vol. 6.1, *Weimarer Klassik 1798-1806*. Ed. Victor Lange. Munich: Hanser, 1986. 90-92.

Goffman, Erving. *Stigma: Über Techniken der Bewältigung beschädigter Identität*. Frankfurt am Main: Suhrkamp, 1967.

Høeg, Tage. *H. C. Andersens Ungdom*. Copenhagen: Levin, 1934.

Kahl, Paul. '"... ein Tempel der Erinnerung an Deutschlands großen Dichter": Das Weimarer Schillerhaus 1847-2007'. *Die große Stadt: Das kulturhistorische Archiv von Weimar-Jena* 4 (2008): 313-326; 1 (2009): 40-75; 2 (2009): 155-176; 3 (2009): 217-237.

Lohmeier, Dieter. 'Kopenhagen als kulturelles Zentrum der Goethezeit'. *Grenzgänge: Skandinavisch-deutsche Nachbarschaften*. Ed. Heinrich Detering. Göttingen: Wallstein, 1996. 78-95.

Meier, Albert. *Goethe: Dichtung – Kunst – Natur*. Stuttgart: Reclam, 2011.

Meier, Albert, Alessandro Costazza and Gérard Laudin, eds. *Kunstreligion: Ein ästhetisches Konzept der Moderne in seiner historischen Entfaltung*. Vol. 1, *Der Ursprung des Konzepts um 1800*. Berlin: De Gruyter, 2011.

Möller-Christensen, Ivy. *Den gyldne trekant: H. C. Andersens gennembrud i Tyskland 1831 -1850. Med tilhørende bibliografi*. Odense: Odense Universitetsforlag, 1992.

Mylius, Johan de. *H. C. Andersens liv: Dag for dag*. 1998. Web, 15 June 2012. www.andersen.sdu.dk.

Pulmer, Karin. 'Brüchige Integration: H. C. Andersen und die Lateinschule'. *Skandinavistik* 1 (1984): 36-50.

Rühling, Lutz. *Opfergänge der Vernunft: Zur Konstruktion von metaphysischem Sinn in Texten der skandinavischen Literaturen vom Barock bis zur Postmoderne*. Göttingen: Vandenhoeck, 2002.

Schiller, Friedrich. *Kabale und Liebe. Sämtliche Werke*. Ed. Peter-André Alt, Albert Meier and Wolfgang
 Riedel. Vol. 1. Munich: Hanser, 2007.

Schöne, Albrecht. *Schillers Schädel*. München: Beck, 2005.

Steinfeld, Thomas. *Weimar*. With photographs by Barbara Klemm. Stuttgart: Klett-Cotta, 1998.

Sina, Kai. 'Kunst – Religion – Kunstreligion: Ein Forschungsüberblick'. *Zeitschrift für Germanistik*
 (new series) 2 (2011): 337-344.

Wullschlager, Jackie. *Hans Christian Andersen: The Life of a Storyteller*. New York: Knopf, 2001.

Notes

1 Translated by the author following the reproduction in the supplement volume to Andersen's *Eventyr*.

2 Biographical dates, here and in the following, according to Mylius.

3 For example, in his diary entries after he had finished his work on 23 April 1860: 'Letter with Schiller's fairy tale to Mrs Serre in Dresden' (Andersen, *Almanakker* 286).

4 On the cultural historical context, see Lohmeier. Not only Danish poetry of this period, but also the extremely productive fashion of the *Bildungsroman* after 1800 would not have been conceivable without the persistent Weimar model, together with the general popularity of *Faust* (on this, essentially, see Meier). Andersen is exceptional among his contemporaries as his infatuation with Goethe can be seen to permeate all of his works. His novels, which were widely read in Denmark and Germany, continuously vary the model of *Wilhelm Meister*. In his novel of society *De to Baronesser* [*The Two Baronesses*], Andersen makes a leitmotif of Goethe's term the 'rote[r] Faden' [the 'golden thread'], an organic development in the seemingly haphazard course of the world (on this, see the chapter on Andersen in Rühling). Even in Andersen's penultimate novel *At være eller ikke være* [*To Be or Not to Be*] of 1857, he elaborates at length on the question of how the second part of *Faust* should be correctly understood; Andersen even has the heroine give a complete retelling of the poem.

5 Translated by the author following the excellent database of Andersen's letters (Andersen, 'Breve') set up by Johan de Mylius in cooperation with Solveig Brunholm.

6 The fact that Andersen not only launched the biography as a preface to his best-seller *Nur ein Spielmann*, but had even written it himself shows the determination and unscrupulousness in his self-mythification. On this, see Möller-Christensen.

7 He then described his first journey in his travel journal *Schattenbilder*; on this, see Mylius' new, annotated edition.

8 The correspondence is accessible in an annotated edition (Andersen, *Briefwechsel*). Cf. also the chapter on Andersen in Steinfeld.

9 Here and in the following, translations of Andersen's diary entries by the author.

10 On Andersen's difficult integration into the 'culture of education and learning' (*Dannelseskultur*) of the Danish civil servants' state, see Pulmer, as well as Wullschläger and Jens Andersen.

11 Meaning the *Billedbog uden Billeder* (*Bilderbuch ohne Bilder* [*Picturebook without Pictures*]).

12 On this, comprehensively, see Schöne. On practices involving the poet's manuscript as a 'relic' in the age of Goethe, often using the term itself, cf. Kai Sina's study in progress *Geschichte des Schriftstellerischen Nachlasses*. Kahl gives an in-depth analysis of the early cult of Schiller's house of birth as a place of pilgrimage in the cult of the artist.

13 Andersen was staying at the hotel 'Zum Elephant, it costs 1 ½ Taler a day, view on the market square. Goethe's house is being decorated, Schiller's too, spoke with its owner, he thought I was the young Wieland. ... Rainy weather. Flags are flying on the town hall, the people are busy running about with flags and garlands. Home and to bed at 9' (Andersen, *Dagbøger* 4: 283 et seq).

14 In the following, quotations from 'Kirkeklokke', in my translations from Andersen, are in the text without further individual references.

15 On the term *religion of art*, cf. Costazza, Laudin and Meier. On an attempt at a definition, see Detering. On an overview of research, see Sina.

16 Reproduced in Andersen's *Mit Livs Eventyr* (163). (Joseph Stieler's reproduction of Ludowike Simanowics' Schiller portrait and Theodor Rehbenitz's pencil-drawn water color of the entombment of Christ.)

17 In Danish literary criticism, the text was especially praised as one of Andersen's 'best works' in its 'plain, naïve depictions' (thus in the Copenhagen journal *Flyveposten* of 2 December 1862). It is here translated following Flemming Hovmann's documentation of the reception history (Andersen, *Eventyr* 4: 210); in the further reception of Andersen, the text has only played a marginal role.

18 Followed by the remark: 'Without any doubt, I was the most popular man about town'.

19 For a basic definition, see Goffman.

20 These lines can be found on a commemorative plaque on its former building.

21 In the following, quotations appear without individual page numbers.

22 'As soon as we stop worshipping God in a temple, night will fall with inspiring showers, the changing moon will preach repentance, and a pious church of stars will be praying with us.'

23 Andersen's essay is titled *Betragtninger i en stjerneklar Nat* [*Thoughts on a clear starry night*] (cf. Høeg 92 et seq.).

THE DEMOCRACY
OF NATURE

[ABSTRACT]

The close connections between Danish art and politics in the 19th century were not limited to the period of the adoption of Denmark's first democratic constitution and the stormy years that followed, up to the country's defeat in the Second Schleswig War in 1864. From around 1800, landscape art became in many ways a mirror of the political situation in the country. The first half of the 19th century offers a wide range of artistic testimonies to the political inclinations and preferences in relation to landscape art. In the works of Jens Juel (1745-1802), C. W. Eckersberg (1783-1853), J. Th. Lundbye (1818-1848), P. C. Skovgaard (1817-1875) and Vilhelm Kyhn (1819-1903), we can make out the emerging contours of a new political and artistic agenda. This article focuses on a number of case studies from the Danish Golden Age that will be used to discuss the relationship between art and politics in this period.

.

KEYWORDS *Landscape art, politics, J. Th. Lundbye, P. C. Skovgaard, Jens Juel.*

GERTRUD OELSNER

Political Landscapes

You would like to know what works I have in progress; I only gather material for works; I paint chiefly around and about, inside the forest; there are wonderful tall trees that stand individually, or gather into voluminous groups and closely-packed masses, now and then with a view, between the trunks, of the lovely Nærum Valley; it is especially lovely in the afternoon; now there is fine green grass for the forest floor, now great clusters of raspberries, ferns and willow-herb in bloom, and finally charming, light young forest; this is more than can be painted, so it is no matter if other countries have even more beautiful landscapes. (Skovgaard, Letter to Orla Lehmann)

This is an extract from a letter written by the painter P. C. Skovgaard (1817-1875) to the National-Liberal politician Orla Lehmann (1810-1870) in 1853. The surviving correspondence between the two is one of many examples of the extensive connections between artists and politicians at a time when the modern nation-state of Denmark was being established and the struggle for a democratic constitution was taking place. However, the close connections between art and politics were not limited to the period around the adoption of Denmark's first demo-

GERTRUD OELSNER, Curator at Fuglsang Kunstmuseum
Aarhus University Press, *Romantik*, 01, vol. 01, 2012, pages 69-101

cratic constitution and the stormy years that followed, up to the country's defeat in the Second Schleswig War in 1864. From around 1800, landscape art became in many ways a mirror of the political situation in the country. The first half of the nineteenth century offers a wide range of artistic testimonies to the political inclinations and preferences of landscape artists. In the works of Jens Juel (1745-1802), C. W. Eckersberg (1783-1853), J. Th. Lundbye (1818-1848), P. C. Skovgaard (1817-1875) and Vilhelm Kyhn (1819-1903), we can make out the emerging contours of a new political and artistic agenda, and in the next few pages a number of case studies of landscape painters from the Danish Golden Age will be used to discuss the relationship between art and politics in this period.[1]

Patriotic Idylls and Political Allegories

Jens Juel is one of the most important Danish portrait artists; he worked at the end of the 18th century, up to the year 1800. A lesser-known but in this context important side of Juel's work is that he also painted 75 landscapes (Hvidberg-Hansen, Miss and Zacho 10), mostly of Danish subjects, though a smaller number were inspired by the long journey Juel made in the years 1772-1779. Besides stays at the classic destinations in Rome and Naples, the journey took Juel to Switzerland, where he became part of a milieu that cultivated a philosophical discourse deriving from Rousseau. In this discourse, the qualities of human beings in the state of nature were a key part of the agenda. This is reflected by Juel in a number of works where the subject of his portrait are shown in natural surroundings: these are not simply figure portraits, since the surrounding landscape is also portrayed. One example of this is *Baroness Matilda Guiguer de Prangins in her park at Lake Geneva* (1779, ill. 1), in which the young baroness is shown in the sheltering context of the foliage above, in her garden, with a wide view of Lake Geneva and her property in the background.

This is not simply a portrait, it is also a detailed rendering of nature; it was undoubtedly produced with inspiration from the milieu of thinkers of which Juel became a part during his stay in Switzerland. Fêted as Juel was as a portrait painter, this genre bore within it the landscape art that Juel claimed to work with 'for pleasure and in idle moments' (Weinwich; Kold 44).

Measured against the large numbers of his portraits, Juel's landscapes represent only a small proportion of the oeuvre, but there is still something conspicuously underplayed in his description of his activity as a landscape painter. This is probably because of the status of landscape painting in the official genre hierarchy of the time, which still favoured history painting. However, this was a hierarchy that was soon to undergo substantial changes, prompted to a great extent by the art requirements of a burgeoning bourgeoisie that was no longer demanding allegorical, historical narratives but preferred the landscape genre. A few years after returning from his long journey abroad, Juel painted *View from Sørup of Fredensborg Castle* (ill. 2).

From the stylized, framing *Baumschlag* of the foreground with the resting red deer, we look out over the landscape to Fredensborg Castle in the distance.

Ill. 1 [Jens Juel, *Baroness Matilda Guiguer de Prangins in her park by Lake Geneva,* 1779. Oil on canvas, 86.5 x 72 cm. Statens Museum for Kunst, Copenhagen, photo SMK Foto]

There is laundry bleaching and the humble figures of peasants filling the middle ground with busy patriotic activity, which is discreetly accentuated by the smoke that billows from the chimney of a small house that can be glimpsed in the middle ground of the picture. The patriotic citizen was willing to make an effort for his fatherland; this was not necessarily the same as the country in which he was born – but more on this later.

This painting is normally assumed to have been executed in 1782 (Fabienke and Oelsner 34). If we believe this date, we can note that the royal property that

Ill. 2 [Jens Juel, *View from Sørup of Fredensborg Castle*, c. 1782.
Oil on canvas, 60.6 x 77.5 cm. Fuglsang Kunstmuseum, Toreby, photo Ole Akhøj]

merges seamlessly with the productive universe of nature in the background must have been occupied by the Dowager Queen Juliane Marie (1729-1796), who shared the real power in the country with Ove Høegh-Guldberg (1731-1808) after the fall of Johann Friedrich Struensee (1737-1772). But the prevailing patriotic discourse did not limit the unified national sense of belonging to a specific place. Instead, it was grounded in the citizenship concept, where the crucial factor was the duties and rights the individual had in relation to the State, with the King as its the highest authority.[2]

Despite the explicit mention of the geographical locality in the title of this painting, Juel was not yet working in the genre of the place-specific landscape study. The need to produce such landscape studies was impressed on C. W. Eckersberg's future pupils and their immediate successors, albeit with a generalized characterization of the type. Juel's work was painted just seven years before the great agrarian reforms decisively changed the Danish landscape. Nevertheless, the discreet positioning of the castle in the periphery of the painting seems to point to a development which, with the agrarian reforms as the economic starting point, not only transformed the Danish landscape forever, but was also of

Ill. 3 [Jens Juel, *View across the Little Belt from Hindsgavl on Funen,* c. 1800.
Oil on canvas, 42 x 62.5 cm. Thorvaldsens Museum, Copenhagen, photo Hans Petersen]

crucial importance to the phasing-out of absolutism and feudalism in favour of a democratic constitution. Juel, who was a member of several patriotic societies (Hvidberg-Hansen, Miss and Zacho 79ff) and well versed in the theoretical literature of the agrarian reforms (Kold 46), was not artistically content to perpetuate a moderate patriotic discourse.

In at least one suite of pictures, he gave voice to a more radical message through his landscape painting. This can be seen in the works *View across the Little Belt from Hindsgavl on Funen* (c. 1800, ill. 3) and *View across the Little Belt from a hill at Middelfart* (c. 1800, ill. 4), which depict scenes from before and after the abolition of adscription respectively.

In the first painting, the seigneurial punishment of the peasant takes place in a highly symmetrical and regulated natural universe where the slender trees and the bare slopes suggest that this could be a newly established garden complex. This garden ends where a white fence marks the transition to the wilder, unregulated landscape on the other side, symbolized by a lush irregular hedgerow. The other work is a different matter. Here, the symmetrical regulation of both landscape and human beings has given way to a conception of landscape that

Ill. 4 [Jens Juel, *View across the Little Belt from a hill at Middelfart,* c. 1800. Oil on canvas, 42.3 x 62.5 cm. Thorvaldsens Museum, Copenhagen, photo Hans Petersen]

seems deliberately to aspire to the natural, rather than the regulated. The winding road functions as a striking compositional element that unifies the picture planes rather than separating and instituting boundaries, as is the case in the former work. Class distinctions are emphasized in *View across the Little Belt from Hindsgavl on Funen* in a very distinct way from in *View across the Little Belt from a hill at Middelfart.* However, class difference is not abolished altogether in the second painting; instead, an easygoing co-existence of peasant and lord is implied. Patriotism and the great agrarian reforms were not only echoes of the 'Liberty, Equality, Fraternity' of the French Revolution, they were also a pragmatic means of maintaining the existing class boundaries by giving the peasants a number of concessions and new privileges.

The Discovery of The Danish Landscape

A common feature of the above-mentioned works by Juel is a discreetly elevated angle of vision that permits a wide view out over the landscape, thereby assigning a particular meaning to it. This *mise-en-scène* of his landscapes is hardly coinciden-

tal. It was accentuated even more by artists later in the 19th century, culminating in Vilhelm Kyhn's (1819-1903) vast panoramas of the Danish landscape (Oelsner and Grand, *Vilhelm Kyhn* 155-183). But let us continue for the moment with this exploration of the early 19th century and its Romantic landscapes, which in this period begin to be profiled as an important artistic genre on an equal footing with history painting. However, new problems were brewing in these years. The enclosures and redistribution of farmlands, the abolition of adscription and the slightly later Forest Reserve Ordinance of 1805, which left clear visual traces on the landscape, were all radical changes that led to an increased flow of people from countryside to town. The dissolution of the common agriculture of the village community in favour of more rational, parcelled-out farming meant, paradoxically, that the whole rural population could no longer be fed by agriculture. As a result, other occupations arose in the wake of increasing industrialization and the patriotic ideal of ensuring domestic production that was not luxury-based.

One of the visible results of this thinking was the establishment, on the English model, of a number of spinning schools all over the country which were to render superfluous imports of foreign luxury textiles; this is very probably the explanation for the linen bleaching in Juel's *View from Sørup towards Fredensborg Castle*. Another visible consequence of the reforms was the incipient metropole-formation of industrialization, which was of great importance for the increased popularity of landscape painting in this period. Greater population density in the towns meant that a large group of people lost their dependence on nature as a resource, and in the sheltering context of the town the modern urban human being could withdraw from nature, which could then be observed from this new position as 'landscape' (Ritter 24-50; Wamberg 9-23).

It is thus characteristic that landscape painting made its impact as an artistic genre in parallel with the emancipation of the urban citizen from a relationship of dependence on nature due to the changing conditions of production. And alongside these structural changes, there seems to have been a rationalization of the view of the landscape. It was now subjected to a succession of surveys and descriptions that would gradually encompass the whole Danish kingdom.

The reconfiguration of the villages and enclosures of the related lands required exact, accurate surveys of the countryside, and at the urging of the monarch the Royal Society of Sciences launched the first thorough survey of the kingdom of Denmark. This project was not concluded, however, until 1841, and in the interim it was taken over by the Office of the Ordnance Survey. But the surveying and description of the Danish kingdom was not only a matter for land surveyors, topographers, cartographers and geographers; literary descriptions of Denmark also made a significant contribution to this new interest in the Danish landscape.

In the Danish context, the most important literary work of the time was probably the historian and linguist Christian Molbech's (1783-1853) two-volume *Ungdomsvandringer i mit Fødeland*, which appeared in 1811/1815. Molbech travelled all over Zealand, including Møn, as well as Funen and Jutland; the many other islands and parts of the country could not be treated within the confines of the

work. Molbech's writings mediated the transition from a patriotic discourse to a National-Romantic discourse, in which issues of historical origins, nation and language emerged as new indicators of the individual's relationship with the nation. In this new paradigm, the nation could no longer be defined exclusively in terms of citizenship; instead, the concept of 'fatherland' became the decisive parameter for the individual's relationship to the state. As a crucially new feature, Molbech had an eye for the landscape he encountered on his journey around Denmark. He went beyond presenting the country's historic monuments to the reader; the natural landscape itself offered authentic experiences. Thus, in the work of Molbech, the landscape was understood for the first time as a constitutive element of the fatherland. In this perspective, Molbech's work became a veritable domestic guide to the Danish landscape (Damsholt 3).

The inspiration for Molbech's work was presumably as much the age's travel literature of 'sensibility', such as Laurence Sterne's (1713-1768) *A Sentimental Journey through France and Italy* (1768), as it was the contemporary topographical literature, for which Alexander von Humboldt's (1769-1859) *Ansichten der Natur* could be seen as an obvious model. But the exchanges with the pictorial art of the period were also an important source of inspiration for Molbech's writing. *Ungdomsvandringer* makes use of a number of visual, almost painterly descriptions throughout, which might indicate inspiration from the contemporary art of painting; the work itself must have had a similar galvanizing effect on the artists of the time.[3]

However, *Ungdomsvandringer i mit Fødeland* cannot be regarded simply as a guide to the Danish national landscape. With its striking geographical choices and omissions, Molbech's work was also a picture of the transition from the United Monarchy of absolutism and patriotism to the nation state of National Romanticism. This was a process that was in motion in the rest of Europe too, not least as a result of the need to redefine nations as a result of the Napoleonic Wars.

Ungdomsvandringer i mit Fødeland put words to a political and geographical process that was taking place concurrently. In 1814-1815, the Congress of Vienna helped to define the new Europe, in which the Duchy of Holstein was admitted to the German Confederation, while Norway was ceded. Denmark was no longer a Dual Monarchy but a monarchy with inherent territorial difficulties. In the longer term, this was not only a matter for the politicians and the military, but also for the artists of the time, many of whom were preoccupied with the national cause.

The Call of the Fatherland

What I have set myself as my life's purpose as a painter is to paint a beloved Denmark, but with all the simplicity and modesty that is characteristic of it; what beauty there is in these fine lines in our hills that undulate so gracefully that they seem to have emerged from the sea, in the mighty sea on whose shores the sheer yellow cliffs stand, in our woodlands, fields and heaths. But only a Dane can paint it; how false is often the tone of the pictures

that German landscape artists paint here; it can be so offensive that I often become unfair and overlook the beauties in them. Then of a full heart I wish that I might once depict the natural beauties of my native land such that it may be obvious to anyone that they are so greatly mistaken. (Lundbye 49)

An early major National-Romantic work is J. Th. Lundbye's and P. C. Skovgaard's joint decoration of the hall in the stockbroker H. C. Aggersborg's (1812-1895) apartment on the occasion of the latter's marriage to Dorothea Elisabeth Bræmer (1810-1879). However, this has been somewhat neglected in critical accounts. The wedding took place on 8th June 1842, and as a setting for the subsequent domestic festivities Aggersborg had commissioned a threefold decoration showing Højerup Church at Stevns Klint (painted by Skovgaard), the Goose Tower in Vordingborg (painted by J. Th. Lundbye after a sketch by Skovgaard) and Frederiksborg Castle (painted by Skovgaard; ills. 5-7).

Aggersborg, who was Skovgaard's uncle and the half-brother of his mother, belonged economically and socially to the country's powerful elite, a group whose demand for landscape paintings was growing all the time. Seen in this light, it is obvious why Aggersborg wanted an artwork for his home in central Copenhagen that embraced the trinity of landscape, people and history. From the sheltering context of the city, the wedding was evidently to be celebrated amongst depictions of natural landscapes that inspired love of one's country.

In Lundbye's diaries we can follow the genesis of the three works. The commission was finally issued in April 1842; Skovgaard and Lundbye only had a few months to get the trilogy finished and installed in the apartment. In his diary entry for 18 April 1842, Lundbye writes:

Today I have begun work on the painting I am to paint for Skovgaard's uncle, showing the Goose Tower at Vordingborg, after a drawing by Skovgaard; I am looking forward to this work, which can be dealt with lightly and broadly; it will be good practice for me, for my own large work from Jægerspris. (Lundbye 60)

And a few days later:

However, I must also remember this day, when I painted the Goose Tower; I have rarely felt such pleasure over any of my works as over this; it is as if I had been there, as if I knew it well, and yet I have never seen it. I can truly feel how beneficial it is for me to paint this piece. – I will go up on the city ramparts now to hear the many bells of the city ringing, will mix in with the crowd and be glad, as one is permitted to be when one has spent one's day well. Today Orla Lehmann got out of his prison again. (Lundbye 63)

And finally, on 2 June, Lundbye writes that the work has been completed:

Now the hall is finished at Skovgaard's uncle's; for three days Skovgaard and I have worked strenuously down there, but how well it has succeeded I do not know. I will not answer for more than the things I have painted, which will be hard enough to defend for a strict judge

like Høyen. As a whole, I have no opinion of it; I do think, though, that there is life and delight in the treatment – now we shall get to hear what people will say'. (Lundbye 75)

Skovgaard himself only mentions the work in passing in his preserved correspondence. Fortunately, we have Lundbye's description of the process behind the decoration job; he also lifts a corner of the veil covering the conceptual history of the trilogy. The National-Liberal politician Orla Lehmann (1810-1870) had just been released from his imprisonment for giving his so-called 'Falster speech' in Nykøbing Falster in 1841, when he agitated for the support of the farmers in the National-Liberals' struggle for a free, democratic constitution. Lundbye also mentions the art historian N. L. Høyen (1798-1870), with whom not only Lundbye, but also the majority of the other Danish artists of the time were closely associated.

Høyen held a number of posts as an art critic and teacher at the Royal Academy of Fine Arts and later also at the university, not the least of which was his influential position as chief curator of the Royal Art Collection with the archaeologist Christian Jürgensen Thomsen (1788-1865). Høyen was deeply committed to the national current which, prepared by the patriotic reforms and the dawning love of one's country, was being borne up by the National-Liberal movement.[4] Høyen was active in the Scandinavian Society, founded in 1843, under whose auspices several of his epoch-making lectures were held.[5] In 1847, he founded the Society for Nordic Art, and he was directly involved in its concrete political work.

Concerning the last of these, the Professor of Botany and Skovgaard's future father-in-law, J. F. Schouw (1789-1852), wrote to C. P. Neergaard (1793-1860), the tenant of the Vognserup estate:

You have done me the honour of asking me to recommend a man who could stand as an electoral candidate for the Rigsdag in the second district of Holbæk County. I believe I could respond to this request no better than by proposing to you our mutual friend, Professor Høyen. You know yourself of his high principles, his unusual independence and his warm love of his country. You know that he has a very wide knowledge of many things and that, although he has not yet made affairs of state the object of his studies, through his historical research he is aware of much in that respect; – to this we can add his rare eloquence, and what in a rural electoral district must surely also be considered, his warm feelings for the farming class, from which he himself originates.[6]

Aggersborg's wedding decoration was thus not only to be judged by the most influential art historian of the time; it was also to be assessed by a man with strong National-Liberal convictions. Notwithstanding the private nature of the decoration, it was always going to be inspected by Høyen. The Aggersborg home housed a large art collection which was open to like-minded people.[7] Lundbye does not write about Høyen's reception of the works, and no other sources tell us anything about it. But if we consider the pictures themselves, it does not seem too hasty to conclude that they were probably well received. Their subjects include: a medieval church situated by the mighty cliff Stevns Klint to which many popular legends

Ill. 5 [J. Th. Lundbye, *The Goose Tower in Vordingborg*, 1842.
Oil on canvas, 141.2 x 156.5 cm. Statens Museum for Kunst, Copenhagen, photo SMK Foto]

were attached; a medieval tower from the fortifications of King Valdemar Atterdag in Vordingborg; and a Renaissance castle in northern Zealand. All are situated in the Danish landscape.

These works were not just artistic responses to the new culture-bearing bourgeoisie's call for landscape painting; to a great extent they were also a political response to the burgeoning National Romanticism of the time. This movement was associated with the notion of 'the fatherland', a concept that was geographically demarcated as the nation state of the 'Denmark to the Eider' policy, as it was pointedly formulated by Orla Lehmann in 1842:

Our Denmark is thus the realms and lands of the King of Denmark, less Holstein, but including Schleswig. That this will gain the free approval of the Schleswigers I feel certain, if only the distinctive conditions and administrative independence of Schleswig are

respected, and as long as we can bring it about that it means freedom and happiness to be a part of Denmark. My toast is therefore to the freedom and happiness of Denmark – 'Denmark to the Eider'. Long live Denmark! (Lehmann 1842)

On the whole, the trilogy involves a number of motifs which had been canonized by Christian Molbech as particularly and significantly Danish.[8] The middle work was of the Goose Tower, which had quickly been established as a tourist destination, as is evident from *Politievennen* in 1828: 'If there were a bench or some chairs, and a telescope could be obtained as well as the key to the tower, it would certainly please many people, and with pleasure they would pay more for admission to such a beautiful view.'

The Goose Tower is the only preserved tower from King Valdemar Atterdag's defences against the Hanseatic cities to the south.[9] As such, it constituted a historical parallel to the conflicts of the time with the German duchies, which must presumably have played a role in the popularization of the motif through the 19th century.[10] Lundbye has placed the tower in classic Danish natural scenery. In his painting, it crowns the top of a small hill; a little winding road leads up to it, and on the hill between this and a grazing herd of typical Danish red-and-white dairy cows a group of children are resting while ducks and geese grub in the little pond. The winding course of the road builds a bridge between nature and culture, making the resting children representatives of the rebirth of the proud past that formed an important part of the age's idea of historical continuity, in which the past becomes mirror for the present. As Høyen formulated it: 'A greater, more meaningful battleground opens up for him, where it is not only a matter of developing talent and having it appreciated, but where he also struggles for his native land, for all of Nordic nature, for the life of the people and all the great memories of the past.' (Ussing 359).

To the left of the picture of the Goose Tower hung Skovgaard's *Højerup Church at Stevns Klint*. Despite the title's emphasis on the church, it is almost hidden behind tall trees in the painting. Instead the artist's focus is on the vast cliff, Stevns Klint, which in one long undulating motion exposes 65 million years of history and prehistory sedimented in its horizontal geological strata. This is a very different historical span from the one in the preceding picture. Measured against this grand narrative of Denmark's creation and genesis, both the church and the fishermen on the beach seem to hold a subordinate position. It is no wonder geology as a discipline was particularly successful in this period, with Johan Georg Forchhammer (1794-1865) as its most prominent figure.

The last part of the trilogy is Skovgaard's *View from Frederiksborg Castle*, in which we view the subject from yet another angle – this time there is a kind of bird's-eye perspective, such that we have a wide view out across the surroundings of the castle with the lake and the Danish beech wood in the background. Frederiksborg Castle had already been described by Molbech, who like Skovgaard emphasized the view offered by the castle as an essential characteristic of what was held to be one of northern Europe's most beautiful Renaissance castles. Molbech writes:

Ill. 6 [P. C. Skovgaard, *Højerup Church at Stevns Klint*, 1842.
Oil on canvas, 142.2 x 149.5 cm. Statens Museum for Kunst, Copenhagen, photo SMK Foto]

Ill. 7 [P. C. Skovgaard, *View from Frederiksborg Castle,* 1842.
Oil on canvas, 140 x 150 cm. Ordrupgaard, Copenhagen, photo Pernille Klemp]

I was lured to the windows and the wonderful, lovely view across the lake [...]. Especially yesterday with the afternoon sun and the clear spring sky, it was so entirely charming that more than once I had to confess that the view is one of the finest things the castle possesses. (Molbech 10-11)

As a whole, the trilogy is a clear example of the politically motivated contemporary art which, with inspiration from Johann Gottfried Herder, subscribed to the idea of an identity of nation, culture, people and history. The trilogy should therefore be seen as a major work of National Romanticism with its celebration of the Danish landscape, monuments and people; its structure shows a forward-thrusting, almost evolutionary progress from morning (Højerup Church) through noon (the Goose Tower) to evening (Frederiksborg Castle), but it is also

a statement about a process that flows from God (Højerup Church) through King (Valdemar Atterdag's Goose Tower) to Fatherland (the view of nature at Frederiksborg Castle). It should be noted that the monuments chosen and their surrounding landscapes were not representative of Denmark as a whole; they are all in Zealand. The Goose Tower is in southern Zealand, Stevns Klint in central Zealand, and Frederiksborg Castle in northern Zealand; all together they give us a picture of the Zealand that was the National-Liberal citadel. Jutland was only just beginning to become established as a subject for the art of the Golden Age, a point that will be dealt with later.

National-Liberal Commissions

The political signals in the Aggersborg decoration were unmistakable, and in subsequent years Skovgaard and Lundbye both received a number of commissions from National-Liberal politicians. Among the most prominent patrons in the National-Liberal group was Orla Lehmann, who built up a substantial art collection over the years (Damsgaard 91-118). In 1844, Lehmann married Maria Puggaard (1821-1849) and thus became a member of a particularly prosperous, politically engaged and art-loving family. We find works by, among others, Skovgaard, Constantin Hansen, Lundbye and Kyhn in Lehmann's collections. Lehmann's collection of Lundbye's works included *Bleaching ground at the manor of Vognserup* from 1844-1845, which is closely related to a work in Randers Kunstmuseum (ill. 8).

As noted earlier, the tenant of the Vognserup manor was a National-Liberal sympathizer called Neergaard. In a way the dialogue with Juel's previously-mentioned work is obvious. Here too cotton lies bleaching,[11] yet Lundbye's work is otherwise very different. The landscape is no longer seen from an elevated vantage point; we are situated as viewers on a normal plane in relation to the subject, and this brings us face to face with it. Here, a single red dairy cow grazes in the fertile landscape, and a single woman is the only human presence. For Lundbye the busy work of the peasants is no longer a guarantee of the patriotic society with its emphasis on citizens' actions for the benefit of their country. Instead the conjunction of the bleaching cotton, the peasant woman, the dairy cow in the grass and the lush green surroundings shows that nature and mankind's utilization of it is no longer able to ensure the economic foundation of the state, but that the farmers must be considered living representatives of Denmark's glorious past. Along with the exuberant depiction of nature, they are the source of the budding national movement and its hopes for a free constitution – just as in the farming society of prehistory. Lundbye himself said of the work on the large painting, which grew up against the background of a sketch:

This picture was meant to show the fertility and peace that can be in such a small view, just outside a manor house garden; it was not the magnificence in nature that I wanted to paint – one senses the hand of man much more everywhere – but the opulence that permits the ground to be seen nowhere for grass and plants.' (Henschen et al. 77)

Ill. 8 [J. Th. Lundbye, *Bleaching ground at Vognserup,* 1844-1845.
Oil on canvas, 31.5 x 42 cm. Randers Kunstmuseum, photo Niels Erik Høybye]

Lehmann's interest in pictorial art can be documented by the many works he commissioned, and to some extent by the preserved correspondence. In particular, Lehmann associated himself closely with Constantin Hansen; using the evidence of major commissions and letters we can observe how he makes specific recommendations and commissions to exploit the potential of art to advocate the fundamental National-Liberal ideas. This comes to expression most significantly in the large decoration for the vestibule of the University, which Constantin Hansen executed with Lehmann on the sideline. For this, Lehmann not only sent Constantin Hansen a detailed program; he also provided him with the historical-philosophical key to the decoration program Lehmann wanted him to realize. After receiving the long, detailed proposal for the decoration program, Constantin Hansen wrote to Lehmann: 'Hegel's *Philosophie der Geschicte* has interested me greatly, and I thank you many times for the gift' (Glarbo 35). The

philosophy of Georg Wilhelm Friedrich Hegel was of enormous influence among the National-Liberal thinkers of the age;[12] most of them presumably read the work in the original language, but in 1842 the first Danish translation of Hegel's influential work also appeared.

If Hegel's philosophy had such a strong impact in the period, it was probably because it supplied the philosophical arguments for the constitutional ideals for which the National-Liberals and a number of artists on their side were struggling. For example, Hegel championed bourgeois democratic rights along with the maintenance of the state, and the introduction of a democratic form of government against the background of a constitutional monarchy is based on the idea of evolutionary progress. From time to time Constantin Hansen was to envy the other artists, especially the landscape painters, who 'had a far easier time covering a piece of canvas with colors than the figure painters, which they are of course far too wise to admit.'[13]

However, if we look more closely at a couple of Skovgaard's works commissioned by Lehmann and the related correspondence, the matter appears less simple than this. In 1846, Skovgaard received a commission for the work *Summer day* (ill. 9). On the occasion of its completion Lehmann wrote to Skovgaard: 'Dear friend! I suspect my piece has cost you more effort than you expected when we spoke of the price. So I ask you to inform me of this, regardless of earlier agreements and statements' (Lehmann, letter to P. C. Skovgaard). Despite the friendly enquiry, though, Skovgaard refused to accept extra payment for the work. We can only guess at the reason for this. One possibility is that he had no wish to prejudice future possible commissions: especially, it seems, when the reception of the work was so very positive. At least Lehmann wrote: 'After your letter came yesterday, I have no choice but to obey. It must naturally please us both that all the world agrees with us that it is a charming picture.'

Summer Day is a convincing translation of the National-Liberal ideology into a pictorial idiom. Skovgaard gives us the essence of the Danish landscape: beneath the blue sky of summer with domed cumulus clouds,[14] a group of women and children are resting among the kerbstones in the shelter of an ancient mound covered in vegetation,[15] while the men are at work in the far background of the picture. The whole scene is framed by full-crowned leafy trees, probably beeches, which were starting to be seen as the Danish national tree. The proud past of the country was to be reinvigorated among the farming class, who were considered the living heirs of the free yeomen of yore. Perhaps the stone circle demarcates more than the ancient barrow; it is tempting to assume that this could have been a kind of 'thing-stead', the proto-democratic assembly site of prehistory. The work thus perfectly exemplified the strengthening of the national painting that Lehmann was advocating in 1846, along with the idea of creating a Danish national gallery (Frandsen 120).[16]

Lehmann must have been particularly satisfied with the work, for shortly after the end of the First Schleswig War Skovgaard again received a commission from him; and the result was *View of Vejle*, 1852 (ill. 10). Orla Lehmann's generally controversial political activities, and his actions on the occasion of the so-called

Ill. 9 [P. C. Skovgaard, *Summer Day*, 1846.
Oil on canvas, 65.5 x 93.5 cm. Horsens Kunstmuseum, photo Svend Pedersen]

Casino Meeting of 20 March 1848 – at which Skovgaard, with his National-Liberal sympathies, as well as Jørgen Sonne (1801-1890)[17] and Constantin Hansen all participated as representatives of the artists – meant that in 1849 he was appointed county prefect in Vejle in Jutland. An appointment in Holbæk on Zealand would also have been an obvious possibility (Wammen 126); Lehmann's new position took him much further from the centre of power.

At this time, Jutland was a relatively new subject for visual art, though the literati, topographers and geographers had long been extending their exploration and 'repatriation' of Jutland, which for centuries had played second fiddle to the culture-bearing elite which defined itself and Denmark from the vantage point of the capital (Frandsen 78-109). Viewed from this perspective, one may well speak of a personal exclusion, but on the other hand it was politically quite in keeping with the rediscovery of Jutland which intensified from the ceding of Norway in 1814 until the secession of the duchies in 1864, as a result of a diminished Denmark's search for a new national identity.

Ill. 10 [P. C. Skovgaard, *View of Vejle*, 1852.
Oil on canvas, 98 x 100 cm. Vejle Kunstmuseum, photo Keld Jensen]

Skovgaard's response to this was a picture that included features associated with the beech woods favoured by the Zealand aesthetic, but at the same time differentiated itself by its emphasis on the hilly terrain which had no parallel in Zealand. The hilly landscape is viewed from a high point, with the town of Vejle in the embrace of the valley far off in the distance. The picture is built up around a winding gravel road which is lined with slender beeches, and on the road there is a scene of an ox-drawn cart toiling uphill with the aid of a couple belonging to the farming class. Far down the road, a group of bourgeois ladies and children are moving in the same direction. Since the Falster speech of 1741, Lehmann had struggled persistently to mobilize the farming class in the battle against absolutism, and after the adoption of the June Constitution to convince the 'Friends of the Farmers' that the National-Liberals were an obvious political ally (Wammen 224-226). Perhaps it was these factors that Skovgaard, with Lehmann as his commissioner, was referring to in his interpretation of the Vejle landscape? It is at all events worth noting that neither of the figure groups on the road is present in

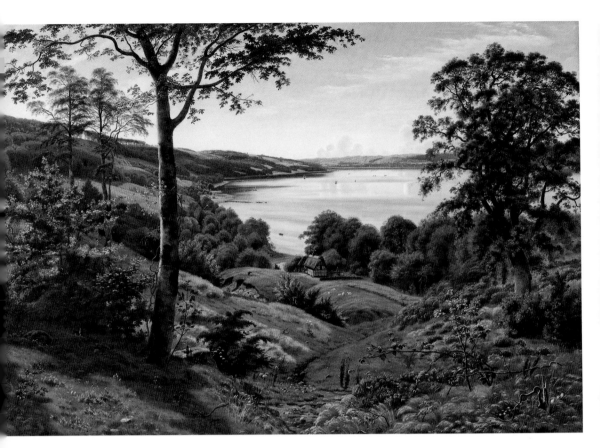

Ill. 11 [Vilhelm Kyhn, *View by Vejle Fjord,* 1862.

Oil on canvas, 151 x 221 cm. ARoS Aarhus Kunstmuseum, photo Ole Hein Pedersen]

the preliminary sketch for the work; nor are the tall, slender beeches as promi-
nent as in the final work. These are features which may reasonably be assumed to
have entered the picture at the wish of the commissioner in order to accentuate
the national statement in the piece.

A decade after Skovgaard's *View of Vejle*, Lehmann received a major work by
another artist, Vilhelm Kyhn. The imposing *View by Vejle Fjord* (1862; ill. 11) helped
to consolidate the place of Jutland in the narrative of the nation state Denmark
(Oelsner and Grand, *Vilhelm Kyhn*).

In 1862, Lehmann had joined the Government again, which was now headed
by C. C. Hall (1812-1888), meaning that he no longer lived at the county prefec-
ture in Vejle. Nevertheless, Vejle was still a sought-after artistic subject, perhaps
because it remained important for the centre of power in Copenhagen to have
knowledge of the part of the kingdom that lay outside the narrow geographi-
cal confines of northern Zealand. Kyhn's depiction of the magnificent landscape
around Vejle was based on accurate, detailed nature studies made on the spot
during previous stays. However, the finished work testifies to the National-Liber-
al conception of Denmark as a unified country. As Orla Lehmann put it in 1838,
'There are no provinces in Denmark.' And despite the starting point of the work

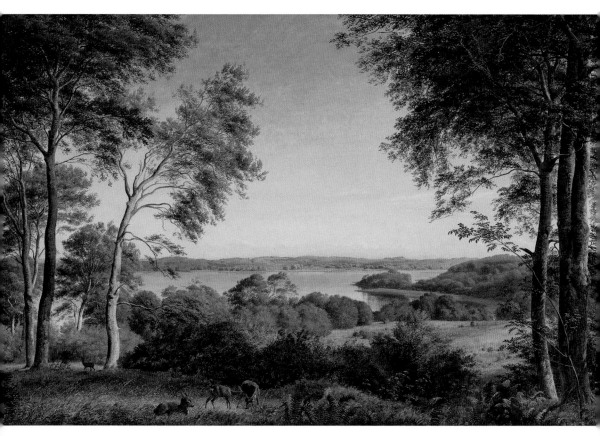

Ill. 12 [P. C. Skovgaard, *View of Lake Skarre,* 1845.
Oil on canvas, 127 x 195 cm. Statens Museum for Kunst, Copenhagen, photo SMK Foto]

being so specific to the place, it is also striking to see how much the subject re-calls, for example, P. C. Skovgaard's monumental subject from the lake Skarresø (*View of Lake Skarre,* 1845; ill. 12). It was not far from Zealand to Jutland.

Lehmann was not alone either in his interest in art or his Hegel-inspired po-litical ideology. We recognize both characteristics in the work of the theologian and politician D. G. Monrad (1811-1887), who over the years built up a similarly large collection of art by a number of the same artists (Jacobsen). Both Skovgaard and Constantin Hansen, to name but two, were represented in his collection. Among the works by Skovgaard was a picture from Møns Klint: 'When the exhi-bition is over, we shall have two pieces by Skovgaard, the one rejected in Norway, which is thus not the same one that Elisa Stampe was enthusiastic about, and a "Møns Klint". I am well pleased with both.'[18] In the book about Monrad and his art collection, it is suggested that the 'Møns Klint' picture in question is identi-cal to Fuglsang Kunstmuseum's *View of Møns Klint,* c. 1846 (ill. 13; Jacobsen 68), where the dimensions of the cliff and the stratified geological sedimentation are marked despite the modest size of the work. This feature is exaggerated by the two human figures and the dog placed at the vanishing-point of the picture.

Subjects from Møns Klint preoccupied Skovgaard for several years from

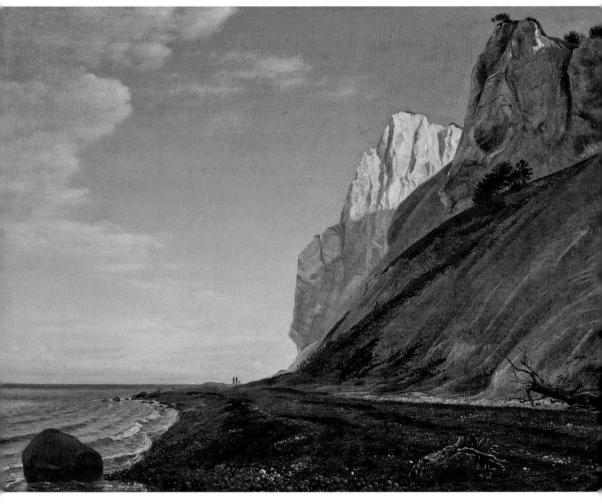

Ill. 13 [P. C. Skovgaard, *View of Møns Klint,* c. 1846.
Oil on canvas, 50 x 67 cm. Fuglsang Kunstmuseum, Toreby, photo Ole Akhøj]

about 1841 until 1853 (Ohrt, 'Historien om et danmarksbillede'). The result was a number of works that ranged from the modest sketches to the often enormous formats of National Romanticism. The artist's many stays at Møns Klint took place during the years of the First Schleswig War, a fact which, however, had no direct consequences on his motives, although in a letter to his fiancée Georgia Schouw (1828-1868) Skovgaard writes:

There has never been a word about politics in your letters – what is happening in the world? How goes it with the war, the peace or the armistice? Today I have seen a real fleet of eight ships of the line, one frigate and probably also a brig coming from the east, and passing the cliffs, or rather Møn, towards Schleswig'. (Skovgaard 1850)

We see no warships in the Skovgaard pictures; on the other hand, in another picture from 1852, a steamer in the distance brings a message about the mod-

ern world.[19] Monrad's art collection, included a wonderful friendship portrait by Christen Købke (1810-1848) showing Constantin Hansen, and over the years Monrad built up an extensive collection of prints.

The Democratic Space of the Forest

The account of the genesis of Skovgaard's undisputed masterpiece, *Beech wood in May*, (1857; ill. 14) is one of the better elucidated stories in Danish art history (Oelsner and Grand, *P. C. Skovgaard* 55-112; Ohrt, 'En forsmag på Paradiset' 125-137). The commissioner of the picture was the principal of the school Borgerdydsskole in Christianshavn, Martin Hammerich (1811-1881). In 1841, Hammerich had married Anna Mathea Aagaard, a daughter of the judge Holger Halling Aagaard of the Iselingen Manor near Vordingborg in southern Zealand. Like the stockbroker Aggersborg, Hammerich wanted a landscape as a decoration for his home in central Copenhagen. Prior to the commission, Skovgaard had been on an extended study trip with his wife Georgia; the journey had taken them to Italy, where they stayed for some time in Venice, Livorno, Naples, Rome and other cities (Oelsner and Grand, *P. C. Skovgaard* 123-166).

Although he was far away from the domestic political upheavals, Skovgaard took a lively interest in the many political complications typical of the time. For example, whilst he was away he corresponded with Carl Ploug (1813-1894), who was not only a National-Liberal politician, but also the editor of the leading organ of the Liberal press, *Fædrelandet* [The Fatherland]: 'On 26th July the Ministry has surprised everyone with something called a People's Constitution, which is however nothing but a grand attempt to get rid of the Constitution and lead us back to Absolutism [....] now it must come to a serious struggle and final settlement, whether we are to continue to be a free people or go back to Absolutism because we do not understand how to use our freedom.' (Ploug, letter from 1854)

Skovgaard was not only one of the National-Liberals' favourite painters, he was, like them, fervently engaged in political life. When he journeyed home again in 1855, Skovgaard received a commission for the work, and shortly after his homecoming he went to Iselingen to make his preparatory studies. The subject of the picture was apparently quickly established. In a letter to Georgia, who had remained in Copenhagen, Skovgaard writes that he '[...] was so fortunate, on a Whitsun morning, to find the subject for the picture, and the Hammerichs are in complete agreement with my idea.'

Skovgaard found the subject for the picture in the woods behind the manor house. At the time, the Iselingen woods had a reputation as a model forest, in accordance with the prescriptions made by C. D. F. Reventlow (1748-1827) in the Forest Reserve Ordinance of 1805. This ordinance was related to the great agrarian reforms. The impetus for these reforms was the bombardment of Copenhagen in 1801, which had left the country without a navy – and unfortunately also without the timber to rebuild one.

Only a small percentage of this area of the country consisted of forest; the communal use of the land, where both animals and people could draw on the

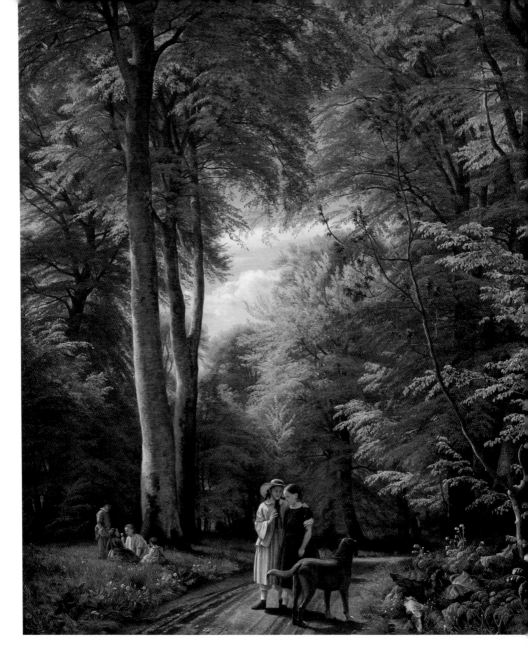

Ill. 14 [P. C. Skovgaard, *Beech wood in May. Subject from Iselingen*, 1857.
Oil on canvas, 189.5 x 158.5 cm. Statens Museum for Kunst, Copenhagen, photo SMK Foto]

resources of the forest, made its reproduction difficult. Timber had suddenly be-
come a valuable political resource that was decidedly scarce in the Danish king-
dom. This was to be remedied by the Forest Reserve Ordinance's regulation of
access to forest areas, its protection orders and the fencing-in of the forests; and
Iselingen, as mentioned, was one of the places where the interaction between
these regulations and Ordinance's instructions for rational and economically
sustainable forestry had most conspicuously borne fruit.

The tall, erect beeches in Skovgaard's picture speak their own clear language
in this respect. Iselingen had succeeded in regenerating the forest so that the
country could once more become a military and political power, which was very

Ill. 15 [H. W. Bissen, *The brave soldier after the victory*, 1852-1858.
Bronze, height 375 cm. Fredericia.]

important in the politically unsettled years between the two Schleswig Wars. The beeches rise skyward like soaring columns,[20] and the full-crowned trees leave room for a modest glimpse of the Danish summer sky with its characteristic blue, shot through by passing cumulus clouds. We are in the month of May, and the forest has just developed its delicate green, still partly transparent foliage that lets plenty of light penetrate to the forest floor, where a gravel road links the groups of children in the foreground and middle ground with a single walking man in the background, presumably the estate owner Aagaard himself. The children in the picture are the commissioner's own children and two girls, cousins on the mother's side; the dog is the Broholmer Leo. As we have seen in some of the pictures mentioned earlier, here too the children are guarantors of the rebirth that is the overall theme of the picture, linking its several levels. Nature has just awakened; everything is greening and bursting forth, symbolizing the picture's hope of a new spring for the democratic politics that had been labouring under difficult conditions since their introduction in 1849.

In this perspective, the beech plays an important role. Since the beginning of the century, the beech had been profiled with increasing impact as Denmark's national tree, a genuine image of the nation of Denmark. Molbech emphasized the beech as a hallmark of the beloved fatherland; Adam Oehlenschläger wrote about it in the text of the national anthem *Der er et yndigt land* [There is a lovely

Ill. 16 [P. C. Skovgaard, *View from Iselingen*, 1861.

Oil on canvas, 122 x 98 cm. Fuglsang Kunstmuseum, Toreby, photo Ole Akhøj]

land] from 1816; we hear about the virtues of the beech from both the geologist Edvard Erslev and the botanist Christian Vaupell. Nor should we forget that the private soldier wields a beech branch as a symbol of victory in H. W. Bissen's (1798-1868) monument *Den tapre Landssoldat efter Seiren* [The brave soldier after the victory], established in 1858 to commemorate Denmark's victory in the First Schleswig War (ill. 15).

In other words, the beech had been conventionalized as a symbol of the politically democratic Denmark, thus assuming the role of Denmark's national tree.

In the process it had overtaken the oak, which had long taken precedence in this role. Over the years, Iselingen had been a sanctuary for the young National-Liberal politicians. In Skovgaard's picture the democratic beech wood has grown strong at the expense of less viable and forward-looking forest regimes, which are visualized here in the form of the small stunted tree in the foreground, doomed to perish in the shade of the vital, upward-striving beeches. Half a century earlier, the Herder disciple Garlieb Merkel (1769-1850) had also used the forest as a meta-phor for the republic: 'A republic is like a well cared-for forest. Each trunk strives upward with all its strength, stretching its arms, so long, so thick with leaves, as far upward and downward as its inner strength permits. All that is in its proper place flourishes, all that is diseased and defective dies' (Warnke 109).

This inherent evolutionary power in nature and society, which of necessity must bring forth constitutional, popular government at the expense of the ab-solute monarchy (symbolized here by the negation of the dead tree in the fore-ground by the beech), moreover seems to have had a certain resonance with the Hegelian ideas which, as we have seen elsewhere, permeated National-Liberal thinking. Of this both the commissioner of the picture, Hammerich, and the art-ist Skovgaard were undoubtedly fully aware; as, presumably, was C. C. Hall (1812-1888), who with his wife Augusta Mathea Hall, *née* Brøndsted (1816-1891) received their version of the woods at Iselingen in 1861 (ill. 16), where the combination of the dead tree and the vital beeches has been retained.

As Steen Steensen Blicher (1782-1848) said,

'*Green* is the festive array of spring, the colour of youth, of hope and joy. In the spring the Danish forests, fields and meadows grow green – and thus now unfolds, like the spring foliage of the beech, the hope of Denmark's rejuvenation into powerful popular life after the long, long, cold, cold political winter' (Blicher 458).

Political Mapping

In the above, the beech forest, hills and slopes have been investigated as expres-sions of the democratic efforts of the age, as have their origins in Juel's part patriotic idylls and part politicizing allegories of the time before and after the abolition of adscription. Together the many National-Romantic subjects from the widely ramified regions of the fatherland constitute a politically motivated mapping of the nation state of Denmark. At first these subjects were chosen from Copenhagen and northern Zealand, where the central administration was based; the movement radiated out to encompass the rest of Zealand and the islands, and finally also Jutland, which in time became a politically important issue that demanded its own visual iconography. Holstein and Lauenburg were hardly ever depicted – Schleswig appeared more frequently, but still relatively rarely. Among the artists who most persistently chose subjects from Jutland in the years be-tween 1814 and 1864 were Vilhelm Kyhn and Thorald Brendstrup (1812-1883) (Oel-sner and Bugge; Oelsner and Grand, *Vilhelm Kyhn*), but before them Martinus Rørbye (1803-1848) and Skovgaard had also visited the mainland peninsula and

Ill. 17 [Vilhelm Kyhn, *View of the sea, Bulbjerg*, 1845.
Oil on canvas, 30 x 41 cm. Private collection, photo Knud Sejersen]

for a while incorporated Jutland in their range of subjects, although it remained parenthetical in their overall oeuvres. For Kyhn and Brendstrup, though, Jutland became something other than an artistic intermezzo, and it is therefore worth dwelling on this briefly. Kyhn's works are in this respect exemplary, *View of the sea, Bulbjerg* (1845; ill. 17) particularly so.

As is the case in several of the two artists' works, Kyhn has here chosen to show his subject from a greatly elevated viewpoint. We look down from a height along the coast at Bulbjerg,[21] and this perspective makes the meeting of land and water, Jutland's outer, nation-defining boundary, the most important concern of the picture. Viewed thus, a considerable affinity can be found between landscape painting and the mapping of the country. The omnipresent topographer of the time, J. P. Trap (1810-1885), showed that he was aware of this during a visit to Denmark's eastern boundary, the Baltic island of Bornholm: 'From the platform of the tower one has an interesting geographical view of all of the land of Born-

holm, both its rocky northern part and its flatter southern part, of the sea round it and across to Christiansø. Only a few times later have I enjoyed such a view where the surroundings lie like a map before one's feet' (Trap, 1966 246).

If one ascends high enough into the air, the encounter between land and water will almost inevitably meet one's gaze. These coastal boundaries also preoccupied the geographer Erslev in the book *Den Danske Stat*: 'It is the sea that makes our native land what it is [...] from almost any high point [one] can view the sea, and it therefore belongs to a Danish landscape, as much as mountains to a Swiss landscape. [...] But our sea is also very beautiful. True, if we except the North Sea, it is by no means as magnificent and mighty as the great ocean; on the other hand there is something so smiling and friendly about it, because it is cut into by these many tongues of land and islands. [...] It is well suited to these recent times in which the Dane has won praise and glory: it is behind the waves of the sea that we have lived in safety from others' (Erslev 1-2).

Kyhn, and with him Brendstrup and many of the other artists of the time, picked up the thread from Erslev's book: the history of Danish art abounds with pictures of the Danish coasts. However, they have rarely been inscribed in a political reading of the Danish landscape painting of the time. The panoramic landscapes, often with coastal subjects, that gave a nod to the age's ongoing mapping of the country became popular subjects in the period. We find them in the Academy exhibitions at Charlottenborg, and Kyhn's works were chosen for the Royal Art Collection by Høyen and Jürgensen Thomsen; but, more than this, artworks like these were to a great extent integrated into popular descriptions of the country. One example of this is the work *Danmark*, published by Emil Bærentzen's Lithographical Institute in 1856, in which the whole of the Danish kingdom within the framework of the 'Denmark to the Eider' program is portrayed in words and pictures. This and several other works of the period – particularly tellingly Trap's *Statistisk-topografisk Beskrivelse af kongeriget Denmark* (1858-1860) – contributed to the textual and pictorial mapping of Denmark that was called for in the years up to 1864, when Denmark emerged in earnest as a defined nation state with a unified language, culture and history. This was a development to which the pictorial artists of the time, often at the urging of the National-Liberal politicians, had made their contribution.

Literature

Allen, C. F. *Breve fra danske Krigsmænd*. Copenhagen: Chr. Bruun, 1873.

Bagge, Povl et al., eds. *Danske politiske Breve*. Vol. 4. Copenhagen: Dansk selskab for fædrelandets historie og sprog, 1958.

Blicher, Steen Steensen. *Udvalgte værker*. Vol. 4. Copenhagen: Gyldendal, 1982-1983.

Damsgaard, Nina. *Orla Lehmann og den nationale kunst*. Vejle: Vejle Kunstmuseum, 1986.

Damsholt, Tine. *Fædrelandskærlighed og borgerdyd*. Copenhagen: Museum Tusculanums Forlag, 2000.

Damsholt, Tine. 'En national turist i det patriotiske landskab'. *Fortid og Nutid* 1 (March, 1999): 3-26.

Davies, Douglas. 'The evocative symbolism of trees'. *The iconography of landscape*. Eds. Denis Cosgrove and Stephen Daniels. Cambridge: Cambridge University Press, 1988. 32-42.

Erslev, Edvard. *Den danske Stat, en almindelig geographisk Skildring for Folket*. Copenhagen: Kittendorff & Aagaards Forlag, 1855-1857.

Fabienke, Tine Nielsen and Gertrud Oelsner, eds. *Our best Pieces*. Toreby: Fuglsang Kunstmuseum, 2008.

Frandsen, Steen Bo. *Opdagelsen af Jylland*. Aarhus: Aarhus Universitetsforlag, 1995.

Gelius, William and Stig Miss, eds. *Under samme himmel. Land og by i tysk kunst 1800-1850*. Copenhagen: Thorvaldsens Museum, 2000.

Glarbo, Henny. *En Brevveksling mellem maleren Constantin Hansen og Orla Lehmann*. Copenhagen: Fischers Forlag, 1942.

Grand, Karina Lykke. *Dansk guldalder. Rejsebilleder*. Aarhus: Aarhus Universitetsforlag, 2012.

Guldberg, Jørn. 'Danmark som billede. Naturvidenskab, historie og æstetik i Christian Molbechs "Ungdomsvandringer i mit Fødeland"'. *Udsigt til Guldalderen*. Ed. Gertrud Oelsner and Iben Overgaard. Maribo and Viborg: Storstrøms Kunstmuseum and Skovgaard Museet, 2005. 65-75.

Hegel, Georg Wilhelm Friedrich. *Forelæsninger over historiens filosofi*. Copenhagen: Gyldendal. 1997.

Henschen, Eva et al., eds. *Johan Thomas Lundbye 1818-1848. ... At male det kjære Danmark*. Copenhagen: Thorvaldsens Museum, 1994.

Holten, Susette. 'Et Patricierhjem fra forrige Aarhundrede'. *Berlingske Tidende* (1934-1935).

Howard, Luke, *The Climate of London I-II*. London: W. Philips, 1818-1820.

Hvidberg-Hansen, Gertrud, ed. *Himlens spejl. Skyer og vejrlig i dansk kunst 1770-1880*. Odense and Maribo: Fyns Kunstmuseum and Storstrøms Kunstmuseum, 2002.

Hvidberg-Hansen, Gertrud, Stig Miss and Birgitte Zacho, eds. *Aftenlandet. Motiver og stemninger i dansk landskabsmaleri omkring år 1800*. Copenhagen and Odense: Thorvaldsens Museum and Fyns Kunstmuseum, 2011.

Jacobsen, Signe, ed. *D.G. Monrad: en kunstsamler i 1800-tallet*. Vejle and Nivå: Vejle Kunstmuseum and Nivaagaards Malerisamling, 1992.

Kold, Anders. 'Ej blot af lyst og i ledige stunder: to landskaber af Jens Juel på Thorvaldsens Museum'. *Meddelelser fra Thorvaldsens Museum 1989*. Copenhagen: Thorvaldsens Museum, 1989. 42-53.

Lehmann, Orla. *Falstertalen*. 30 January 1841. Web 16 May 2012. www.danmarkshistorien.dk.

Lehmann, Orla. *Danmark til Ejderen*. 28 May 1842. Web 16 May 2012. www.danmarkshistorien.dk.

Lehmann, Orla. Letter to P. C. Skovgaard, 21 April 1846. Skovgaard Museet.

Lundbye, J. Th. *Et Aar af mit Liv*. Introduction and notes by Mogen Lebech. Copenhagen: Foreningen for boghåndværk, 1967.

Mitchell, W. J. T. 'Imperial Landscape'. *Landscape and Power*. Ed. W. J. T. Mitchell. Chicago: The University of Chicago Press, 1994. 5-34.

Molbech, Christian. *Ungdomsvandringer i mit fødeland*. Copenhagen, 1811/1815.

Nygaard, Bertel, 'Frihed, enhed og historie. Hegelianisme i dansk politisk kultur i det 19. århundrede'. *Slagmark* 50 (2007): 15-29.

Nygaard, Bertel. 'Civilisation, kamp og fremskrift i C.F. Allens *Haandbog i Fædrelandets Historie*'. *Historie* 1 (2009): 35-63.

Oelsner, Gertrud and Iben Overgaard, eds. *Udsigt til guldalderen*. Maribo and Viborg: Storstrøms Kunstmuseum and Skovgaard Museet, 2005.

Oelsner, Gertrud and Ingeborg Bugge, eds. *Thorald Brendstrup. I guldalderens skygge*. Aarhus: Aarhus Universitetsforlag, 2012.

Oelsner, Gertrud and Karina Lykke Grand, eds. *P.C. Skovgaard. Dansk guldalder revurderet*. Aarhus: Aarhus Universitetsforlag, 2010.

Oelsner, Gertrud and Karina Lykke Grand, eds. *Vilhelm Kyhn & det danske landskabsmaleri*. Aarhus: Aarhus Universitetsforlag, 2012.

Ohrt, Nils. 'Historien om et danmarksbillede: P.C. Skovgaard og Møens Klint'. *Møen i dansk kunst*. Ed. Claus M. Smidt. Nivå: Nivaagaards Malerisamling, 1994. 23-44.

Ohrt, Nils. 'En forsmag på Paradiset'. *Udsigt til guldalderen*. Eds. Gertrud Oelsner and Iben Overgaard. Maribo and Viborg: Storstrøms Kunstmuseum and Skovgaard Museet, 2005. 125-137.

Ploug, Carl. Letter to P. C. Skovgaard. 16 August 1854. Skovgaard Museet.

Ritter, Joachim. 'Landskab'. *Æstetiske Teorier*. Ed. Jørgen Dehs. Odense: Odense Universitetsforlag, 1995. 23-50.

Skovgaard, P. C. Letter to Georgia Schouw. 11 June 1850. Skovgaard Museet.

Skovgaard, P. C. Letter to Orla Lehmann. 25 July 1853. Rigsarkivet.

Trap, J. P. *Statistisk-topographisk Beskrivelse af Kongeriget Danmark*. Copenhagen: G.E.C. Gad, 1858-60.

Trap, J. P. *Fra fire kongers tid* 1-3. Copenhagen: G.E.C. Gad, 1966.

Ussing, J. L., ed. *Høyens samlede Skrifter*. Copenhagen: Thieles Bogtrykkeri, 1871.

Vaupell, Chr. *De danske Skove*. 1863. Randers: Nabu Press, 1986.

Wamberg, Jacob. 'Kunstens landskaber. En lille mentalitetshistorie'. *Landskab. Meddelelser fra Ny Carlsberg Glyptotek*. Vol. 7. Ed. Anne Marie Nielsen. Ny serie 7. Copenhagen: Ny Carlsberg Glyptotek, 2005. 9-23.

Wammen, Hans. *Den tomme stat*. Copenhagen: Museum Tusculanums Forlag, 2011.

Warnke, Martin. *Political Landscape. The Art History of Nature*. Cambridge, MA: Harvard University Press, 1995.

Weinwich, N. H. *Maler-Billedhugger-Kobberstiks-Bygnings og Stempelskjærer Kunstens Historie i Danmark*. Copenhagen: Johan Frederik Schultz, 1811.

Notes

1 It should be noted here that the concept of the 'Danish Golden Age' is widespread in Danish art history, where the term is normally used to designate the epoch c. 1800-1850. The Golden Age concept has had its greatest impact on the internal Danish context; the same period is often called 'Biedermeier' in the German-speaking world. In the English-speaking world the term 'Romanticism' is used, and in Denmark the literature of this time is usually referred to as Romantic; but since the subject of this article is a survey of the period's visual-art idiom in Denmark, the term 'Golden Age' is retained here.

2 This mode of thinking found its premises to some extent in ancient Greece. On this, see Damsholt, *Fædrelandskærlighed* 93.

3 In the work of J. C. Dahl (1788-1857) and C. W. Eckersberg, among others, we find a suite of subjects that seem closely related to Molbech's. This is true of several of Dahl's subjects from southern Zealand and Eckersberg's Møn pictures.

4 At first, the National-Liberals were not a true party with a related electoral program, but a group of like-minded people who were united in their struggle for the abolition of absolutism and a democratic constitution. For more on this see Wammen.

5 Among the influential lectures are 'Om betingelserne for en skandinavisk Nationalkunsts Udvikling' [On the conditions for a national art], given on 23rd March 1844, and 'Om national Kunst' [On national art], given in 1863.

6 See Bagge et al. 295-296. It should be remarked that Høyen's name featured on a list of candidates who were presumably willing to be elected.

7 Skovgaard was not the only one to enjoy the patronage of the stockbroker Aggersborg, who bought several works by other contemporary artists. See Holten.

8 After a visit to the top of Goose Tower Molbech wrote: 'a region where harbour and land and forest in the closest union and most perfect harmony form a glorious picture, in which it seems all of Denmark's natural beauty is reflected.' Quoted here from Guldberg 70.

9 It should also be mentioned that the Goose Tower was the object of one of the first heritage preservation cases in Danish history. As part of the work of the Royal Commission for the Preservation of Antiquities, the Goose Tower, which until 1808 belonged to a Mrs. Rejersen, was then transferred to the Crown as a protected building.

10 There are several indications of how the Goose Tower became part of the cult of the past that typified the age, inspired not least by Herder's linkage of culture, language and history. In 1816, the poet Adam Oehlenschläger wrote of Valdemar's Tower, as it was then called: 'In the dusk we walked out to Valdemar's Tower; and it pleased me so see this ancient stone ruin, the oldest in the kingdom, in the twilight, looming like a great black giant while the present was hidden in a light mist. One can walk up into the tower. The previous owner has presented it to the Crown. If it were mine I would have a chamber up there. There, Snorri Sturlusson, and Saxo Grammaticus, and the old heroic ballads, would lie in beautiful vellum bindings; and there I would read them, and drink beer from a Golden Horn in the afternoon." Quoted from Oelsner and Overgaard 99.

11 A motif we also find in P. C. Skovgaard's work, in his *Bleaching ground beneath large trees*, 1858. Oil on canvas, 44.5 x 36.5 cm. Statens Museum for Kunst, inv. KMS3772.

12 Hegelianism has as a rule been understood in relation to Johan Ludvig Heiberg, Hans Brøchner and Hans L. Martensen, but as Bertel Nygaard shows, National-Liberal politics were based on a Hegelian foundation. On this, see Nygaard 15-29.

13 Letter from Constantin Hansen to Orla Lehmann, dated 9 July 1855. Skovgaard had just come home from his long journey abroad and had been commissioned to paint the large *Beech wood in May* for Martin Hammerich. The letter is reproduced in Glarbo, 96-97.

14 In 1855-1857 the geographer Edvard Erslev published *Den danske Stat, en almindelig geographisk Skildring for Folket*, in which he reviews the distinctive characteristics of the Danish landscape in a highly political manner. Erslev also discussed the Danish climate, giving us to understand that in summer the weather is capricious and mutable, and that cloudless days are rarities in Denmark. It is characteristic of painters from the Danish Golden Age that they take a detailed, accurate approach to the given weather conditions; they presumably also drew inspiration from the English meteorologist Luke Howard who in 1818 published the two-volume work *The Climate of London*, in which he drew up a systematic account of various cloud types which is used to this day, with a few variations and additions. For more on this, see Hvidberg-Hansen, *Himlens spejl*.

15 One might wonder about the plants on the ancient barrow, since the Antiquities Commission was tasked with preserving and protecting the country's many ancient monuments from exploitation. As far as I can see, though, there is no doubt that this is an ancient burial mound, marked by the telling stone circle.

16 The next year, 1847, Høyen backed up Lehmann's ideas by founding the Society for Nordic Art.

17 Discussed in Allen. The representatives of the Danish artists were hardly coincidental: they all belonged to the group of artists whose work Orla Lehmann, through purchases and commissions, incorporated in his private collection. Besides the above-mentioned works by Skovgaard and Constantin Hansen, Lehmann owned at least two works by Jørgen Sonne; details follow. *Midsummer Eve. Peasants who have lit a bonfire on a burial mound dancing around the fire*, 1860. Oil on canvas, 103.5 x 143.5 cm. Statens Museum for Kunst, KMS 3780. *The Battle of Fredericia, 6th July 1849. After the enemy batteries have been taken and the battle won, during the pursuit the Danish troops come upon an enemy artillery park at Heise Inn*, 1849, [watercolors]. Pencil on paper, 320 x 780 mm. Museum of National History at Frederiksborg, inv. A4939.

18 Letter from D. G. Monrad to Emilie Monrad, dated 29 January 1848, repr. in Bagge et al. 38. The rejected picture mentioned is presumably a view from the Jægersborg Deer Park, discussed in Jacobsen 42.

19 See P. C. Skovgaard, *Prospect of Møn's Klint*, 1852. Oil on canvas, 126 x 190 cm. Fuglsang Kunstmuseum, Toreby. In *Dansk guldalder. Rejsebilleder*, Karina Lykke Grand also includes a discussion of the significance of the infrastructure for the travel patterns of these artists.

20 The column metaphor could profitably be researched in relation to the period's interests in antiquity and its democratic forms of government. Unfortunately there is no room for this analysis here.

21 In the years between 1840 and 1842 Bulbjerg hosted the so-called Bulbjerg Rallies, which were inspired by Steen Steensen Blicher's Himmelbjerg Rallies.

THIS TIME AS ROMANTIC FICTION

Monarchism and Peasant Freedom in the Historical Literature of B. S. Ingemann 1824-1836

LONE KØLLE MARTINSEN

[ABSTRACT]

This article examines the relationship between the monarchy and the people as represented by one of the foremost Danish Romantics, the poet B. S. Ingemann (1789-1862), in the historical literature he published between 1824 and 1836. It argues that what was slowly becoming a master narrative in the years when Ingemann wrote his Danish history, the so-called 'myth of an original peasant's freedom', is also inherent in Ingemann's novels and poems. Drawing on the literature of the Danish historian Peter Frederik Suhm, Ingemann embraces and 'recycles' the idea that historically an ancient constitution existed in Denmark to ensure that the peasant was on equal political terms with the nobility and the clergy. No decision could be made without the consent of the commonality. The article stresses that this idea has had an enormous impact on Danish society, both as a cultural indicator and as an actual political tool, not least in the crucial years following the French Revolution.

.

KEYWORDS *B. S. Ingemann, Post-Napoleonic Era, Romantic Fiction, Danish Historiography, Monarchism, Myth of an Original Peasants' Freedom.*

Denmark 1796

En Dag saae han en Marionet-Farce, der blev spillet af nogle omreisende Gjøglere i en Bondegaard. Der blev snakket en hel Del med grove og pibende Stemmer, som han ikke forstod – der var megen Tummel og Skrigen. Endelig blev der opreist et Stillads med en lille Træmaskine paa Bræderne, og under Larm af Trommer, Piber og Skrig blev der hugget Hovedet af to kronede Trædukker. Det var Tidsalderens største Tragødie, der her var bleven til en Leg for Børn og Almuesfolk, som loe og morede sig derover ret lystigt. At det dog har gjort et andet Indtryk paa den lille forbausede Tilskuer fra Præstegaarden, og at han forud maatte have opfattet nogle Forestillinger om de Rædselsbilleder, man her legede med, synes klart, medens han endnu over 60 Aar derefter ikke har forglemt den uhyggelige Klang af hine kronede Trædukkehoveders Rullen paa Fjællebodbræderne.[1] (Ingemann, *Levnetsbog I-II* 91)

This childhood memory is recounted in the memoirs of the popular Danish writer and poet Bernhard Severin Ingemann (1789-1862). The anecdote took place on

LONE KØLLE MARTINSEN, Postdoctoral fellow at SDU
Aarhus University Press, *Romantik*, 01, vol. 01, 2012, pages 103-122

a peasant farm on the rural island of Falster in the south of Denmark. On this farm, only a few years after the actual historical event yet geographically remote from its original location, the French Revolution had been re-enacted. A theatre group had arrived at a small, sleepy village somewhere on the cold, Nordic periphery of the European continent. In this spot, transformed into the Place de la Révolution, actors had portrayed the cruel fate of Louis XVI (1754-1793) and his queen, Marie Antoinette (1755-1793). These events were among the most significant of the French Revolution: the imperious King and his Queen, sentenced to death by their own people during those momentous days of January and October 1793. On that day in Denmark in 1796, the young Ingemann, only seven or eight years old, vividly experienced those powerful events which apparently gave him what Stephen Greenblatt calls 'a touch of the real' (21).

Evidently, neither this kind of historical event nor its re-enactment pleased the young Ingemann. The description of how, as an adult, he would still recall with a shiver the ugly noise of the wooden puppet heads rolling on the stage perfectly demonstrates his strong dislike of the gory outcome of the French Revolution, be it as a historical event, a theatrical play or a vivid childhood memory.

The French Revolution was, as the English poet P. B. Shelley would later put it, 'the master theme in the epoch in which we live' (504) and had a stupendous impact all across Europe. Significantly, Ingemann opens his earliest life story by placing his very personal experience within this context (Ingemann, *Levnetsbog I-II* 329). From his later account, we learn that every Friday people would gather to hear the news from France as the postman delivered the latest newspapers from Copenhagen (Ingemann, *Levnetsbog I-II* 90). From Paris to as far as the Danish island of Falster, the famous battle song La Marseillaise was sung. Having evolved into a lively and entertaining ditty, it was well-suited for festive occasions around Danish dinner tables (Ingemann, *Levnetsbog I-II* 106). Ingemann compares it to songs written by the Danish composer Thomas Thaarup (1749-1821) and concludes that these songs also capture the idea of freedom and humanity, but unlike their French counterpart, they do so only in a peaceful manner (Ingemann, *Levnetsbog I-II* 92). Ingemann believed that what happened in France was a violent tragedy, whereas the liberation of the Danish people had been achieved by peaceful means (107). He was a reformist, not a revolutionary. If the French Revolution was a rough and bloody model for democracy, Ingemann was convinced that its Danish counterpart avoided the mistakes made by the French by carefully considering its pitfalls. This has become a dominant idea in Danish historiography, where it is commonly held that the Danish monarchy managed to restore itself in the aftermath of the French Revolution by apparently absorbing and implementing the Enlightenment in its own (Nordic) way (Sørensen and Stråht 7). In short, the understanding is that between 1788 and 1814, the Danish Kingdom underwent several reforms reminiscent of those introduced during the French Revolution, albeit in a nonviolent and peaceful manner and under monarchical rule: 'In many respects this Northern European monarchy personified the ideals of the Enlightenment thinkers' (Østergaard 28). Whether the King was aware that the political system needed reformation, or whether he simply had no choice but

to accept the reforms remains an open question. It seems, however, that the Danish absolutist monarchy was sensitive to public opinion. In historiography, this is what is characterized as 'opinion based absolutism' (Seip).

The abovementioned childhood anecdote exemplifies the general perception of the French Revolution central to Danish historiographical thought. Its location – a farm – becomes an almost iconic setting due to the myth of the so-called 'original peasants' freedom', which was slowly becoming the standard narrative in the years when Ingemann produced his voluminous tomes on Danish history.[2] The reading of Ingemann's works presented in this paper is inspired by the hermeneutic practice known as New Historicism.[3]

The Historical Literature of B. S. Ingemann

B. S. Ingemann's historical writings about medieval Denmark and its kings were published between 1824 and 1836. They comprise the poem *Valdemar den Store og hans Mænd* (1824) [Waldemar the Great and his Men], the historical novels *Valdemar Seier* (1826) [Waldemar, surnamed Seir, or the Victorious], *Erik Menveds Barndom* (1828) [The Childhood of Erik Menved], *Kong Erik og de Fredløse* (1833) [King Eric and the Outlaws], *Prinds Otto af Danmark og hans Samtid* (1835) [Prince Otto of Denmark and his Time], and finally the poem *Dronning Margrete* (1836) [Queen Margaret I].[4] These pieces were not immediately translated; in some cases, more than ten years elapsed between their original publication in Danish and their translation into another language. In most cases Ingemann read and approved the foreign translations, often engaging in enthusiastic letter exchanges with the translator. It therefore makes good sense to use these later translations, primarily because of their authenticity. Only the first poem in the history, *Valdemar den Store og hans Mænd*, was never translated into another European language, although passages from the poem appeared in English review magazines during the first half of the 19th century (Black, Young and Young; Cocrane; Milligan).

Traditionally, Ingemann's historical prose pieces have been considered naive and simple, their loyalty to the Danish monarchy old-fashioned. For generations, it has been commonplace to ridicule them as substandard popular literature and poor historical writing, ever since the contemporary critic and historian Christian Molbech (1783-1857) laid the ground for a negative reception of them when they were first published (cf. Molbech, 'Bidrag', 'Kritiske' 260, 'Erik'). At the time when Ingemann was creating his historical fictions, history was slowly becoming a professional and scientific subject in Denmark. One of the architects of this development was none other than Molbech himself, who established himself as an authoritative expert on the new historical science by founding the *Danish Historical Journal* in 1839 (cf. Molbech, 'Om Historiens'). Molbech pursued a persistent line of criticism against Ingemann's pieces, dedicating almost fifty pages to a thorough, almost meticulous critique of the author's first Danish historical novel, *Valdemar Seir*. Several other literary and historical magazines refused to print his review, suggesting that even his contemporaries considered his judgement to be harsh.

Later, another influential literary critic, Georg Brandes, re-visited and elaborated on Molbech's critique. As the towering figure of the so-called moderne gennembrud [Modern Breakthrough] of Scandinavian literature, Brandes denounced Danish Romanticism, with which Ingemann's name was synonymous.[5] According to Brandes, Danish Romanticism had created an unrealistic, exaggerated form of national self-esteem. This nationalism was introverted, closed off from the main currents of European intellectual life, and, Brandes claimed, it had lost touch with the real world. Ingemann's pieces were considered not to deserve the name of literature nor of historiography. After Brandes' onslaught, critics would shun Ingemann's historical literature for nearly forty years until 1922, when the scholar Kjeld Galster (1885-1960) published a book on Ingemann's historical novels, continuing Brandes' line of criticism (cf. Galster).

So far, Ingemann's historical pieces have been read without contextualization in a wider societal and political framework; but in the context of (1) the history of mentalities and (2) the cultural history of Denmark in the Restoration period, they are useful resources with which common patterns of ideology and intellectual thought can be reconstructed – as is proposed here. They will, in the following, be read as Romantic, historiographical fictions. Ingemann's works contain a full-blown synthesis of Danish medieval history calibrated so that it mirrored his own age.

Ingemann conceived his historical works as literary pieces that 'form a series of historical delineations' directly related to each other.[6] Moving from a time of prosperity turning to decline, then prosperity again, the pieces follow a cyclic notion of time and represent the longest coherent literary work on Nordic history. They cover a large part of Danish, and to some extent Nordic medieval history and would amount to over 3,000 'standard pages' today. The work describes approximately 250 years of history, from the wars shortly before the reign of Waldemar the Great (1131-1181) in 1150 up to the political union of the three Nordic countries (Denmark, Sweden and Norway) that was created in the Swedish city of Calmar in 1397 under the rule of Queen Margaret I (1353-1412). On reading the pieces, there can be no doubt that Ingemann was in favour of the Danish monarchy. The fact that each piece is devoted to monarchs of ancient Denmark earned them the nickname 'Kongebøgerne' [The Books of Kings].

Each piece includes detailed descriptions of characters as well as events. To a certain extent, all the characters in Ingemann's pieces are historical ones: the character of Lady Helena in *Valdemar Seir* (1826) is known only from an old medieval song, though more is known about King Waldemar himself. More than 120 historical figures are introduced in this novel alone – a considerable character gallery. The composition of the cycle is unique in that it creates a distinctive universe by combining sources from archaeology, history, literature, law, folksong, legends, myths and Greek tragedy. It takes a well-informed reader to notice all the references to classic literature. Besides the representatives of royalty, we also find members of the commonality in characters such as the orphan Carl of Riise, Morten the Cook, Dorothy Brushbom, Henner the Frisian and the peasant Ole Stam. These are all popular protagonists of the narratives and they are often

given more narrative space than the monarchs, their patriotic and monarchist deeds every bit as important, if not more so. Using the form of fiction to communicate cultural nationalism (Leerssen 13ff), Ingemann merges ancient myth and vivid descriptions of heroic acts. One example can be found in the story of Carl of Riise, who goes crusading with Waldemar the Victorious (1170-1241). During the battle at Lyndanisse in the year 1219, he grasps the Danish banner, the Dannebrog, as it falls from the sky:

'The Sign! The Sign! Salvation from Heaven,' he shouted, and sprang up, half frantic with joy. The banner descended on the summit of the hill; he ran and seized it; then waved it over his head with triumphant enthusiasm. The sun shone full on the white cross; and the tall form of Carl of Riise, in his well-known armour, was instantly recognised by the Danish host. The helmet had fallen from his head – His long, golden locks flowed in the breeze, and, as he thus stood, he resembled the picture of the Archangel Michael, as he is sometimes represented, with the banner of victory in his hands, and the vanquished Demons under his feet. (Ingemann, *Waldemar Surnamed Seier* [Chapman, 1841 108])

The Archangel Michael is one of the only Biblical figures mentioned in Ingemann's writings. He is a part not only of Christian, but also of Jewish and Islamic traditions. Michael is the field commander of the Army of God, whereas Carl is in the army of the Danish King serving the Danish monarchy. By likening Carl to the Archangel, Ingemann insists on a special connection between religion (Christianity), nation (Denmark), the people (the Danes) and the monarch (the Danish King). At the same time, Carl is described as an ordinary boy with friends and sweet dreams of Rigmor, the maiden he will eventually marry. G. W. F. Hegel speaks of this as a 'necessary anachronism' with regard to the identification processes of ordinary people (277-279). In other words, the manner in which fictitious characters speak and express their feelings, ideas and accomplishments can illuminate the foreign (the past) in the known (the present).

Traditionally, Ingemann's prose pieces are defined as belonging to the genre of the historical novel, but Ingemann himself thought of them as historical romances, i.e. pieces about the North's glorious past. He considered himself part of a long line of great ancient poets (Ingemann, *Prinds Otto* xii). Furthermore, he compared his works to the sagas and 'people's chronicles' [almue krøniker], thereby indicating the relationship between common people and Danish history as exemplified in the character of Carl. Ingemann undoubtedly pursued a well-planned programme when writing his Danish history, which it would take him fourteen years to finish (Vogelius 52). With the dawn of popular culture in post-revolutionary Europe, Ingemann was instrumental in making a certain ideology the defining basis upon which the Danish state was built and conceptualized. As the Danish historian Jens Chr. Manniche has remarked, the fate of Denmark is connected to a special alliance between the King and the people; a historical interpretation of Denmark as a nation; and the Danes as a people. This unique connection dominated the bourgeois historical consciousness in Denmark in the period from 1807 to 1849 (Manniche 261).

Following the French Revolution and the revolutionary wars from 1791 on-wards, the Kingdom of Denmark was deeply and helplessly involved in the complicated re-negotiations of inner European boundaries. When diplomacy failed, Copenhagen was attacked by the British fleet in 1801 at Slaget på Rheden [The Battle of Copenhagen]. A few years later, in 1807, a catastrophic attack known as the Bombardment of Copenhagen, also mounted by the British forces, severely damaged the Danish capital (Due-Nielsen and Feldbæk). As a consequence of the Napoleonic wars, Denmark had to give up Norway at the peace negotiations in Kiel in 1814, and when an agricultural crisis bankrupted the State that same year, the former Danish empire was left vulnerable and fragile on the Northern fringe of the European continent.

Ingemann's historical literature shares with poets such as Walter Scott, Alessandro Manzoni and Alexandre Dumas specific didactic purposes amalgamating common patterns of European experiences in the early 19th century. In the wake of the Napoleonic wars and the redrawing of Europe's boundaries, there was a general tendency in European Romantic historiography to identify a glorious, long bygone golden age of the nation and the fatherland: an age of heroism and virtue useful in turbulent times. By looking back to ancient times, historians, poets and novelists found both inspiration and comfort, which helped them to deal with current history. Thus, historical experiences cultivated and encouraged national Romantic movements and forged cultural nationalism all across Europe. Ingemann's historical literature is a response to historical catastrophes as seen from a Danish perspective. The opening lines of his first poem *Waldemar the Great and his Men* (1824) sets the scene for his didactic history class:

> 'Tis Epiphany Night, and echoes a sound
> In Haraldsted Wood from the hard frozen ground.
> Loud snort three steeds in the wintry blast –
> While under their hoof-dint the snow crackles fast.
> On his neighing charger, with shield and sword,
> Is mounted a valiant and lofty lord;
> A clerk and a squire his steps attend,
> And their course towards Roskild the travellers bend:
> But distant is Denmark's morning!
> (Ingemann, *Waldemar the Great and his Men* [Cocrane 134])

Archbishop Absalon Hvide (1128-1201) is on his way back from Paris, accompanied by the historian Saxo Grammaticus (1160-1208) and the old poet and Squire Arnold, who is not a historical figure but an invention of Ingemann's. Arnold is neither learned nor a great warrior, but he represents the people and has an inner wisdom and a great faculty of judgement. Hvide is said to have founded Copenhagen in c. 1160. In the poem, he is riding with his friends towards Roskilde to save Denmark having received news that the country is under threat. One of the oldest chroniclers of Danish history, Saxo Grammaticus is the source of much ancient Danish history. His *Gesta Danorum* documents a very ancient part

of Denmark's history,[7] which proved crucial in the 19th century when antiquity legitimized nationhood. Saxo's deep affiliation with the past is made clearly noticeable: '[H]e seemed as though he saw and held converse with the great spirits of former ages, and as if he himself belonged to another world and to another time' (Ingemann, *Waldemar surnamed Seier* [Chapman, 1841 4]). Ingemann describes the *Gesta Danorum* as an important and precious gift bestowed upon the Danish people. On his deathbed, Saxo speaks the following words:

'but, ere I can rest in peace,' he continued, as he exerted himself to reach the heavy package of books to the Bishop, 'I must deposit in thine hands my legacy to Denmark's people and their king: I mean my Danish History.' (Ingemann, *Waldemar surnamed Seier* [Chapman, 1841 61])

Saxo is not only a person of flesh and blood whom Ingemann made a great effort to portray well, but he was also one of the authorities from which Ingemann drew his knowledge. In the Danish foreword to his last historical novel, *Prince Otto and his Time* (1836), he furthermore names Arild Huitfeldt (1546-1609) and Peter Frederik Suhm (1728-1798) as his main sources.

In this paper, I shall focus on the historian Peter Frederik Suhm, as Ingemann's 19th-century history writing drew heavily on his histories. I will illustrate how, by inscribing his literature in a common Danish historiographic narrative, Ingemann contributed to the establishment of Danish identity in the 19th century. The key issue in this context is the relationship between the king and his people.

Historiography in the Time of Ingemann

Peter Frederik Suhm was a prominent man in Copenhagen in the closing decades of the 18th century. He was well educated and enormously prolific as a history writer. When Ingemann wrote his Danish history, Suhm was already considered the greatest historian of his time. In particular, his sixteen-volume work *History of Denmark*, written between 1788 and 1799, made him a common reference point in academic circles. He maintained his position as the country's leading historian until the national liberal historian Carl Ferdinand Allen published his *Handbook in Danish History* in 1839. Suhm, who was very liberal for his time, was in favour of the abolishment of censorship, which became official policy in 1770 under the de facto reign of the German Johan Friedrich Struensee (1737-1772). Officially, Struensee was personal physician to King Christian VII (1749-1808), who suffered from the effects of mistreatment and severe mental illness (Lange). Struensee took advantage of the situation by gradually usurping the King's power until he could assume the position of Cabinet Minister. As a man of the Enlightenment, Struensee was progressive and tried to reform several important issues in Danish society, such as freedom of the press (Laursen, 'Spinoza' and 'David Hume'). Eventually, he lost favour with the Danish people, and the court turned its back on him. On 16 January 1772 he was arrested for treason, specifically for planning

a countercoup from within the court. Ironically, the abolishment of censorship had contributed to the public opinion turning against him. On top of every-thing, Struensee had an affair with the Danish Queen Caroline Mathilde (1751-1775). After a brief trial, he was tortured and executed in Copenhagen on 28 April 1772 in an especially barbaric and cruel manner (he was put on the wheel and the rack). Counterfactually speaking, if Struensee's tour de force in Danish political society had been successful, Denmark would have become one of the most pro-gressive states in Europe.[8] However, matters more or less returned to the former status quo and among other things, censorship was re-established.

Suhm, decidedly in the minority within the Danish Court, responded posi-tively to Struensee's progressive ideas. He was well aware of the crisis the Danish monarchy was facing. In a famous letter 'To the King' [Brev til kongen] (Suhm, vol. 16: 3), handed to the new Prime Minister Ove Høgh Guldberg (1731-1808) on the morning after the coup d'état against Struensee, Suhm urged Guldberg to introduce a new law ensuring the enhancement of the people's civic rights. The letter subsequently made Suhm known all over intellectual Europe and earned the King a congratulatory missive from the ageing Voltaire. Suhm's proposal was, in fact, a re-draft of constitutional law, since it endorsed a limited monarchy. Al-though the proposal was rejected, Suhm revised the idea of an original peasants' freedom into a new and updated version, which would soon enter the canon of Danish history.

Suhm believed that in heathen and mythical times, an ancient constitution allowed peasants to elect and legitimize the monarchs alongside the nobility and other high-ranking people. In fact, no decision could be made without the consent of the commonality. The peasant was on an equal political footing and could own property; he was a free man. This idea of peasant freedom was based upon civil liberties such as freedom of speech and the rights to vote, to due pro-cess and to ownership of property. Most importantly, there existed a special bond between king and subjects, since the in ancient times the king used to live among hunters and warriors himself as a member of the commonality which, for orga-nizational purposes, needed to choose a leader. The legal function of this ancient society was carried out at a thing-stead. This term derives from the Old Norse word þing, meaning 'assembly' or 'meeting'. Later, the word came to denote the act, deed, or matter discussed at the 'thing-stead', namely the thing in question. Its modern-day Danish form 'ting' is also preserved in the names of the Danish, Icelandic and Norwegian parliaments (folketinget, altinget and landstinget, re-spectively). The thing-stead has always been defined as a political and legal space where in ancient, legendary times, the decisions of the people were carried out and disputes were settled in accordance with the law (Skovgaard-Petersen 29-30). Today, the term survives in the denotation of an archaeological site where, char-acteristically, one large flat stone marks the centre of a circle of upright stones and serves as a platform for speakers. In olden days, all decisions among citizens are believed to have been made at such places. It is the oldest known institu-tion in which the commonwealth convened to rule in legal matters.[9] Freemen, among them innumerable peasants, would presumably assemble and form the

fundamental unit of government and law at local, provincial and sometimes national thing-steads located in the open air across the country. During the 13th and 14th centuries, the prerogatives of these assemblies were gradually eroded by the increasingly powerful groups of bureaucrats and nobles. The monarch lost his special alliance with the peasants, who in turn would soon become prisoners in a restrictive feudal system. Once freeholders, they were soon degraded to mere tenants [fæstebønder] in large numbers (Paludan 1). As Suhm writes, 'Instead of many thousands of independent farmers, one now had a few bishops, abbots and priors, and a few hundred lords [herremænd], who had turned the tillers of the land into serfs' (Suhm, vol. VIII, 336). Thus, in Danish history, the idea of a lost peasants' freedom is inextricably linked to the emergence of feudalism and its consequences.[10]

In a European 18th-century context, the myth of an original peasants' freedom has its origins in the writings of Montesquieu, who wrote of a Nordic liberty (*L'ésprit des lois*, 1748), and the German philosopher Justus Möser (*Osnabrückische Geschichte*, 1768). Montesquieu gave the myth its classical formulation which is an attempt to return to early, fabled history writing and its ancient ideas of freedom in new contexts (cf. Kidd; Leerssen 39). In a larger framework of historiography, we will have to turn to the Roman history writer Publius Cornelius Tacitus (AD 56-117), who published his influential *De origine et situ Germanorum* in 98 AD. Tacitus saw the misdemeanours and shortcomings of the Roman Empire reflected in the cultural customs, laws and state of the Germanic tribes of his Germania. The virtues of the Germanic tribes and their primitivism were celebrated as a polar opposite to Roman decadence. Tacitus described depravity and immoral virtues as a consequence of the absolute powers of kings, said by some scholars to have caused the fall of the Roman Empire (Leerssen 71). In a Nordic context, the virtues of the tribal, ancient people were combined with the rule of a sovereign, a concept Suhm embraced and developed with reference to Danish history.

We know that Suhm's understanding of the peasantry and its freedom was also inspired by an earlier Danish historian, Hans Gram (1685-1748). In 1746, Gram claimed that the very word 'peasant' [bonde] had developed negative connotations as a consequence of the loss of the civil rights originally enjoyed by the peasantry (265). In 1771, Suhm would more or less adopt Gram's view of the peasantry as witnessed by his claim that until 1100,

Det ord Bonde var I de Tider et hæderligt navn, som Husbonde endnu vidner. De vare ei foragtelige og usle, som de, vi nu omstunder kalder Bønder, men de vare at ansee som vore Herremænd, kun at de vare mange flere i Tallet, og havde i visse Maader herligere rettigheder, i det de med Adlen eller de fornemmere udvalgte og stadfæstede vore Konger. (Suhm, vol. VIII, 120)[11]

This definition was soon to gain crucial significance among Danish historiographers. Ever since the death of Suhm it has been a common pursuit for Danish historians (and, interestingly, poets) to restore, in their writings, the lost civil liberties of the Danish peasantry. How and when this came about has been sub-

ject to numerous historically and geographically conditioned speculations. Similarly, interpretations depended on how conveniently the myth tied in with the current political situation. With the abolishment of serfdom in 1788, the myth of an original freedom was given even more credit. In Danish historiography, it has been emphasized that the agricultural reforms of 1788 were primarily the work of the Danish King, Frederic VI (1768-1839), who turned against the Danish nobility in favour of the peasants' interests. The agricultural reforms gave rise to what in Danish historiography has been called 'The Farmers' Interpretation', i.e. history writing focusing on peasants' rights and history (Kjærgaard). Other historical events which have been merged with the peasant myth in the course of history are the establishment of the Consultative Provisional Assemblies in 1831 and the Constitution of 1849. As an instrument of powerful cultural significance, the peasants' myth has shown enormous political potential in Danish society, eventually becoming an actual political tool. It has been adjusted a number of times in order to fit better with the given historical situation. However, the bond between sovereign and peasant was never seriously threatened in a broader perspective, not even in the aftermath of the French Revolution. On the contrary – between 1792 and 1797, at the height of the French Revolution, a national monument known as the Freedom Monument [Frihedsstøtten] was erected in Denmark, commemorating the freedom of the Danish peasants (Flacke 91).

The Danish historian Henrik Horstbøll has conducted extensive research on Danish monarchism within the framework of the French Revolution and Enlightenment (cf. 'Enevælde', 'Natural Jurisprudence'; Horstbøll and Østergaard). He concludes on several occasions that the Danish versions of monarchism from the Enlightenment onwards have had a somewhat rigid outlook. In a piece that was co-written with the scholar Uffe Østergaard, the Lex Regia [Kongeloven] (1665), the written constitution of Danish absolutism, serves as an interpretative starting point for this argument (5). The scholars contend that central elements from the writings of the Dutch jurist Hugo Grotius (1583-1645) were singled out and passed as law; they argue convincingly that Danish absolutism was, in fact, legitimized through the international language of natural law (cf. also Fabricius; Horstbøll, 'Natural Jurisprudence'; Olden-Jørgensen). From this time onwards, explaining freedom in terms of 'justice' gradually became common practice. Samuel Pufendorf's *De Jure Naturæ et Gentium* (1673), a definitive work of natural law and theory, had a particularly profound influence on Danish intellectual thinking. The protection of citizens through laws protecting both the individual and the public good was independent from the formal structure of government (Horstbøll and Østergaard 5). This line of argument was further developed by Danish early modern writers such as Ludvig Holberg (1684-1754) and Jens Schielderup Sneedorff (1724-1764) who, it is claimed

laid the foundations for the ideological political bulwark which so successfully prevented the collapse of the absolutist political culture under the pressure of revolutionary demands for freedom during the period of the French Revolution. (6)

As a Romantic writer, Ingemann has always been said not to embrace politics in his writing. However, in his popular version of Danish history he evidently adopts the myth of an original peasants' freedom and thus perpetuates in a popular form an idea that political thinkers had developed as a useful model to defend Danish monarchism. The myth circulates in his writings alongside popular representations of the monarchy and considerations of a law-based Danish monarchy. Ingemann's history offers a theoretical framework in which the people can be regarded as the 'true sovereign'. This framework implies and insists on an original freedom in which the people – i.e. the peasants – actively participated in affairs of the state. This complex and fictitious historiographical constellation will be investigated in the next section.

The Representation of the Peasant Myth in Ingemann's History

The myth of an original peasants' freedom is not made explicit in Ingemann's text. As a reader one needs to be well-informed about Danish and Nordic historiography in order to uncover this myth beneath the layers of national Romantic representations of kings and fatherlands, and the fascination with medieval knighthood. The myth is never broached via, say, allusions to the manner in which kings perform their duties. Not until later historical periods can common patterns of mentalities be identified, and their labels are, of course, also of a later date. Obviously, Ingemann would have had no inkling about the context in which the myth would circulate in future generations.

It is commonly accepted that, within the genre of the historical novel, the notion of Romantic medievalism emerged in the wake of the French Revolution.[12] Historical novels are often referred to as 'romances', indicating their penchant for medievalism, chivalry and romantic love, and a deep fascination with the Middle Ages. As such, Romanticism is a Janus-faced movement in that it can effectively serve conservative as well as radical ideologies. Ingemann's usages of Romantic medievalism are all centered on the symbolism of the thing-stead: a place where a primitive democracy was located in the medieval villages all across Denmark, where liberties were guaranteed by the contractual relationship between the people and the elected, popular monarch.

In *Waldemar the Great and his Men* (1824), we learn that the peasant Ole Stam used to speak at the thing-stead until tyrants came to power. Now Stam has to live as an outlaw because of his beliefs, or he will be killed by the new regime. In the following, we hear a conversation between him and Absalon, Saxo and Arnold who have taken shelter in his hiding place out in the forest:

> "Have you not heard of Ole Stam?"
> The peasant then replied,
> "I've spoken on the Ting, and am
> In battle's danger tried
> I back'd against the tyrant Sven

The customs of our land,
When coward, crouching Seelandmen
First stoop'd to his command.
While wealthy, thus I rais'd my voice
And, outlaw'd, still will say, –
A sov'reign, not the nation's choice,
Slaves only can obey. ... "
(Ingemann, *Waldemar the Great and his Men*
[Black, Young and Young 71])

Here, the basic ideas of the original peasants' freedom are borne out: only slaves, not freemen, can obey a tyrant, implying that the monarch must be elected by the commonality. Most importantly, it becomes clear that as a formerly wealthy owner of land, Ole used to have the right to speak at the thing-stead. In accordance with the peasant myth, property was associated with active participation in the political sphere. In these lines, the reader is offered the first glimpse of what can be construed as the myth of an original peasants' freedom in Ingemann's history. Ole is a prominent figure throughout the poem, fighting to restore the righteous King to the throne as well as to secure his own ancient rights. In one verse before Ole slays the tyrant king (yet another right according to the peasant myth), Ole refers to an ancient constitution in which peasants were equals with and advisors to their King:

Bonden taler fra høien Sten
"Dankonning agted det ei før ringe
Med Dannemænd at Raadslaa på Tinge
Nu, som i hendenske Tid igjen
Maa Sværdet skifte blandt Danske Mænd."[13]
(Ingemann, *Valdemar den Store og hans mænd* 62)

Again, the stone represents the thing-stead. The line 'The sword must move among Danish men' alludes to the ancient status of the monarch as an equal amongst other warriors. When, in *Valdemar den Store og hans Mænd* (1826), the king has been taken prisoner, the situation is described as follows:

All business was at standstill; sadness and gloom reigned in the peasant's hut as well as in the lordly castle. The women and children wept, and the men assembled in the streets as well as in the Council Chamber,[14] to consult, not about the choice of a new sovereign, nor how the land should be governed during this emergency, but only how to obtain vengeance and the King's release, in the event he was still alive. (Ingemann, *Waldemar surnamed Seier* [Chapman, 1841 219-220])

Evidently, the core issue in these lines is not the peasants' freedom but rather the problem of how to release the captured king. However, we also learn that when the people meet at the thing-stead the procedure is for them to consult,

govern and choose their kings. It could be argued that the peasants' freedom merely serves as a backdrop against which the history of great ancient kings is narrated. The thing-stead is important as a symbol of the old, legitimate rights of the people, and in every single piece of Ingemann's history, crucial action unfolds at these important law-sites, e.g. those in Nyborg, Ringsted and Viborg. It is here that the people vest the king with legitimate authority on behalf of the state. This theory of justice is omnipresent in Ingemann's literature. Moreover, freedom of expression is also valued: 'In Denmark, God be praised, thoughts, and their rudest expression, are still free, when the law of the land is not transgressed' (Ingemann, *The Childhood of King Erik Menved* [Kesson 30]). At the Dana Court in the village of Nyborg,[15] the following words are spoken: 'Not only were the vassals of noble extraction, the prelates and the bishops of the kingdom admitted, but also the peasants and the burghers' (Ingemann, *The Childhood of King Erik Menved* [Kesson 79]). As evidenced by the following passage, set at Dana Court, Ingemann also recounts the medieval decline of the ancient rights of the peasantry (as historiography has it in the tradition of Suhm):

As soon as Mass was over, the knights and ecclesiastics proceeded through the crowds to the long salon of the palace, where the Dane-Court was now held, instead of in the open air – an old custom, which, by degrees, fell more and more into disuse, much to the discontentment of the people, because by this means, it sought to exclude the burghers and peasants from taking part in the proceedings of the Danish parliament. (Ingemann, *The Childhood of King Erik Menved* [Kesson 70])

In Ingemann's history these are the darkest times; but thanks to the efforts and character of the Danish people the righteous king reconquers his kingdom, as chronicled by the last poem in the history, in which the Danish Queen Margaret I becomes the official representative of the three Nordic countries, Denmark, Norway and Sweden, following the meeting in Calmar.

Ingemann's description of the people is equally important for understanding how the myth of an ancient constitution of the free peasantry works in his literature. His depiction of commoners is an exemplary representation of the Romantic idea of the people as the true backbone of the country. This idea is illustrated in the following lines in which the singer Arnold appears alongside Saxo Grammaticus and Archbishop Absalon:

> He boasts no lore – the dust of schools,
> The careful cloister's polish'd rules,
> He views with cool, contemptuous sneer –
> But his the spirit of a Seer!
> Dark and deep as ocean's roll
> Often swells the old man's soul!
> And his voice heroic thrills
> Like the Elf's of northern hills,
> Warning of the days to come;

And of God's avenging doom,
Which he sees, tho' veil'd in gloom!
(Ingemann, *Waldemar the Great and his Men*
[Black, Young and Young 70; Milligan 211])

Arnold's acumen is mainly an expression of his transcendent, spiritual human condition which affords him insight into the 'real world'. He needs neither wisdom nor sword in order to gain a deep and wide understanding of the truth and to tell right from wrong. In fact, the entire intellectual climate of the 19th century was characterized by this quest for the true meaning of the world, its deeper spiritual essence (Leerssen 109 ff). Ingemann himself is no exception from this trend, and his beautifully realized Danish history elegantly combines Romantic thoughts with ideas passed down from the Enlightenment. The resulting picture, laid out in six works of historical literature, would enter the canon not only of Danish but also of Nordic historiography:

The peasants in this historiographical tradition were carriers of freedom and equality. They were the core of the folk, not as a passive crowd but as the incarnation and manifestation of the general will. The free peasant (odalbonden), who also became a political reality in Denmark in the 1780s when villeinage was abolished, was historically derived from the Viking age and a mythical past in which, when the peasants met at the thing, they were not only free but equal. (Stråht and Sørensen 8)

In Ingemann's works, the king is the representative of the people, but he is not an absolute ruler chosen by God. Ingemann's fictions play out the transformations from a liberal, popular monarchy to a tyrannical kingdom, and then back to a liberal monarchy again, in a non-violent manner. The author comprehensibly yet authoritatively presents complex historiographical thoughts while at the same time achieving easily readable and popular literature. His vision of an ideal state combines an un-modernized past, a modernizing present and a modernized future achieved without revolutionary cataclysm or a Napoleonic totalitarian empire. This makes his literature liberal for the time in which it was published. We have to bear in mind constantly that Ingemann's contemporary context and reality were those twelve years, from 1824 to 1836, in which Denmark was an absolute monarchy. There was no national parliament and no provincial or local assemblies. There was no freedom of speech. The King wrote and passed laws, and his officials saw to their implementation. When people offended or criticized the government, they were punished accordingly. The monarchy depicted by Ingemann is certainly not absolute, since ordinary people act on the political stage and have civic rights as members of the national and regional parliaments, the thing-steads. The peasantry is the epitome of the people, with role models such as Ole Stam, who is not afraid to speak up and take an active part in the affairs of the state, and the orphan Carl of Riise, who grasps the Danish banner as it falls from the sky during the crusade in 1219.

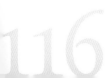

Conclusion

In Denmark, the modernization of the state came about without heads rolling on the historical stage. By referring to an ancient constitution embodied by a politically active peasantry casting its votes at the thing-stead, it became possible to fuel (or fool) the self-image of the Danish people as originally free men living in harmony as subjects under an elected sovereign. Following the history of the most cited historian of his time, Peter Frederik Suhm, Ingemann integrated this interpretation into his six historical fictions, thus combining the intellectual impulses of Romantic thought with Enlightenment ideas. Ingemann's works constitute a narrative which resembles his predecessors' authoritative histories; but unlike them, they are composed as Romantic fiction, written in a smooth and controlled fashion while deliberately unfolding the idea of peasants' freedom. The myth of an original peasants' freedom has had an enormous impact on Danish society as an actual political tool. However, though this is the very essence of Danish history, it is in this sense difficult to say where myth ends and history begins.

Literature

Allen, C. F. *Haandbog I Fædrelandets Historie med stadigt henblik paa Folkets og Statens indre Udvikling*. Copenhagen: Et af Selskabet for Efterslægten kronet Priisskrift. Bianco Luno, 1840.

Black, Young and Young, eds. *The Foreign Review and Continental Miscellany*. London, 1828.

Bloch, Marc. *La Société Féodale*. Paris: Editions Albin Michel, 1939.

Blom, Hans, John Christian Lauersen and Luisa Simonutti. *Monarchisms in the Age of Enlightenment: Liberty, Patriotism and the Common Good*. Toronto: University of Toronto Press, 2007.

Brandes, Georg. *Samlede Skrifter*. Vol. 1. Copenhagen: Gyldendalske Boghandels Forlag, 1899.

Cocrane, John George, ed. *The Foreign Quarterly Review*. Vol. XXI. London: Black and Armstrong, 1838: 132-149.

Due-Nielsen, Carsten, Ole Feldbæk and Nikolaj Petersen. *Dansk Udenrigspolitisk Historie*. Vols. 3-4. Copenhagen: Gyldendal, 2003.

Erslev, Kristian. 'Europæisk Feudalisme og dansk lensvæsen'. *Historisk Tidsskrift* 7, II (1899): 247-304.

Erslev, Kristian. *Danmarks Riges Historie*. Vol. 2, Den senere Middelalder. Copenhagen: Gyldendal, 1898-1905.

Flacke, Monika, ed. *Mythen der Nationen. Ein europäisches Panorama*. München/Berlin: Koehler & Amelang, 2001.

Fay, Elizabeth. *Romantic Medievalism: History and the Romantic Literary Ideal*. Basingstoke/New York: Palgrave Macmillan, 2002.

Galster, Kjeld. *Ingemanns historiske Romaner og Digte*. Copenhagen: Ascheoug, 1922.

Ganshof, F. L. *Feudalism*. London: Longmans, Green, 1960.

Gram, Hans. 'Om det gamle Ord Herremand'. *Skrifter som udi det Kiøbenhavnske Selskab af Lærdoms og Videnskabers Elskere er fremlagte og oplæste i Aaret 1745*. Copenhagen, 1746. 263-308.

Greenblatt, Stephen. 'The Touch of the Real'. *Representations* 59 (1997): 14-29.

Hegel, G. W. F. *Aesthetics. Lectures on fine Art*. Trans. T. M. Knox. 2 vols. Oxford: Clarendon Press, 1975.

Haakonssen, Knud and Henrik Horstbøll. *Northern Antiquities and National Identities*. Symposium held in Copenhagen, August 2005. Copenhagen: The Royal Danish Academy of Science and Letters, 2008.

Horstbøll, Henrik. 'Enevælde, opinion og opposition'. *Historiske. Jyske Samlinger*, new series 17 (1987-1989): 35-53.

Horstbøll, Henrik. *Natural Jurisprudence, Discourses of Improvement, and the Absolutist State*. Aarhus: Center for Cultural Research, 1988.

Horstbøll, Henrik and Uffe Østergaard. 'Reform and Revolution: The French Revolution and the Case of Denmark'. *Scandinavian Journal of History* 15 (1990): 155-179.

Horstbøll, Henrik. 'Historiens nytte'. *Danmarks Historie. Historiens Historie*. Vol. 10. Ed. A. E. Christensen, H. P. Clausen, S. Ellehoj and S. Mørch. Copenhagen: Gyldendal, 1992. 176-177.

Ingemann, B. S. *Prinz Otto und seine Zeit*. Trans. L. Kruse. Leipzig: C. E. Kollmann, 1835.

Ingemann, B. S. *Prinds Otto af Danmark og hans samtid*. Copenhagen. Hus og Hjems forlag, 1922.

Ingemann, B. S. *Levnetsbog I-II og Tilbageblik paa mit Liv og min Forfatter-Periode fra 1811 til 1837*. Ed. Jens Keld. Copenhagen: C. A. Reitzels Forlag, 1998.

Ingemann, B. S. *Waldemar, surnamed Seir, or the Victorious*. Trans. Jane F. Chapman. London: Saunders and Otley, 1841.

Ingemann, B. S. *King Eric and the Outlaws; or, The Throne, The Church and The People in the Thirteenth Century*. Trans. Jane F. Chapman. 3 vols. London: Longman, Brown, Green and Longmans, 1843.

Ingemann, B. S. *The Childhood of King Erik Menved*. Trans. John Kesson. London: Bruce and Wyld, 1846.

Ingemann, B. S. *Königin Margarethe. Historisches Gedicht in zehn Gesängen*. Trans. C. W. G. von Rumohr. Berlin: Enslin, 1846.

Ingemann, B. S. *Valdemar Seier*. Ed. Marita Akhøj Nielsen. Copenhagen: Det Danske Sprog og Litteraturselskab/Borgen, 1987.

Kidd, Colin. 'Northern Antiquity: The Ethnology of Liberty in Eighteenth Century Europe'. *Northern Antiquities and National Identities*. Ed. K. Haakonssen and H. Horstbøll. Copenhagen: The Royal Danish Academy of Sciences and Letters, 2008. 19-40.

Kjærgaard, Thorkild. 'Gårdmandslinien i dansk historieskrivning'. *Fortid og Nutid* 28 (1979-80): 178-191.

Langballe, Carl. *B. S. Ingemann. Et digterbillede i ny belysning*. Copenhagen: Gyldendal, 1949.

Lange, Ulrich Lang. *Den afmægtige – en biografi om Christian 7*. Copenhagen: Jyllandspostens Forlag, 2008.

Laursen, J. C. 'David Hume and the Danish debate about the freedom of the Press in the 1770's'. *Journal of the History of Ideas* 59.1 (1998): 167-172.

Laursen, J. C. 'Spinoza in Denmark and the Fall of Struensee'. *Journal of the History of Ideas* 2 (2000): 61, 189-202.

Leerssen, Joep. *National Thought in Europe*. Amsterdam: Amsterdam University Press, 2006.

Manniche, Jens Chr. 'Historieskrivningen 1830-1880'. *Danmarks Historie, Historiens Historie*. Vol. 10. Ed. A. E. Christensen et al. Copenhagen: Gyldendal, 1992. 199-266.

Milligan, Sophia. *Original Poems with translation from Scandinavian and other poets*. London: Hurst and Blackett, 1856.

Molbech, Christian. 'Bidrag til en Bedømmelse af Hr. Lector Ingemann's episke Digt: Waldemar (Valdemar) den Store og hans Mænd'. *Nyt Aftenblad* (Copenhagen) 16 October 1824: 365-372.

Molbech, Christian. 'Valdemar Seier, en historisk Roman af B. S. Ingemann. 1ste, 2den og 3die Deel.' *Nordisk Tidsskrift for Historie, Literatur og Konst* (1827): 622-628.

Molbech, Christian. 'Erik Menveds Barndom. En Historisk Roman af B. S. Ingemann. 1.2.3 Deel'. *Maanedsskrift for Literatur* (1828): 473-520.

Molbech, Christian. 'Om Historiens nationale Betydning og Behandling; om historiske Arbeider og Formaalene for en historisk Forening i Danmark'. *Historisk Tidsskrift* 1 (1840): 1-44.

Munck, Thomas. 'The Danish Reformers'. *Enlightened Absolutism: Reform and Reformers in Later Eighteenth-Century Europe*. Ed. H. M. Scott. Michigan: University of Michigan Press, 1990. 245-263.

Olden-Jørgensen, Sebastian. 'Enevoldsarveregeringsakten og Kongeloven. Forfatningsspørgsmålet i Danmark fra oktober 1660 til november 1665'. *Historisk Tidsskrift* (1993): 295-321.

Paludan, Helge. 'Vor danske Montesquieu. Historiografiske iagttagelser vedrørende dansk middelalderforsknings opfattelse af fæstevæsenets herkomst'. *Historie. Jyske Samlinger*, new series 13.3 (1980): 1-32.

Seip, Jens Arup. 'Teorien om det opinionsstyrte enevelde'. *Historisk Tidsskrift* 38 (1958-1959): 397-463.

Shelley, Percy. *The Letters of Percy Shelley*. Ed. Frederich L. Jones. Oxford: Clarendon Press 1964.

Skovgaard-Petersen, Inge. 'Oldtid og vikingetid'. *Danmarks Historie: Tiden indtil 1340*. Ed. S. Mørch et al. Copenhagen: Gyldendal, 1977. 15-209.

Skovgaard-Petersen, Inge. 'Tinget'. *Danmarks Historie. Tiden indtil 1340*. Vol. 1. Ed. S. Mørch et al. Copenhagen: Gyldendal, 1977. 29-30.

Suhm, P. F. *Samlede Skrifter*. 16 vols. Copenhagen: S. Poulsens Forlag, 1788-1799.

12 For the Middle Ages in literature, cf. Fay.

13 'The peasant speaks from the stone: / "Usually the Danish king did not find it a loss / On the Thing with Danes to discuss; / Now, as in ancient times again, / The sword must move among Danish men."' (My translation)

14 Translators of Ingemann's history have had great difficulties in translating 'tingsted'. The most common terms are Council Chamber and Parliament, which underline the thing-stead's character of a democratic institution.

15 Literally 'Danish Court', both a medieval parliament and a thing-stead.

THE MASSES AND THE ELITE

The Conception of Social Inequality in 1840s Scandinavian Literature

JOACHIM SCHIEDERMAIR

TRANSLATED BY LAURA ZIESELER

[ABSTRACT]

The opposition between the masses and the elite is the constituting formula by which the classic texts of elite theory justified social inequality around 1900. Nowadays, contemporary theorists of social inequality interpret this opposition primarily as a panic reaction to demographic developments that occurred towards the end of the 19th century. Uncovering the same mechanisms in fiction from that period is an obvious task for literary scholars. In the present article, however, it will be argued that the 'true' contemporaries of elite theories are already manifest in texts from around 1840 – texts that are usually regarded as belonging to the Romantic period. The argument is based on Johan Ludvig Heiberg's essay 'Folk og Publicum' (1842) [The People and the Audience] and the drama 'Den indiske Cholera' (1835) [The Indian Cholera] by Henrik Wergeland. Heiberg's and Wergeland's texts will not be read as anachronistic reflections of 1900 elite theories, but rather as complex analyses of precisely those bourgeois concerns that led to the emergence of elite theories toward the end of the century.[1]

.

KEYWORDS *Gaetano Mosca, Vilfredo Pareto, elite, masses, Johan Ludvig Heiberg, theatre, Henrik Wergeland, freedom, Den indiske Cholera.*

The Anachronistic Relationship between Elite Theories from around 1900 and Romantic Literature of the 1840s

Among the persistent facts and tendencies of public life, one is particularly obvious: each society, from the most primitive at the dawn of civilisation to the most advanced and powerful, consists of two classes: the ruling and the ruled. The first one is always fewer in numbers; it is in charge of all political functions, monopolises power and enjoys its privileges, whereas the second class, though stronger in numbers, is under the command and leadership of the first one. (Mosca 53)

This quotation is taken from the second chapter of Gaetano Mosca's magnum opus *Elementi di Scienza Politica* (1896), which can be regarded as the founding text of elite theory. Mosca is the first in a series of authors from around 1900

JOACHIM SCHIEDERMAIR, Professor of Modern Scandinavian Literature, Greifswald University
Aarhus University Press, *Romantik*, 01, vol. 01, 2012, pages 125-138

who view the opposition between the masses and the elite as an inevitable start-
ing point for reflections on society, and who – at the eve of Europe's fascist era
– endorse Machiavellian legitimations of leadership.[2] According to these writers,
merely to have power sufficiently justifies wielding it. Today, just over a century
later, contemporary elite theorists interpret the beginnings of their field primar-
ily as a reaction to the demographic developments that took place during the late
19th century (cf. Hartmann 13-16). A rising birth rate coupled with a concurrent
drop in the mortality rate led to an unprecedented and socially unmitigated pop-
ulation explosion in urban areas.[3] The triumph of the mass media and industrial
mass production resulted in an uncertain drive towards cultural unification and
massification. The beginnings of elite theory presented a way of channelling the
bourgeois fear of revolution by conceptualising the masses as a necessary coun-
terpart to bourgeois superiority, thus rendering it acceptable. To repeat Mosca's
words, where there are masses, it is one of 'the persistent facts' that an elite will
emerge. At the same time, elite theory ignored the very phenomenon to which it
owed its existence – it dismissed the novelty of massification as 'same old, same
old'. 'Each and every society' is characterized by the opposition of the few against
the many. Thus, elite theory around 1900 could be seen as a classic case of bour-
geois repression, i.e. as a defence mechanism to exclude taboo and threatening
issues from conscious perception, but also to ensure identity maintenance.

How relevant is this finding for literary studies? One suggestion would be to
see the sociological discovery of the elite as a time-bound phenomenon and to
look for an equivalent preoccupation in contemporary literature of the 1900s.
Herfried Münkler, however, points out that Mosca and Pareto at least were react-
ing to an Italian phenomenon, that is, to a situation in which 'a country which
had been lagging behind its northern neighbours in terms of modernization was
eventually developing from an agricultural to an industrial nation' (Münkler 77).
In other words, Mosca and Pareto based their observations on the obsolete model
of a stratified class society. From Münkler's argument, it can be concluded that
Mosca's and Pareto's 'true' literary contemporaries are not to be found among
the authors writing around 1900, but in an earlier period, among the authors of
Romanticism, to whom the idea of a stratified society was still self-evident. This
is the basic thesis of this paper. By comparing a factual and a fictional text from
the middle of the 19th century within the framework of classic elite theory, I do
not mean to imply that there is a truth to the Italian perspective on elites which
had somehow been anticipated by Scandinavian authors of the mid-19th century.
Rather, I intend to use these two texts to uncover the analogies in the construc-
tion of social hierarchies and thus to highlight aspects of Romantic literature
which so far have not been sufficiently studied.

Johan Ludvig Heiberg's *Folk og Publicum*

In his 1842 paper entitled 'Folk og Publicum' [The people and the audience],[4]
Heiberg's intention is to analyse the relationship of the many to their elite, or
rather: he is interested in finding out about the kind of structural change that

needs to take place within the group of 'the many' in order for it to start rebelling against political and aesthetic authority. His argument is based on two conceptually opposing pairs. First, Heiberg distinguishes between the people, which he sees as an internally consistent organism comprised of different, harmonic parts, and an amorphous mass which is only defined in quantitative terms, and which he grudgingly refers to as the audience. Heiberg treats this systematic opposition as an all-encompassing notion operating in every social sphere, especially the political, religious and artistic ones. In each of these spheres, social reality is dominated by the audience that Heiberg so despises.

The second opposition is a temporal one – between the past and the present – and puts the aforementioned opposition between the people and the masses into a chronological order. In the past, the people constituted an organism, whereas today it is dissolving into an amorphous mass. Nonetheless, Heiberg stresses that this state of the 'dull masses' is not permanent, but needs to be seen as a crisis phenomenon which from a Hegelian dialectic point of view merely indicates the transition of one organizational state to another:

Idet man paa den ene Side bør indrømme, at Folkets Opløsning til et Publicum, Organismens til en Masse, eller – med nærmest Hensyn til Litteratur og Kunst – at Publicums egen Overgang fra en organisk Representation til en atomistisk, Intet repræsenterende Mængde, er, som enhver Desorganisation, et Tilbageskridt: saa bør man igjen paa den anden Side indsee, at en saadan Gjæringstilstand er en nødvendig Følge af Tidsalderens retmæssige Emancipations-Idee, og vistnok Overgang til en ny og fuldkomnere Organisation.[5] (Heiberg 267)

The systematic and temporal aspects of Heiberg's opposition are both intimately connected to elite theory. It could be claimed that the notion of 'the people' also includes the elite, while the notion of 'the audience' does not; here, the masses face the elite in much the same way as the audience faces the stage – maintaining a critical distance. Unlike the masses, the organism of 'the people' is defined precisely by its voluntary subordination to a representative elite; if we regard them as an organism, then church, nation and theatre cannot 'undvære Autoriteten, og nødvendig maa staae i et Superioritets-Forhold til Individerne, som de Subordinerede' (269) [cannot shirk authority and necessarily stand in a relationship of superiority to the individuals as their subordinates]. Heiberg elaborates on this idea with reference to literature. Although true literature is national literature, this does not imply that everyone becomes an author as seems to be the case in the mass media: 'den journalistiske Litteratur ... har emanciperet de uberettigede Individer, og gjort Publikum til Skribent' (273 f.) [journalistic literature ... has emancipated the unauthorized individuals and turned the audience into authors]. Instead, 'the people' write in an unconscious fashion 'ved Hjelp af sine bevidste Organer, Dem, som man i egenlig Forstand kalder Digtere og Skribenter' (273) [with the help of its conscious organs known as poets and authors in the true sense of the word]. The good audience, which resembles the people rather than the masses, behaves in a purely recipient manner and respects

'Litteraturens Autoritet og Superioritet' (273) [literature's authority and superiority].

Though he concedes that the zeitgeist champions a legitimate interest in emancipation, Heiberg does not proclaim the end of the elite in favour of the masses. He writes that this state of crisis is not to be understood as a complete change in social power structures, but merely as a single step in an evolutionary circle in which one elite is supplanted by another. Heiberg's ultimate concern is the advent of a new elite. This is remarkable insofar as he anticipates essential ideas of elite theory as early as 1842. After all, Heiberg allays the fear induced by the masses with a social model which in 1916 will come to be named 'elite circulation' in Pareto's *Trattato di Sociologia generale* (§ 2042), another classic text. Pareto uses this model to describe a process in which an elite either constantly renews itself by incorporating and integrating elements from the ruled classes, or is completely supplanted by a new elite.

However, the most remarkable aspect is the role given to theatre in Heiberg's interpretation of elite circulation. He states that it had only taken a few years to change theatre-goers from an audience which actually represented the people into an atomised mass:

Dengang var det almindeligt, at man i Litteratur, Kunst- og Theaterverdenen ... betragtede Publikum som identisk med Folket; idetmindste betragtede man det som Folkets Repræsentant, ja erkjendte endog denne Repræsentation i ganske ubetydelige og tilfældige Masser; thi for at vælge et eneste Exempel, hvor almindeligt var det ikke i den Tids Leilighedspoesie at give de faa hundrede Mennesker, som paa en enkelt Aften vare samlede i det kjøbenhavnske Theater, Navn af det danske Folk? Og ganske naivt kunde man overlade sig til den Tanke, at man ved at behage en saadan ringe Menneskemasse i et høist indskrænket rum og i et par Timers indskrænket Tid, have behaget sin Nation.[6] (Heiberg, 'Folk og Publicum' 264-265)

Of course, what Heiberg describes in this passage is a feudal representation scheme in which the elite (with the king at the top) represents the nation during public acts (at court, in the royal theatre). Thus, the elitist theatre audience served as a medium through which the people became visible to itself.

In his essay 'Om Vaudevillen' (1826) [On Vaudeville], Heiberg replaces this obsolete model of elitist representation with a model of average-based representation. Only if every class is represented in its audience can the theatre regain its status as a place where the nation recognizes itself. However, Heiberg maintains that this requires a particular kind of aesthetics – Vaudeville aesthetics. For example, his piece 'Kong Salomon'

behagede ikke blot Hoffet og de høiere Cirkler, men den blev sungen paa Gadehjørnerne og i Kjelderne, og skaffede Theaterkassen en Indtægt, selv fra den Klasse, som aldrig eller sjelden besøger Comedien, medens tillige en stor Mængde dannede Mennesker, som i mange Aar havde trukket sig tilbage fra Theatret og dets Interesser, forførtes ved dette Stykke til at komme tilbage[7] (Heiberg, 'Om Vaudevillen' 71)

If the theatre audience is to once more become a place where the masses recognize themselves as the people, in other words, if it wants to once more become a founding theatre,[8] then it has to become a medium of the masses that captivates all social strata. This is Heiberg's basic idea, although he himself did not verbalize it that way. It also means a shift in the masses' potentially dangerous perspective on the formerly feudal-elitist theatre audience: If the theatre becomes a mass medium, then the masses and the elite share the same view onto the stage. This shared view forms the foundation of national unity.

These few illustrations should suffice. Johan Ludvig Heiberg's text exemplifies how the fear of the masses provoked reflection on elites as early as the mid-19th century. In the following passages, I want to highlight the same connection by analysing a fictional text. However, this fictional text requires a substantially more complex analysis: at first glance, it is not obvious that it deals with the elite phenomenon, and nor is it immediately evident that it is actually the fear of the masses which acts as the driving force behind the message of the drama's inner and outer systems of communication.

The Discourse of Freedom in Henrik Wergeland's *Den indiske Cholera*

Henrik Wergeland regarded his political and literary commitment to the cause of Norway's national independence as a contribution to a global peace movement. Whether he was writing about the July Revolution in France ('Det befriede Europa'), the Polish uprising against Tsar Nikolaj I ('Cæsaris') or the South-American struggle for independence from Spain ('Bolivar'),[9] Wergeland always took the side of the rebels striving to throw off the yoke of foreign rule. When the melodrama *Den indiske Cholera* [The Indian Cholera] was published on 24 June 1835, he had already established himself as a poet of revolutionary freedom – and it is with this reputation in mind that this play has been received so far.

But however closely this drama follows the much praised poetry of freedom, it has not received equal praise from the perspectives of literary history. For example, in the early 1930s, Fredrik Paasche argues in the vein of genre-essentialist Hegelianism that Wergeland had failed to cast his idealist content adequately into dramatic form. His 'drama is a poem about the price of freedom, peace and love, and rather lyrical than dramatic; the characters are neglected by the poet' (Paasche 229). Paasche reproaches Wergeland for having not properly considered, but rather slung out or 'extemporeret' [extemporized] his drama, as Wergeland himself puts it.[10]

This verdict assumes that Wergeland actually intended to revisit the subject matter of freedom without changing it. This might be possible, of course. Nonetheless, it is impossible to verify an author's intentions *post hoc*. In the following passage, I will show that the text goes beyond merely revisiting an old topic. For if it is read in the context of Mosca's and Pareto's elite theories, it becomes clear that the staple rhetoric of liberty is actually based on a second, opposing and much better-informed discourse that has obviously been overlooked by lite-

rary historians in their effort to canonize Wergeland as a poet of freedom. Thus, we need to establish the structures that the classical reading responds to before looking for alternative or contrasting structures. To this end, it is necessary to briefly summarize the drama's plot.

This time, the story of a just struggle for national freedom is situated in a colonial context. 'I *Den indiske Cholera* er farsotten de undertryktes forbundsfælle, Indiens vaaben mot det engelske voldsherredømme' (Paasche 229) [In *Den indiske Cholera*, the pandemic is the ally of the oppressed, India's weapon against English tyranny]. On one side is the corrupt and fraudulent governor of an English factory, supported by his equally villainous administrator, John. On the other is the venerable, old and deposed Raja who fights for India's freedom and places political above personal matters. When the governor offers to release his son Sewaji from death row if the Raja tells him a particular secret, the Raja defiantly and nobly refuses to cooperate. Only if the British leave his country is he willing to reveal the secret: 'Frigiv Indiens Millioner; / og paa det yderste af Indiens Forbjerg / skal jeg tilhviske det den sidste Britte' (Wergeland 122) [Set India's millions free; / and on the outermost Indian outcrop / shall I whisper it into the ear of the last retreating Briton]. And when the governor offers him riches and freedom to boot, Raja dismisses the legitimacy of the offer, saying that freedom is a natural right and therefore not at the disposal of one individual: 'Engang af Gud, som Kjernen i Demanten / i Livets første tindrende Øjeblik / uskillelig indlagt, den [= Friheden] ham [= Mennesket] forærtes' (123) [Once by God, as the diamond's core / in life's first quivering moment / embedded inextricably, it [= freedom] was given to him [= man]].

The secret the governor is so eager to know, concerns an immeasurable treasure allegedly kept hidden by the Raja. When an English warship arrives in order to pronounce judgement on the infidel governor, he remembers the rumor. The gold could help him compensate for his embezzlements and thus avert his punishment. He finds out about the Raja's secret, and is led to a shaft sealed by a stone. But when the shaft is opened, he finds no treasure, but cholera in the shape of a demon. The disease is released, and it does not discriminate between Indian and British bodies. The future has been determined: Cholera will spread throughout Europe, thus avenging colonial rule. But the disease will also lay waste to India. Only two lovers escape the chaos: Sami, the Raja's daughter, and Francis, the son of the English governor, who have long been in love against their fathers' will. They represent the utopian counterbalance to their parents' hatred. On an island that has been spared by the pandemic, they found a new society: 'Derfra, / som Stenen Cirkler i det stille Vand, / vi atter sprede over uddød Jord / en voxende Velsignelse' (159) [Thence / like the stone forming rings in calm water / we will once again spread out across deserted earth / a growing blessing].

Elite Circulation in *Den indiske Cholera*

If we read the text as an extension of the aforementioned freedom poetry, then this reading needs to be constructed via the opposition between the governor

and the Raja, as previously hinted at. However, one must not overlook the fact that this dichotomic reading is predicated on the characters' statements, i.e. their interpretation is the starting point for all following interpretations of this drama. In other words, the Raja and the governor stage themselves as opposing forces of good and evil, the freedom fighter and the tyrant, by drawing amply on the dichotomy of servant and master in their ripostes. For example, the governor sees all Indians as slaves and teaches his son in Hegelian dialectics: 'Frygter Herren Slaven, da / er Slaven Herre' (93) [If the master fears the slave, then / the slave is the master]. And the Raja is convinced that '[d]en siste Seir paa Jorden bliver Slavens' (102) [the last victory on earth belongs to the slave], referring of course to the victory of the colonized over the colonial power. The dichotomy derives its persuasiveness from the fact that both figures belong to the same universe of discourse, that is, they support the same semantization of the concept of freedom, albeit from opposing angles.

There is yet another character in the play who defines himself via the dichotomy of slave and master: the Malay Vakiti. Vakiti is introduced as a character maniacally lusting for Sami, the Raja's daughter. The fact that she is in love with Francis, the governor's son, does not improve his situation. When he appears on stage for the first time, Vakiti delivers the following monologue:

> Her gjemme Natten mig som dyndgraa Slange,
> af Gift igjennembølget, til Han [= Francis] kommer,
> som vovede at gribe efter
> min Elskov, Trældoms ene Trøst og Glemsel
> og Ret og Ejendom og sidste Levning
> af Menneskenatur. Her kræver Slaven.
> Og Sami af Naturen kræver jeg,
> den ene Fryd den mig skal skjænke. Thi
> jeg elsker Aaget, som har gjort os lige.
> Høibaaren er hun lavest; ja høibaaren
> hun er ei meer, da Trældom er en Fødsel,
> fra Guds forskjellig, til et værre Tilvær.
> Den Liighed er en Slaves Frihed. Mens
> Fribaarnes Liighed er som Træernes
> og takkede Fjeldes, regelløse Bølgers,
> som Straae ved Siden af hverandre paa
> en maalløs Slette Trællene jo staae.[11] (88-89)

At this point an opportunity presents itself for him to reach the object of his desire. The old Raja's son has been dwelling abroad for a long time, and his father is afraid that he might die before he can pass on the family secret about the Cholera Demon, which is, after all, nothing less than the Indians' last weapon against the English intruders. Therefore, the Raja is looking for a suitable husband for his daughter Sami – an heir who can be trusted with the secret. His criterion: his son-in-law ought to share his ardent passion for India's freedom. Thus, Vakiti needs

to present himself accordingly and also to dispose of the newly returned natural son in order to 'trænge ind til [... Samis] Barm' (89) [to enter [... Sami's] bosom]. When he realizes towards the end of the drama that all of his schemes have failed and that he is facing his downfall, he decides to take as many people with him as possible; and so it is he who opens the shaft and releases the demon which will wipe out Indians and Britons alike.

The negative role assigned to Vakiti makes it easy to miss the fact that this character actually undermines the straightforward opposition between the governor and the Raja, between the villainous oppressor and his noble victim. For Vakiti rivals the governor for the role of the villain while at the same time being untouchable (a Pariah) and thus sharing the Raja's role of the unfree. As an incommensurable third party (cf. Esslinger et al.), he thwarts the interpretative structure established on reciprocal grounds by the governor and the Raja. In this function he sheds an entirely new light on the Raja's freedom rhetoric. Like the Raja, Vakiti considers himself oppressed, but unlike him, he does not interpret the dichotomy of the ruling and the ruled on a national level: For him it is a social distinction, as can be seen in his speech above. He welcomes British rule because it deposes the old elite and thus makes Sami socially attainable: 'Thi / jeg elsker Aaget, som har gjort os lige' [For / I love the yoke that has made us equal]. From the point of view of the socially out of place, colonization is not construed as slavery, but rather as just another step in elite circulation – a perspective which dovetails nicely with the aforementioned elite theories. Vakiti's credo could be reformulated with the help of Mosca's sentence cited in the introduction to this paper: 'Among the persistent facts and tendencies of public life, one is the most obvious: each society [...] consists of two classes: the ruling and the ruled.' From this perspective, the legitimization of power is of no consequence. Regardless of whether it is the Raja or the governor who wields political power, everything will stay the same for Vakiti unless he himself becomes a movable part in the process of elite circulation. This becomes feasible by way of marrying Sami (89).

This interpretation is by no means applicable to the villain alone (if this were the case, its validity for the drama would be very restricted); ultimately it is an (albeit hidden) component of the national discourse of freedom – a fact borne out by Raja's major monologue in which he tells his supposed new son Vakiti about the Cholera Demon's secret. He says that 'i Indiens Old' (134) [in ancient India] a tribe of Tsengari had subjugated the Hindus. One of the Tsengari sultans surpassed all of his predecessors in his cruelty and inhumanity.[12] Guided by Brahma, the forefather of the Raja manages to outwit him and pushes him into a shaft which is then sealed with a stone. There, his spirit lives on as a cholera demon. This founding myth legitimates the family's status as India's elite while at the same time justifying social hierarchy, since the Tsengari who survived the Hindu rebellion are either still roaming the nation 'foragtet, hjemløs og forhadt' (137) [despised, homeless and hated] – a description that clearly refers to the Sinti and Romani – or they belong to the untouchables, the Pariah (137). What is even more important is that the story also indirectly reveals that, before ascending to power, the Tsengari themselves had been oppressed by the Hindus (136). In order

to ingratiate himself with the Tsengari sultan, the forefather of the Raja depicts the Tsengari victory as an act of vengeance for their oppression: 'til Seiersjubel gjort de Usles Klage, / i Hæder hyllet tusind Aars Foragt' (136) [into victorious cheers the mourning of the wretched has been turned, / clad in honour a thousand years of disdain]. The Raja's struggle for freedom is therefore only a small passage of a much longer narrative which in Pareto's terms we would need to call elite circulation. The Raja's story of legitimization alone recounts a succession of at least four elites: Hindu, Tsengari, Hindu, British. Against the background of Vakiti's disruption of the master-slave dichotomy, the Raja's monologue can be read as a story not of deliverance from oppression, but of elite circulation in which the only thing that changes is the distribution of power and oppression – a reading that strips the monologue of its pathos of freedom. In Pareto's terms, the Raja's rhetoric of national freedom can be decoded as a derivation, while Vakiti's function is to expose the residuum behind that derivation with regard to the drama as a whole. A short explanatory note on these terms is necessary here. Pareto uses the term *derivations* to denote norms or rationalizations used by society as a means of motivating its actions (ch. IX and X). However, these derivations are *post-hoc* constructions disguising the actual, irrational motivation. In reality, the actions of both individuals and societies are steered by *residues* which in turn follow a timeless logic of instincts (ch. VI-VIII). 'The derivations keep changing while the residues stay the same' (§ 1454). In Pareto's voluntarist theory of action, political action – and here one could also include the Raja's narrative of legitimization – is seen as a 'mere arsenal of masquerades and metamorphoses of man's constant will for power' according to Kurt Lenk (32). It is precisely this timeless aspect of the will for power that comes to bear in Raja's founding myth, where history is understood as an unchanging circle of one elite replacing another (supplemented, of course, by a derivative legitimization of one particular elite, the Hindus). Or, to cite Pareto: 'History' – including the story told by the Raja – 'is a cemetery of the elites' (§ 2053). In her highly readable overview of elite theories, Beate Krais also notes another common feature of theories from the 1900s: '[T]hey do not only state the power of the elites, but also the powerlessness of the masses. The elites rule over the "dull masses" which in turn do not make any effort to push for social change' (13-14). And indeed, the victory of the Hindu hero of liberty over the Tsengari sultan has the Hindu refugees return immediately from their hideouts in the woods: 'Fra Skogene brød Hindufolket frem; / og Hevnen førte, Sejren fulgte dem' (Wergeland 137) [From the woods the Hindu people sallied forth; / and revenge led them, victory followed them].

The Masses

However, when the text (through Vakiti) unmasks the Raja's motivation as derivative, and when the governor cannot fill in as an alternative since he is obviously motivated by the residue of mere preservation of power, then why is it necessary for Vakiti to act as the villain? Why isn't he presented as the drama's voice of truth?

Even in this regard, the Raja's monologue offers a telling hint as it comments on the utmost evil conceivable within the elitist frame of interpretation (i.e. that of the Raja and Pareto): the masses as an independent social variable that defies regulation. The only calamity that could justify the catastrophic release of the demon is not the foreign occupation of India, nor the oppressive power of the Tsengari, nor colonialism, but the dissolution of social differences within Indian society. If it comes to this, the time to open the demon's shaft will have come,

> naar sammen reen och ureen Kaste slettes
> som Sæd og Ukrud hvor en Strøm brød Vei;
> naar Aag Brahmin og Paria sammenbinder;
> naar Sletten bærer ingen fri Mahrat;
> naar sidste Rajah mistet har sin Stat;
> ... naar Fyrster ikke og Nationer, men
> kun Trælles lige Masse gaaer igjen [.][13] (139)

On the one hand, this quotation demonstrates the social narrow-mindedness of the Raja's elitist idea of freedom. The social state he favours is hierarchically structured and does not rule out the bondage of the lower classes ('reen och ureen Kaste', 'Sæd og Ukrud' [pure and impure caste, seed and weed]). On the other hand, this quotation also makes it clear that the actual fear fueling the Raja's rhetoric of freedom is that of the abolition of hierarchical differences ('naar Aag Brahmin og Paria sammenbinder' [when yokes bind together Brahman and Pariah]). It shows that the elitist discourse is driven by the elite's fear of an uncontrollable force ('en Strøm' [a torrent]) which will lead to indifferent massification ('Trælles lige Masse' [the uniform masses of the servants]), which in turn knows no hierarchy ('ingen fri Mahrat', 'sidste Raja mistet har sin Stat' [no free Maratha, the last Raja has lost his kingdom]). Or, reformulated within the drama's meaning structure: The indistinctness which characterizes the masses threatens the discourse universe shared by the Raja and the governor while at the same time making it plausible. The Raja's actual enemy is not the unscrupulous Briton, since he subscribes to the logic of the supposedly eternal legitimacy of the elite – rather, it is the advocate of massification: Vakiti. Even in his first appearance on the stage he presents himself in this function. Let me once more quote a part from the abovementioned passage:

> ... Mens
> Fribaarnes Liighed er som Træernes
> og takkede Fjeldes, regelløse Bølgers,
> som Straae ved Siden af hverandre paa
> en maalløs Slette Trællene jo staae.[14] (88-89)

If, in analogy to Pareto, the text were to be read as an analysis of elitist structures, it would not be surprising to find the paradoxical relationship between elite theory and the masses represented here as well. Thus, Wergeland distances

himself from his earlier freedom poetry by characterizing the discourse of freedom as a derivation, which is why Vakiti is allowed to puncture the rhetoric of freedom and get away with it. However, the fact that Vakiti still remains the villain indicates that Wergeland, like the rest of the bourgeoisie towards the end of the 19th century, lives in fear of the masses. Due to this, the drama contains the very connection I identified in 1900s elite theories in the introduction to this paper; although it was the amorphous threat posed by social massification that originally gave rise to a theory of derivations, residues and elite circulation, the actual purpose of this theory is to deny that very threat.

In the context of the drama, the character who embodies this paradoxical state of affairs is Vakiti. Unlike in elite theory, the fear of the masses is not banished from the foreground in Wergeland's drama, but rather spelt out as a massive showdown in which Vakiti's vision of a leveling massification becomes reality. The cholera pandemic is more than the Indian's way of making the British pay; it is the dreaded annihilation of social stratification, the end of the elite-based dichotomy between the Raja and the governor. Throughout the drama, there are usually no more than two or three characters present on stage. However, in the third and final act, that number rises. Soldiers and sailors enter the stage. Finally, all of the characters are assembled around the Cholera Demon's shaft. And then Vakiti

[l]øfter Stenen. Døden afbilder sig i fortrukne Træk i *Vakitis* Aasyn. Hans sidste Blik søger *Gouvernørens* Idet han styrter i Dybet speile alt samme Dødstræk sig i *Gouvernørens*, og derfra i *Johns*. Nogle flye. ... Døden udbreder sig fra Ansigt til Ansigt.[15] (158)

The cholera, spreading from gaze to gaze, thus makes everyone equal; it spares neither the British nor the Indians, neither the elite (the Raja and the governor) nor the ruled (Vakiti and John, the governor's administrator). The pandemic's occurrence at the end of the drama has to be interpreted as the annihilation of all (national and social) differences, while the cholera itself can be seen as the most forceful figuration of massification.

From this, it can be concluded that *Den indiske Cholera* is a text based on an internal contradiction. The rhetoric of freedom is punctured, its elite-building function exposed. However, at the same time, the drama does not abandon the motivations that justify elitism. It is precisely because of this paradox that the drama acts as a seismograph of a contemporary upheaval which would eventually lead to the elite theories that appeared around 1900. In Sigrid Weigel's words, literary texts 'relate the prelude and the aftermath of terms, theories and concepts, the conflicted genesis of cultural interpretation paradigms as well as their implementation in social interaction' (64). From this perspective, Wergeland ceases to merely act as a freedom advocate of the tardy Norwegian Romantic movement – and what becomes obvious instead is the common ground he shares with Heiberg's conservative Hegelian position. Thus, the texts of both authors can be read as analyses of bourgeois fear and hence as anachronistic analyses of elite theories from the 1900s.

Literature

Beyer, Edvard. *Norges litteraturhistorie, Bd. 2. Fra Wergeland til Vinje*. Oslo: Cappelen, 1974.

Esslinger, Eva et al., eds. *Die Figur des Dritten. Ein kulturwissenschaftliches Paradigma*. Berlin: Suhrkamp, 2010.

Glienke, Bernhard. *Metropolis und nordische Moderne. Großstadtthematik als Herausforderung literarischer Innovationen in Skandinavien seit 1830*. Frankfurt am Main: Peter Lang, 1999.

Hartmann, Michael. *Elitesoziologie. Eine Einführung*. Frankfurt/New York: Campus Verlag, 2004.

Heiberg, Johan Ludvig. 'Folk og Publicum' (1842). *Prosaiske Skrifter*. Vol. 6. Copenhagen: C. A. Reitzels Forlag, 1861. 263-283.

Heiberg, Johan Ludvig. 'Om Vaudevillen som dramatisk Digtart og om dens Betydning paa den danske Skueplads. En dramaturgisk Undersøgelse' (December 1826). *Prosaiske Skrifter*. Vol. 6. Copenhagen: C. A. Reitzels Forlag, 1861. 1-111.

Kabell, Aage. *Wergeland*. Vol. 2, *Manddommen*. Oslo: Aschehoug, 1957.

Krais, Beate. 'Die Spitzen der Gesellschaft. Theoretische Überlegungen'. *An der Spitze. Von Eliten und herrschenden Klassen*. Ed. Beate Krais. Konstanz: UVK, 2001. 7–62.

Lenk, Kurt. '"Elite" – Begriff oder Phänomen?'. *Aus Politik und Zeitgeschichte*. Supplement to the weekly newspaper *Das Parlament*, B42/32 1982: 27-37.

Mosca, Gaetano. *Die herrschende Klasse. Grundlagen der politischen Wissenschaft*. München: Francke, 1950.

Müller-Wille, Klaus. 'Phantom Publikum. Theatrale Konzeptionen des *corps politique* in der dänischen Ästhetik von Andersen bis Kierkegaard'. *Kollektive Gespenster. Die Masse, der Zeitgeist und andere unfassbare Körper*. Ed. Michael Gamper and Peter Schnyder. Freiburg im Breisgau: Rombach, 2006. 105-127.

Münkler, Herfried. 'Werte, Status, Leistung. Über die Probleme der Sozialwissenschaften mit der Definition von Eliten'. *Die neuen Eliten*. Spec. issue of *Kursbuch*, vol. 139 (2000): 76-88.

Paasche, Fredrik. *Norges Litteratur. Fra 1814 til 1850-Aarene (= Norsk Litteratur Historie, Vol. 3)*. Oslo: Aschehoug, 1932.

Pareto, Vilfredo. *Vilfredo Paretos System der allgemeinen Soziologie*. Ed. Gottfried Eisermann. Stuttgart: Enke, 1932.

Schiedermair, Joachim. '"Liighed er en Slaves Frihed" (Gleichheit ist eines Sklaven Freiheit). Die Literatur des Idealismus als anachronistischer Kontext früher Elitetheorie'. *Hoch, Ebenhoch, der Dritte. Elite als Thema skandinavischer Literatur- und Kulturwissenschaft*. Ed. Wilhelm Heizmann and Joachim Schiedermair. Munich: Herbert Utz Verlag, 2012. 261-284.

Vogl, Joseph. 'Gründungstheater. Gesetz und Geschichte'. *Übertragung und Gesetz. Gründungsmythen, Kriegstheater und Unterwerfungsstrategien von Institutionen*. Ed. Adam Armin and Martin Stingelin. Berlin: Akademie Verlag, 1995. 31-39.

Wechsel, Kirsten. 'Herkunftstheater. Zur Regulierung von Legitimität im Streit um die Gattung Vaudeville'. *Faszination des Illegitimen. Alterität in Konstruktionen von Genealogie, Herkunft und Ursprünglichkeit in den skandinavischen Literaturen seit 1800*. Ed. Constanze Gestrich and Thomas Mohnike. Würzburg: Ergon, 2007. 39-59.

Weigel, Sigrid. 'Zur Differenz von Gabe, Tausch und Konversion. Shakespears The Merchant of Venice als Schauplatz von Verhandlungen über die Gesetze der Zirkulation'. *Literatur als Voraussetzung der Kulturgeschichte. Schauplätze von Shakespeare bis Benjamin*. Munich: Wilhelm Fink Verlag, 2004. 63-85.

Wergeland, Henrik. 'Den indiske Cholera'. *Samlede Skrifter. Trykt og utrykt II, Digterverker, 3. Bd., 1832-1837*. Ed. Herman Jæger and Didrik Arup Seip. Kristiania: Steenke Forlag, 1920. 81-159.

Notes

1 For a more comprehensive German version of this article with a different focus cf. Schieder-mair.

2 Other authors in this group are Gustave Le Bon, Vilfredo Pareto and Robert Michels.

3 Statistics on the urbanization of the big Scandinavian cities Copenhagen, Stockholm and Kristiania can be found in Glienke 14-16.

4 In his paper 'Phantom Publikum', Klaus Müller-Wille sets this text in its context of the aesthetic innovation of the broad public (Müller-Wille 112-113).

5 'If one has to admit, on the one hand, that the people's dissolving into an audience, the organism's disintegration into a mass, or – especially with regard to literature and fine arts – that the audience's transition from an organic representation to an atomic, featureless mass is a retrogressive step, as is every kind of disorganisation, then one has to concede, on the other hand, that such a volatile state inevitably follows from the legitimate idea of emancipation entertained at that time, and thus can certainly be seen as the transition to a new and more complete organization.'

6 'At the time, it was common practice in literature, art and theatre to equate the audience with the people; at least, it was regarded as a representative of the people, its representing function was acknowledged even in the most insignificant and random masses; after all – just to pick one single example – wasn't it common practice in contemporary occasional poetry to address a few hundred people assembled at the theatre of Copenhagen as the Danish People? And one could naively entertain the idea of having pleased one's nation by pleasing such a small crowd in such a confined location during such a short time-span.'

7 '[Kong Salomon] did not only please at court or in higher circles, but was also sung on street corners and in basements, and saw money being spent at the box office by members of those classes who never or rarely went to see a comedy, while at the same time winning back a large number of educated but lapsed theatre-goers.'

8 On 'founding theatre', cf. Vogl, and also Wechsel on Heiberg's text.

9 All of these poems were published in 1834 in *Digte – Anden Ring*.

10 Similarly Edvard Beyer: 'Intrigen er innfløkt og menneskeskildringen enkel, personene er representanter mer enn enkeltmennesker'(149) ['The scheming is intricate and the character depiction simple, they are representatives rather than individuals']. Cf. also Aage Kabell: 'Som en sildig frugt af ungdommens fantasier og ideer lader *Den indiske Cholera* meget tilbage at ønske under dramatisk synsvinkel' (59) ['Like a late fruit of juvenile fantasies and ideas, *Den indiske Cholera* leaves a lot to be desired in dramatic terms'].

11 'May the night conceal me here like a mud-grey snake / heaving with venom, until He [=Francis] arrives / who dares to grasp for my love, / slavery's sole comfort and oblivion /and right and property and last remainder / of human nature. Here, it's the slave demanding. / And I demand from Nature Sami, / the only delight She ought to give me. For / I love the yoke that has made us equal. / High-born she is the lowest of all; yes high-born / she is no-more, for slavery is a birth / unlike God's, to a worse existence. / This equality is freedom to a slave. While / the free-borns' equality is like that of the trees / and that of the ragged mountains, that of the unruly waves, / like stalks side by side on / an endless plane the slaves do stand.'

12 Among other things, he is said to enjoy anthropophagy and sexual intercourse with crocodiles.

13 'when together pure and impure caste are leveled out / like seed and weed where a torrent forces its way; / when yokes bind together Brahman and Pariah; / when the plane no free Maratha bears; / when the last Raja hath lost his kingdom; / ... when neither princes nor nations, but / just the uniform masses of the servants return.'

14 '... while / the free-borns' equality is like that of the trees / and that of the ragged mountains, that of the unruly waves, / like stalks side by side on / an endless plane the slaves do stand.'

15 'lifts the stone. Death is mirrored in Vakiti's distorted features. His dying eyes seek those of the governor ... Even as he tumbles down, the same morbid rictus is reflected in the governor's eyes and from there in John's. Some flee. ... Death is spreading from face to face.'

'NORTHERN GODS IN MARBLE'

The Romantic Rediscovery of Norse Mythology

KNUT LJØGODT

[ABSTRACT]

The Norse myths were rediscovered in the late 18th century, and became important to contemporary culture during the first half of the 19th century. The Romantics discussed the usage of themes from Norse mythology; soon, these themes became widespread in art and literature. Their popularity is closely connected with the national ideals and political situations of the period, but they were often given individual artistic interpretations. The Romantic interest in Norse myths and heroes held sway over artists and writers throughout the 19th century.

.

KEYWORDS *Norse myths, Norse heroes, pagan religion, Knud Baade, Romanticism vs Classicism.*

Introduction

Karen Blixen's short story 'Sorrow-Acre', published in *Winter's Tales* (1942) takes place at a Danish country estate in the late 18th century. During a conversation between the baron and his nephew, they discuss Classical versus Norse mythology. The young man has discovered the Norse myths through a recently published work: 'He mentioned the name of the author, Johannes Ewald, and recited a couple of the elevated verses.' The book he refers to is Ewald's play *The Death of Balder* (1775). He goes on to praise the Norse gods:

'And I have wondered, while I read,' he went on after a pause, still moved by the lines he himself had declaimed, 'that we have not till now understood how much our Nordic mythology in moral greatness surpasses that of Greece and Rome. If it had not been for the physical beauty of the ancient gods, which have come down to us in marble, no modern mind could hold them worthy of worship. They were mean, capricious and treacherous. The gods of our Danish forefathers are as much more divine than they as the Druid is nobler than the Augur. For the fair gods of Asgaard did possess the sublime human virtues, they were righteous, trustworthy, benevolent and, even within a barbaric age, chivalrous.' (Blixen 178)

The old baron, however, defends the established mythology of the Greeks. The alleged mildness of the Norse gods he despises as weakness, while admiring the Greek gods for their almighty power. In this encounter, Karen Blixen has given

KNUT LJØGODT, Director of The Art Museum of Northern Norway, Tromsø
Aarhus University Press, *Romantik*, 01, vol. 01, 2012, pages 141-165

141

us a good illustration of the situation in the late 18th century, when new ideas opposed the old ones: the emotions of the *Sturm und Drang* against the rationalism of the Enlightenment, as well as the desire for liberty and the discovery of national identity against the supreme powers of *l'ancien regime*. These opposite forces are here represented by the young and the old man, who use the gods of Valhalla and of Olympus respectively as their allegorical champions.

The Nordic Renaissance

The Proto-Romantics and Romantics' fascination with Norse mythology must be seen in the light of their period's national ideals. The French Revolution and the Napoleonic Wars had changed the political map of Europe. Among the freshly emerged nation states, as well as the old kingdoms, there was a need to define both nations and peoples. The idea of defining the identity of the different nations and peoples by exploring their culture and history was first introduced in the late 18th century by German philosophers such as Johann Gottfried Herder and the Schlegel brothers. Soon, themes from folklore, mythology and history were treated by different authors – and eventually also visual artists – in Germany and in the rest of the Western world.

The first attempt to create a literature based on national themes was made as early as the 1760s by the Scottish writer James Macpherson, in his *The Poems of Ossian*, presented as a cycle of ancient, Celtic or Gaelic epics (Macpherson).[1] These poems about mythical heroes became a craze throughout Europe, including in the Scandinavian countries (Mjøberg, vol. 1 37-40; Uthaug 92-93; Ljøgodt, *Historien fremstilt i bilder* 15-16).[2] Each nation now wanted to find its own heroes and to reinvent its own mythical past. For the Scandinavian nations, this necessitated investigations of the history of the saga era and of Norse mythology.

The rediscovery of Norse history and mythology – often referred to as the 'Nordic Renaissance' – took place in Denmark in the 1770s. In 1770, the poet Johannes Ewald (1743-1781) published the historical drama *Rolf Krake* and, five years later, the aforementioned *The Death of Balder*, which are recognized as the works that reintroduced the Norse gods and myths into Scandinavian literature. However, a few years earlier the English author Thomas Gray had addressed the same subject in his poem 'The Descent of Odin' (1768), an interpretation of 'The Dreams of Balder' [Baldrs draumar] from the Elder Edda. Other Scandinavian writers in the late 18th century also used Norse subjects, among them authors that belonged to the circle around the Norwegian Society [Norske Selskab] in Copenhagen (Bliksrud 98-118; Nettum 122-144).

Around the same time, subjects from Norse mythology were also appearing in the visual arts. Two pioneering artists in this respect were the Dane Nicolai Abildgaard (1743-1809) and the Anglo-Swiss Henry Fuseli (Johann Heinrich Füssli, 1741-1825). They both studied in Rome in the 1770s, where they became friends. At this time, the two artists started to depict Norse subjects. Fuseli took the inspiration for his drawing *Odin Receives the Prophecy of Balder's Death* (1776) from Gray's poem (Monrad and Nørgaard Larsen 102).[3] Later, he painted *Thor*

Ill. 1 [Henry Fuseli (Johann Heinrich Füssli), *Thor Battling the Midgard Serpent*, 1790. Oil on canvas, 131 x 91 cm. Royal Academy of Arts, London]

Ill. 2 [Nicolai Abildgaard, *Ymer Suckling the Cow Audhumbla*, (ca. 1777).
Oil on canvas, 37 x 45.5 cm. Statens Museum for Kunst, Copenhagen, photo SMK Foto]

Battling the Midgard Serpent (1790; ill. 1) as his reception piece for the Royal Academy of Arts in London.[4]

Abildgaard's *Ymer Suckling the Cow Audhumbla* (ca. 1777; ill. 2) takes its subject from the Norse creation myth.

Abildgaard also depicted other subjects from Norse and Germanic mythology and history later in his career. Both Abildgaard and Fuseli were scholarly artists who researched new themes not only in Norse mythology but also in the Ossian poems, as well as the works of Shakespeare. These themes offered alternatives to the established mythology of the Classical world, which until this time had dominated Western art and literature. For the Romantics, it was also important that Norse mythology had national relevance.

The Gods of the North in Literature

In the early 19th century, subjects from Norse mythology became quite popular among Scandinavian authors and artists (Mjøberg; Grandien; Nykjær). In 1801, the Danish writer Adam Oehlenschläger (1779-1850) published a dissertation defending the use of Norse instead of Greek subjects (Oehlenschläger, *Æstetiske Skrifter*).[5] One of his arguments was that the use of ancient history stimulates the people's love for the fatherland. Norse themes became a part of a national program. According to Oehlenschläger, this material also had the advantage of being more open to interpretation than the more established mythologies (Oehlenschläger, 'Fortale til Poetiske Skrifter'; *Æstetiske Skrifter* 15-16). Furthermore, Oehlenschläger emphasized the allegorical value of Norse myths:

The Asar (gods), and the Jetter (Giants), represent the two conflicting powers of nature; the former represent the *creative, embellishing* nature; the latter the *defacing destructive* one. Lok vacillates between both, as the *variable spirit* of time. ('Argument of the Poem', Oehlenschläger, *Gods of the North* lxxix)

As a poet, Oehlenschläger used Norse themes extensively. With *The Gods of the North* (1819), he realized his dream of an epic based on Norse mythology. The work was also intended as a source of inspiration for other poets, as well as painters and sculptors. Another Danish writer who was interested in Norse themes was N. S. F. Grundtvig, who is best known for his hymns. In 1808, he published a dissertation on Norse mythology in which he, like Oehlenschläger, regards the gods and myths as allegories of the battle between good and evil, and between civilization and barbarism, a view that was held by many intellectuals of the time.

There was also a great interest in Norse themes in Sweden, particularly in the milieu of the Gothic Society [Götiska Förbundet], which included authors such as Esaias Tegnér (1782-1846), Gustaf Geijer (1783-1847) and Pehr Henrik Ling (1776-1839). Tegnér's *Frithjof's Saga* (1825) is a Romantic epic about the life and deeds of the Viking hero Frithjof. It soon became well-known and was translated into several languages; it was also a much-used source among artists. Although the epic's theme is really more literary than historical or mythological, it made Norse subjects highly popular at the time.

In Norway, saga history and Norse mythology were held in high regard as representative of the golden age of the nation; they were seen as an important part of the country's identity. This must be considered against the background of Norway's political situation. With the constitution of 1814, Norway gained a certain degree of independence, but was forced into a union with Sweden. This created an enthusiasm for all things Norwegian – nature, folklore and of course history and mythology. The poet Henrik Wergeland (1808-1845) and his circle urged the use of Norse themes, while the writer Johan Sebastian Welhaven (1807-1875) treated subjects from Norse mythology and history in several poems from the 1830s and 1840s (Mjøberg; Ljøgodt, *Historien fremstilt i bilder* 30).

Visual Arts

Literature made Norse mythology popular, and soon many – Oehlenschläger included – raised the question of depicting such subjects in painting and sculpture too. In 1812, a Danish theologian called Jens Møller published a dissertation on this topic. Møller's aim was also to stimulate the people's love for the nation (Nykjær). In the years to follow, the cultivation of Norse themes flourished in the milieu of the Royal Academy of Arts in Copenhagen. The art historian Niels Laurits Høyen pursued these ideals; his lectures at the Academy in Copenhagen from the 1820s onwards had a considerable impact on both Danish and Norwegian artists at the time. Høyen stressed the importance of a national art, essentially encouraging the use of subject matters from Old Norse history and mythology. In an influential lecture in 1844, he pointed out that the arts must have their roots in the people and in the history of the nation if they were to have a chance of finding acknowledgement among the people.

Artists often found their subject matters in the original, Norse sources, which were translated into modern Scandinavian languages throughout the 19th century. In 1821-1823, the Elder Edda was published in a Danish translation by the Icelandic scholar Finn Magnusson, who also lectured on Norse mythology at the Royal Art Academy in Copenhagen. Of equal importance were the books on mythology and history published by the historians of the day. In Norway, the pioneering historian P. A. Munch (1810-1863) brought out a book on Norse mythology in 1840.[6] It soon became popular and ran into several later editions. However, many of the painters and sculptors of the period seem to have found their subjects in the works of contemporary authors such as Oehlenschläger, Tegnér or Welhaven.

Despite their different sources, all of these artists faced the same challenge: How should they depict the gods and heroes of the Norse universe? Literary sources were available, but what about visual sources? At this stage, knowledge about the material culture of the Saga era was very limited. The archaeological excavations of Viking ships and graves did not take place until late in the century. There was an abundance of sources for themes from Classical mythology, both literary and visual. In addition, this mythology had an established iconography. For Norse mythology in the first half of the 19th century, the situation was completely the opposite. Artists simply had no idea about how the Old Norsemen had imagined their gods and heroes. They therefore set themselves the important task of developing a Norse iconography. To achieve this, artists drew on the limited material from the saga era that was available, and combined it with models from other cultures and periods such as Greco-Roman antiquity and the European medieval ages. One of the dangers of this, identified by many artists of the time, was that their depictions could become more Classical than Norse (Wilson).

According to Høyen and others, folk culture was perhaps the most important source for these artists. The different peoples supposedly preserved elements of an unbroken tradition that could be traced back to ancient times – for the Scan-

Ill. 3 [Christoffer Wilhelm Eckersberg, *The Death of Balder,* 1817.
Oil on canvas, 142 x 178 cm. Det Kongelige Danske Kunstakademi, Copenhagen,
photo Det Kongelige Danske Kunstakademi]

dinavian people meaning to their Viking forefathers. Thus, in many history paint-
ings with Norse subject matters, artefacts such as tapestries and wooden carvings
appear. This idea became a central element in National Romantic thinking, which
was echoed later in, for instance, the folk life paintings of Adolph Tidemand.

Not everyone shared the Romantic enthusiasm for Norse themes. The move-
ment's opponents used arguments that were partly practical, such as pointing
out the lack of Norse models, and partly aesthetic, claiming the Northern cul-
ture to be crude and lacking the refinement of the Classical world (Meldahl and
Johansen 164-166; Ljøgodt, *Historien fremstilt bilder* 26-30). Echoes of this debate
could be heard in Scandinavian countries throughout the 19th century, in paral-
lel with the artists' attempts to give the Norse gods physical form.

Northern Gods in Marble

Two of the Danish artists who depicted Norse themes were Johan Ludwig Lund
(1777-1867) and Christoffer Wilhelm Eckersberg (1783-1853), both professors at
the Royal Academy of Arts in Copenhagen from 1818. Eckersberg's first large

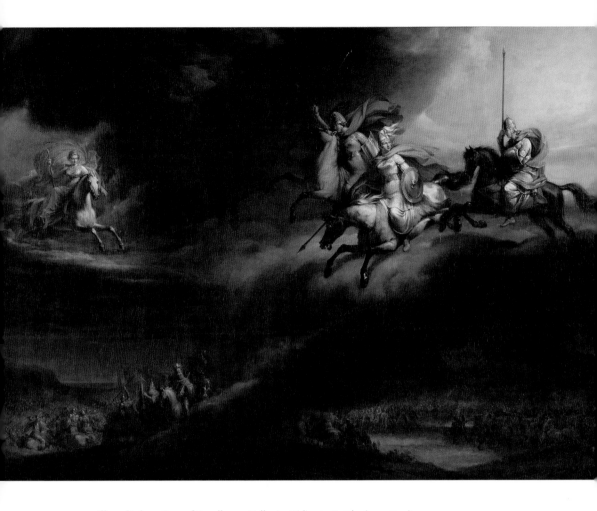

Ill. 4 [Johan Gustaf Sandberg, *Valkyries Riding to Battle*, (ca. 1820).
Oil on canvas, 140 x 210 cm. Nationalmuseum, Stockholm, photo Erik Cornelius]

work as a history painter depicts a mythological subject, *Loki and Sigyn* (1810).
Some years later, he painted *The Death of Balder* (1817; ill. 3) as a reception piece
for the Academy.

The subject matter is based partly on the Elder Edda, and partly on Oehlen-
schläger's drama *Balder the Good* (1807). The death of Balder and related myths
had drawn the attention of both writers and painters since the late 18th century.

In Sweden, artists in the circles around the Gothic Society and The Society for
the Study of Art [Sällskapet för Konststudium] took on the challenge of depict-
ing Norse subjects.

In 1814-17, Pehr Henrik Ling gave a series of lectures in Stockholm, urging the
use of Norse myths in the visual arts. In 1818, the Gothic Society organized the
first of a series of exhibitions, asking for works with subjects from Norse history
and mythology. Johan Gustaf Sandberg (1782-1854) displayed a drawing at this
exhibition entitled *Valkyries Riding to Battle*, a subject he later also executed as a
painting (ill. 4).

Ill. 5 [Bengt Fogelberg, *The Asa Gods: Balder, Odin, Thor,* ca. 1850. Reproduced after an old lithograph, photo Nordnorsk Kunstmuseum, Tromsø]

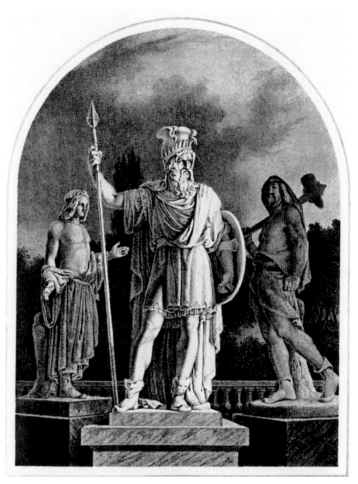

The Valkyries were war goddesses who sometimes participated in battle, but whose main task was to bring slain warriors to Valhalla. They were introduced to the modern public in Ewald's *The Death of Balder* and appeared occasionally in the works of Oehlenschläger and other authors. The first visual depictions of the Valkyries were probably Daniel Chodiowiecki's illustrations for Ewald's work. Later, different artists, such as the Danish sculptor H. W. Bissen and the Norwegian painter Peter Nicolai Arbo, attempted to visualize these forceful women, who also made their entrance on the opera scene in Richard Wagner's cycle *The Ring of the Nibelungen*.

At the exhibition of the Gothic Society, the sculptor Bengt Fogelberg (1786-1854) showed three statuettes of Norse gods: Odin, Thor and Frey. During the following years, Fogelberg made large-size marble versions of the statues, commissioned by King Carl XIV Johan. As the first king of the Bernadotte dynasty, holding the thrones of both Sweden and Norway, Carl Johan wanted to be associated with Nordic history; he particularly favoured depictions of Norse history and mythology, as did his son Oscar I. He was probably inspired by Napoleon's fascination with the Ossian legends (Björk 2005).

In the final versions of Fogelberg's godly trio, Frey was replaced by the popular Balder (ill. 5).

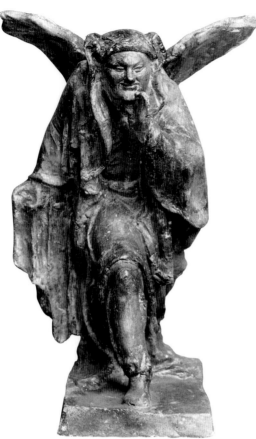

Ill. 6 [Herman Ernst Freund, *Loki*, 1822. Statuette in red clay, height 29 cm. Ny Carlsberg Glyptotek, Copenhagen, photo Ole Haupt]

These statues demonstrate the iconographic challenges which the artists faced in depicting such motifs. All the sculptures seem to have Greek or Roman models. Thor, for instance, is obviously modelled on Classical statues of Hercules. However, to distinguish him as a Nordic god, Fogelberg has equipped him with a bear skin and with his sledgehammer, *Mjölnir*. These were to become Thor's standard attributes in later 19th-century depictions. The standing Odin, holding a spear and a shield and wearing a crown, seems to take statues of Jupiter as its model. The problem of a Nordic subject depicted in a Classical style was pointed out by a contemporary writer, Axel Nyström, in 1835. On *Odin*, he comments: 'At first glance, all ideas about a Greek god are forgotten. The impression is Romantic, but by no means modern, while the image has a Classical pose. It expresses great force, but calm and simple, without exaggeration or affectation.' In spite of the Classical elements, Nyström concludes that the overall impression is Nordic, as the head belongs to 'a Jupiter, but not a Greek one [...] there is wisdom, but the Wisdom of Vala' (quoted from Nordensvan 272-273; my translation).

With these works, Fogelberg became the first sculptor in modern times to deal with Norse subjects. Only a few years later, the Danish sculptor Hermann Ernst Freund (1786-1840) started to work with similar themes. As a student and assistant of Bertel Thorwaldsen in Rome, Freund was schooled in the Classical universe. However, inspired by the art patron Jonas Collin, he soon turned his attention to the world of the Norse gods. On Collin's initiative, a competition calling for art works with Norse subjects was arranged in 1820. Collin saw

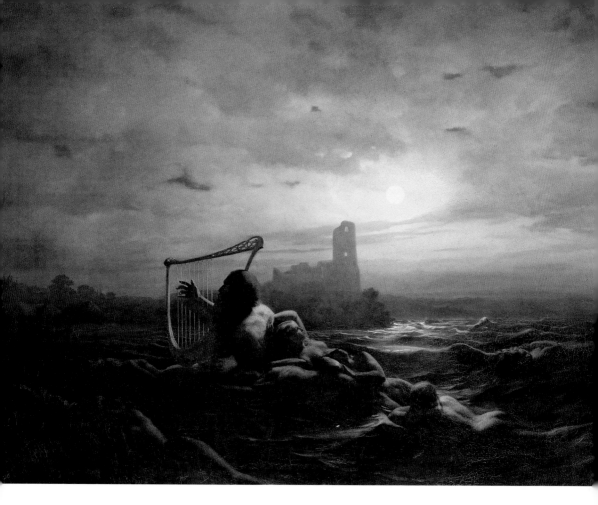

Ill. 7 [Nils Blommér, *The Water-Sprite and Ägir's Daughters*, 1850.
Oil on canvas, 114 x 147 cm. Nationalmuseum, Stockholm, photo Erik Cornelius]

that Freund was sent an invitation for this and also sent him a copy of Oehlen-schläger's *Gods of the North*. The art historian Julius Lange regarded this as a turn-ing-point, not only in Freund's artistic career, but even for the development of a Norse iconography (Lange, *Udvalgte Skrifter* 141-142). Freund participated in the competition with several *bozzetti* in 1822, and won a prize for *Odin*. However, his statuette *Loki* (ill. 6) is regarded as a more successful attempt at the depiction of a Nordic figure by most art critics and historians (Poulsen 315).

In the 19th century, Loki was interpreted as the personification of evil in Norse mythology, and it is this aspect that gives Freund his focus here. Later, Freund also executed *The Ragnarok Frieze* (1825-26), a relief depicting the Norse deities, for Christiansborg Palace in Copenhagen.[7]

The Norse gods also appear in several works by the Swedish painter Nils Blommér (1816-1853). Originally specializing in subject matters from folk tales, he eventually turned to the mythological world. In *The Water-Sprite and* Ägir's *Daughters* (1850; ill. 7), he combines a figure from Northern folklore with crea-tures from Norse mythology.

This reminds us that the Romantics regarded folk culture as a live link to the Old Norse culture, as expressed by Høyen and others. In other paintings, such as

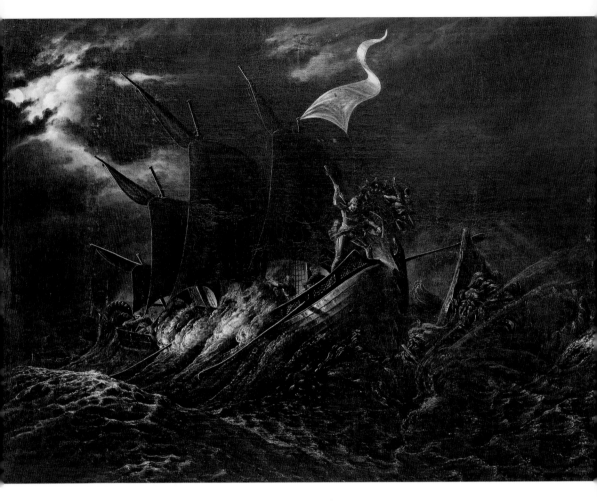

Ill. 8 [Carl Peter Lehmann, *Frithjof Slaying two Trolls at Sea*, 1826.
Oil on canvas, 86 x 115 cm. Bergen Kunstmuseum, photo Bergen Kunstmuseum]

Freya in Search of her Husband or *Freya and Heimdall*, Blommér has a more genre-like approach to mythological subjects, reflecting a change in the ideals of history painting.

In Norway, artistic life was not as developed as in the other Scandinavian countries, but had to be built up more or less from scratch. Art as well as literature played an important part in the young nation's self-image. Nature and folk life were preferred themes, but gradually subjects from history and mythology found a following. The Danish-born artist Johannes Flintoe (1787-1870) settled in the Norwegian capital Christiania (present day Oslo) in 1811 (Alsvik 10-15). He was genuinely interested in ancient history. Though he only executed one real history painting as far as we know, he played an important part in transmitting new ideas from the milieu in Copenhagen to Norway. An early attempt at a Norse subject is *Frithjof Slaying two Trolls at Sea* (1826; ill. 8), a scene from *Frithjof's Saga* painted by Carl Peter Lehmann (1794-1876), another Danish-born artist (Haverkamp; ill. 8).

Ill. 9 [Knud Baade, *Heimdall Summons the Gods to Battle*, 1828.
Oil on canvas, 150 x 101.5 cm. Norsk Folkemuseum, Oslo, photo Norsk Folkemuseum]

One of the first Norwegian artists who devoted himself whole-heartedly to subjects from Norse mythology was Knud Baade (1808-1879). His first attempt in the genre was *Heimdall Summons the Gods to Battle* (1828; ill. 9. Willoch; Ljøgodt, 'Knud Baade als Historienmaler'; Ljøgodt, *Måneskinnsmaleren*).

This was painted when Baade was studying with Eckersberg at the Academy in Copenhagen; the young Norwegian was obviously well acquainted with the contemporary fascination with Norse mythology. Later in life, Baade would recount: 'The mysteriousness of Norse mythology had great appeal to me in my youth. Heimdall Calling the Gods to Battle and Hermoder in Helheim were childish attempts during my stay in Copenhagen.' (Baade's autobiographical note).[8] Baade's painting represents Heimdall, guardian of the gods, blowing his horn to call the gods to battle at Ragnarok – the apocalypse of Norse mythology. This scene is described in the Norse poem 'Voluspa' in the Elder Edda. Baade, however, seems to have found his motif in a poem by Oehlenschläger, 'The Prophecy of Vola' [Volas Spaadom], from *The Gods of the North*. Here the end of the world is foretold:

> Upon the bridge,
> Heimdaller perch'd blows fearfully his horn
> to rise all nature to th'eternal strife;
> While Jormundgardur lifts his head and hisses.
> (Oehlenschläger, *Gods of the North*)

In the background, Odin and Thor arrive, as in the epic, while in the lower left corner two troll heads peek out at the scene, probably the giants fretting at the sight of the gods gathering for war. The picture was shown at the Copenhagen Academy Exhibition of 1828 and was later acquired by King Carl Johan, whose interest in Norse mythology has already been mentioned.

Another relevant work by Baade is the drawing *The Prophecy of Vala* (1843; ill. 10).

Vala is the seeress of Norse mythology. In the Elder Edda, the story is that Odin summons her and she prophesies the fate of the gods and the world, ending with Ragnarok. Once again Baade must have found the subject in Oehlenschläger's 'The Prophecy of Vala' from *The Gods of the North*. In Oehlenschläger's poem, as well as Baade's drawing, Thor is surrounded by the giants he has slain, and out of the vapor of their blood Vala appears. The same subject can be found in the Danish artist Andreas Ludvig Koop's painting *Vala Appears to Thor* (1823).[9] Romantic interpretations in art and literature vary, as we see, from the original Edda Poem. Baade's pictures are examples of how artists found their subjects in the literary works of the day, and not necessarily in the original Norse sources.

The debate over the use of Norse subjects in the visual arts reached Norway in connection with the decoration of the newly erected University buildings in Christiania around the middle of the century (Ljøgodt, '"… nordiske Marmorguder"'). Originally, Adolph Tidemand was asked to paint a scene from Saint Olaf's saga, but this project was abandoned – partly due to opposition against the theme. In 1852, the University's arts committee decided that they wanted a sculpture for the main hall. The young sculptor Julius Middelthun (1820-1886) was approached, and he accepted the commission eagerly. Middelthun had studied at the Academy in Copenhagen and had acquired an interest in Norse themes through the lectures of Høyen and the writings of Oehlenschläger. At this time, he was living in Rome and belonged to the circle of Scandinavian artists that included, amongst others, the abovementioned Bengt Fogelberg, Nils Blommér, and the Swedish sculptor Johan Peter Molin (1814-1876); all were interested in Norse themes. Middelthun naturally discussed his task with his friends and colleagues, of which the Swedish writer Gunnar Wennerberg writes in his diary:

The choice of subject matter was left to him [Middelthun]. First he had thought of a Minerva, but that was opposed, first by Blommér, then by me. Later, we talked about his other ideas: Idun, Snorre Sturlason and Heimdall. He spoke well for himself, with both historical and poetical understanding. He himself preferred his idea about Idun. I argued for Snorre, without anything against Idun. (Quoted from Gran 84; my translation.)

Ill. 10 [Knud Baade, *The Prophecy of Vala*, 1843.
Pencil and watercolour on paper, 406 x 472 mm. Bergen Kunstmuseum,
photo Bergen Kunstmuseum]

Middelthun sent sketches of the different subjects back home, including *Idun* (ill.
11), pictured carrying a basket of the apples of youth.

However, Middelthun's fascination with Norse themes met with scepticism
from certain circles in Norway. Johan Sebastian Welhaven, who as a poet had
himself treated motifs from Norse mythology, was heavily opposed to these
themes in the visual arts. As a member of the University's arts committee, he
wrote to Middelthun in the autumn of 1852, arguing against the artist's sug-
gestions: 'You seem to favour subject from the Norse myths. I am sceptical

about the idea, as I find these subjects unsuitable for the visual arts. I am surprised whenever I hear that sculptors are urged to make us Northern gods in marble.' (Quoted from Gran 87-89; my translation.) An important argument was that no original images of these gods existed which could be used as models. Probably on account of this opposition, Middelthun abandoned his ideas. Another sculptor who eagerly encouraged the use of Norse themes was Christopher Borch (1817-1896). For the frontispiece of the University, he suggested a relief of Odin seeking wisdom with Mime. But this project was not realized either: the University of Christiania never got any 'Northern gods in marble'.

One major project that *was* executed was Oscarshall, a neo-gothic building constructed for King Oscar I of Sweden and Norway at Bygdø outside of Christiania around the middle of the century. The King commissioned works by Norwegian artists of the day that depicted themes from Norwegian nature, folk life and history. The sculptor Hans Michelsen (1789-1859) made four statuettes of Norwegian kings from the saga era. As an overall theme for the decoration program, *Frithjof's Saga* was chosen. The painter Hans Gude (1825-1903) executed a series of landscapes from Sognefjorden, where the saga is supposed to have taken place. Here Christopher Borch got a chance to depict Norse themes, and made a series of reliefs with scenes from Tegnér's epic (ill. 12).

Ghosts and Bogeymen

As late as 1866, the Norwegian art historian Lorentz Dietrichson raised the question of Norse topics in the visual arts (Dietrichson, *Skandinaviska Konst-Exposi-*

Ill. 12 [Christopher Borch, *Frithjof and King Ring*, 1849.
Relief in plaster, 59 x 77 cm. Oscarshall, Oslo, photo The Royal Court]

tionen 59). The Romantic interest in these themes held its sway over the artistic imagination well into the second half of the 19th century. A new generation of artists, who could be described as Late Romantics, became interested in themes from Norse history and mythology. In Denmark, Constantin Hansen (1804-1880) painted *The Feast of* Ägir (1857), another subject related to the conflicts between the Asa gods and the evil forces represented by Loki. In particular, the fascination with Norse themes flourished among a small group of Swedish and Norwegian painters in the 1860s and 1870s (Björk, 'Från Ragnar Lodbrok til Laokoon'). The most important were the Swedes Mårten Eskil Winge (1825-1896) and August Malmström (1829-1901), and the Norwegian Peter Nicolai Arbo (1831-1892), who had studied together in Düsseldorf in the 1850s, and who all specialized in Norse subjects. While Malmström favoured subjects from the heroic sagas, the myths of the Norse gods were depicted in paintings by both Winge and Arbo.

At the Scandinavian Exhibition in Copenhagen in 1872, Winge showed his *Thor Battling the Giants*, and Arbo his major works *The Valkyrie* and *The Wild Hunt of Odin* (ills. 13, 14, 15).[10]

These pictures are all forceful representations of Norse deities, rushing through the sky, prepared for battle. We might say that they bring the gods into action, in contrast with the earlier, more serene presentations. Both the Valkyries and Thor had been popular among poets and artists since the beginning of the

Ill. 14 [Peter Nicolai Arbo, *The Valkyrie*, 1869.
Oil on canvas, 243 x 194 cm. Nasjonalmuseet for kunst,
arkitektur og design, Oslo, photo Jacques Lathion]

<

Ill. 13 [Mårten Eskil Winge, *Thor Battling the Giants*, 1872.
Oil on canvas, 484 x 333 cm. Nationalmuseum, Stockholm, photo Erik Cornelius]

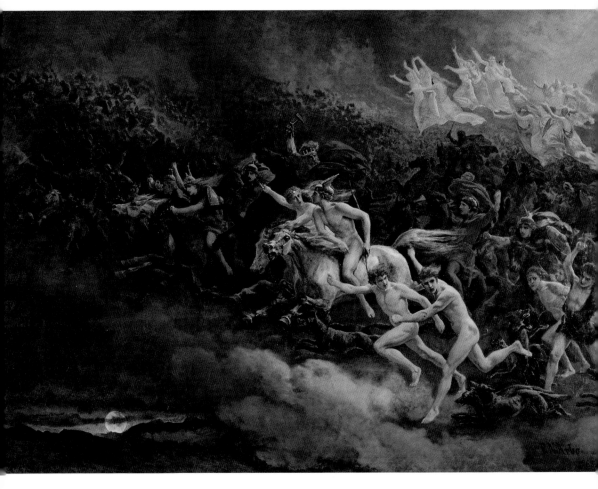

Ill. 15 [Peter Nicolai Arbo, *The Wild Hunt of Odin,* 1868.
Oil on canvas, 169 x 241 cm. Drammens Museum, on long term loan to
Nordnorsk Kunstmuseum, Tromsø, photo Nordnorsk Kunstmuseum]

century. *The Wild Hunt of Odin,* on the other hand, is in addition to Freund's
The Ragnarok Frieze one of the few attempts to visualize all the Norse gods in
one work. The subject matter is inspired by Johan Sebastian Welhaven's poem,
'Asgaardsreien' [The Wild Hunt of Odin], from 1845. The subject of the Norse
gods is blended with the traditional European legend of 'der Wilde Jagd'. In his
important work *Deutsche Mythologie* (1835), Jacob Grimm had identified this as an
example of how elements of pagan religion could survive into Christian times as
daemonic phenomena (Grimm vol. 1 765-766), The artist also knew depictions of
this motif by other German artists, such as Joseph Führich and Rudolf Friedrich
Henneberg (Ljøgodt, *Historien fremstilt i bilder* 102-105). Another visual source was
August Malmström's painting *Bråvallaslaget* (1860-62), in which the gods appear
in the sky above the combatants (Lange, 'Historiemaleren Peter Nicolai Arbo').
Arbo used various sources, from mythology and folklore as well as contemporary
literature and art, to create this grand composition.

Contemporary critics regarded these pictures as essentially ethical allegories, rather than representations of real deities, a view already held by early 19th-century writers such as Oehlenschläger and Grundtvig. The Romantic tradition was still alive – but not for long. The critics, headed by Julius Lange, took a sceptical position with regard to the depiction of Norse myths. In his review of the Scandinavian Exhibition of 1872, Lange was highly critical of the mythological works of both Arbo and Winge, referring to them as 'Ghosts and Bogeymen' (Lange, 'Den svenske og norske Kunst' 443). At this stage, Realism had become the dominant force of art and literature. Within the boundaries of the new movement's ideals, there was little or no room for the Late Romantics' imaginary depictions of the Norse myths.

The Romantics and the Norse Myths

The Norse myths were rediscovered in the late 18th century, and during the Romantic period they became popular sources of inspiration for art and literature, in particular in the Scandinavian countries. This was closely connected with the political thinking of the period, and in particular with the ideals of national cultures and identities. For a freshly emerged nation state such as Norway, it was important to link the present with the glory of the past. In old, powerful kingdoms like Denmark and Sweden, the lineage to ancient history was also emphasized. We should recall that Denmark had been on the losing side of the Napoleonic war, and later in the century was the victim of German aggression. Sweden also had its losses, giving up Finland to Russia, and in addition it had a new royal dynasty with a need to legitimize itself. In different ways, the Norse themes became a part of national programs in these countries.

However, once introduced, the Norse myths started to develop a life of their own in art and literature. One of the alluring aspects of these themes was the fact that they did not have an established iconography and thus were open to interpretation and even poetic license, as Oehlenschläger pointed out. The artists, it seems, chose freely from different themes and different kind of sources. More often than not, the works of contemporary writers such as Oehlenschläger were preferred to the original Norse sources. This suggests, I believe, that the artists were not so occupied with recreating a Norse iconography as they were with the myths and stories as subject matter. It was a matter of finding original and interesting – and very often obscure – motifs for works of art: artistic interest prevailed over antiquarian research.

A good example of this is can be found in the oeuvre of Knud Baade. We have already seen two of his works, both with subjects from Norse mythology taken from Oehlenschläger's *The Gods of the North*. A recurring motif in his work is the lonely warrior. In a painting from 1850, *Scene from the Era of Norwegian Sagas* (ill. 16), a Viking stands alone on the top of a cliff, contemplating the moonlit sea.

The lonely Viking, the last of his kind, is a motif we also know from Romantic poetry, such as Geijer's 'The Last Warrior' [Den siste kämpen] and Welhaven's 'Coastal Scene' [Kyst-Billede]. Baade's painting is probably not a representation

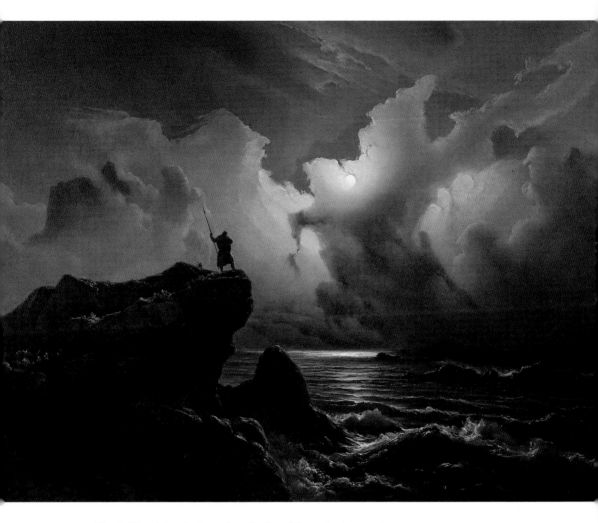

Ill. 16 [Knud Baade, *Scene from the Era of Norwegian Sagas*, 1850.
Oil on canvas, 87.5 x 119.5 cm. Collection of Asbjørn Lunde, New York,
photo Nordnorsk Kunstmuseum, Tromsø]

of any concrete story or scene from Norse mythology, but more likely reflects the
melancholy mood of an encounter with a hero of the ancient past, perhaps in-
spired by the poems of Geijer or Welhaven. According to Baade's own statement,
it was the 'mysterious and poetic Element' that appealed to him in the Norse
myths (Baade's autobiographical note). Rather than an antiquarian reconstruc-
tion, Baade prefers a poetical interpretation of the Norse myths – like so many
other artists of the Romantic era.

Literature

Alsvik, Henning. *Johannes Flintoe*. Oslo: Kunst og Kulturs serie, 1940.

Björk, Tomas. *August Malmström: Grindslantens målare og 1800-talets bildvärld*. Stockholm: Nordiska Museet, 1997.

Björk, Tomas. 'Från Ragnar Lodbrok til Laokoon: August Malmström och Mårten Eskil Winge i Rom'. *Inspirationens skatkammer: Rom og skandinaviske kunstnere i 1800-tallet*. Eds. Hannemarie Ragn Jensen, Solfrod Söderlind and Eva-Lena Bengtsson. Copenhagen: Museum Tusculanums Forlag, 2003. 213-232

Björk, Tomas. 'Historiemåleriet'. *Signums svenska konsthistoria: Konsten 1845-1890*. Lund: Bokförlaget Signmum, 2000.

Björk, Tomas. 'Praktfulla kungar och nordiske historier: Kungaporträtt och historemåleri i svensk konst under 1800-talet'. *Myt och landskap: Unionsopplösning och kulturell gemenskap*. Ed. Hans Henrik Brummer. Stockholm: Prins Eugens Waldemarsudde, 2005. 75-99.

Bliksrud, Liv. *Den smilende makten: Norske Selskab i København og Johan Herman Wessel*. Oslo: Aschehoug, 1999.

Blixen, Karen (Isak Dinesen). *Winter's Tales*. Harmondsworth: Penguin, 1983.

Borch, Christopher. *Optegnelser efter nogle Foredrag om Kunsten*. Kristiania, 1881.

Baade, Knud. Letter to Thorvald Christensen. 29 March 1872. Documentation Archive, National Museum of Art, Architecture and Design, Oslo. Includes autobiographical note.

Dietrichson, Lorentz. *Adolph Tidemand, hans liv og hans Værker*. Vols. 1-2. Christiania: Chr. Tønsbergs Forlag, 1878-1879.

Dietrichson, Lorentz. *Skandinaviska Konst-Expositionen i Stockholm 1866*. Stockholm, 1866.

Geijer, Erik Gustaf. *Minnen. Dikter. Tal och artiklar. Ur Geijers historiska författarskap. Anteckningar. Brev*. Stockholm: Albert Bonniers Förlag, 1958.

Gran, Henning. *Billedhuggeren Julius Middelthun*. Oslo: Aschehoug, 1946.

Grandien, Bo. *Rönndruvans glöd: Nygöticistisk i tanke, konst och miljö under 1800-talet*. Stockholm: Nordiska Museet, 1987.

Grimm, Jacob. *Deutsche Mythologie*. Vols. 1-2. Wiesbaden: Fourier Verlag, 2003.

Grundtvig, Nils Frederik Severin. *Værker i Udvalg*. Vols. 1-10. Eds. Georg Christensen and Hal Koch. Copenhagen: Gyldendal, 1940-1949.

Haverkamp, Frode. *Carl Peter Lehmann*. Bergen: Bergen Kommunes Kunstsamlinger, 1994.

Høyen, Niels Laurits. *Skrifter*. Vols. 1-3. Ed. J. L. Ussing. Copenhagen: Den Gyldendalske Boghandel, 1871-1876.

Lange, Julius. 'Den svenske og norske Kunst paa den nordiske Udstilling i Kjøbenhavn 1872: 4. Billeder af Nordens Oldtid'. *Nutids-kunst*. Copenhagen: P. G. Philipsens Forlag, 1873. 430-447.

Lange, Julius. 'H. E. Freund' (1891). *Udvalgte Skrifter*. Vol. 1. Copenhagen: Det Nordiske Forlag, 1900.

Lange, Marit. 'Historiemaleren Peter Nicolai Arbo, noen synspunkter'. *Peter Nicolai Arbo 1831-1892*. Eds. Marit Lange and Anne-Berit Skaug. Drammen: Drammens Museum, 1986. 5-14.

Lange, Marit and Knut Ljøgodt, eds. *Svermeri og virkelighet. München i norsk maleri*. Oslo: Nasjonalgalleriet, 2002.

Liberg, Astrid. *Edda og saga i romantikkens billedkunst i Norden og med særlig henblikk på Norge*. MS thesis. Oslo: Universitetet i Oslo, 1951.

Ljøgodt, Knut. *Historien fremstilt i bilder*. Oslo: Pax, 2011.

Ljøgodt, Knut. 'Knud Baade als Historienmaler'. *Münchner Jahrbuch der Bildenden Kunste 2009* 60 (2008): 289-299.

Ljøgodt, Knut. *Måneskinnsmaleren/Moonlight Romantic: Knud Baade (1808-1879)*. Stamsund & Tromsø: Orkana & Nordnorsk Kunstmuseum, 2012.

Ljøgodt, Knut. '"... nordiske Marmorguder": Utsmykninger og utsmykningsplaner ved Det kongelige Frederiks Universitet i Christiania på 1800-tallet'. *Edvard Munchs aulamalerier: Fra kontroversielt prosjekt til nasjonalskatt*. Eds. Peder Anker and Patricia G. Berman. Oslo: Messel Forlag og Universitetet i Oslo, 2011. 73-87.

Macpherson, James. *The Poems of Ossian and related works*. Ed. Howard Gaskill. Edinburgh: Edinburgh University Press, 2006.

Malmanger, Magne: *Norsk malerkunst fra klassisisme til tidlig realisme*. Oslo: Nasjonalgalleriet, 1981.

Meldahl, F. and P. Johansen. *Det Kongelige Akademi for de skjønne Kunster 1700-1904*. Copenhagen: H. Hagerups Boghandel, 1904.

Monrad, Kasper and Peter Nørgaard Larsen, eds. *Mellem guder og helte: Historiemaleriet i Rom, Paris og København 1770-1820*. Copenhagen: Statens Museum for Kunst, 1990.

Mjöberg, Jöran. *Drömmen om sagatiden*. Vols. 1-2. Stockholm: Natur och Kultur, 1967-1968.

Munch, P. A. *Nordens gamle Gude- og Heltesagn*. Christiania: Guldberg & Dzwonkowski, 1840.

Munch, P. A. *Norrøne gude- og heltesagn*. Ed. Jørgen Haavardsholm. Oslo: Universitetsforlaget, 1996.

Nettum, Rolf Nyboe. *Christen Pram: Norges første romanforfatter*. Oslo: Aschehoug, 2001.

Nordensvan, Georg. *Svensk konst och svenska konstnärer i nittonde århundradet*. Vol. 1. Stockholm: Albert Bonniers Förlag, 1925.

Nykjær, Mogens. 'Nationalopdragelse, mytologi og historie'. *Kundskabens billeder*. Aarhus: Aarhus Universitetsforlag, 1991. 31-57.

Oehlenschläger, Adam. *Gods of the North*. Trans. William Edward Frye. London: Pickering; Paris: Stassin and Xavier, 1845.

Oehlenschläger, Adam. *Poetiske Skrifter*. Vols. 1-33. Ed. F. L. Liebenberg. Copenhagen: Selskabet til Udgivelse af Oehlenschlägers Skrifter, 1857-1972.

Oehlenschläger, Adam. *Æstetiske Skrifter 1800-1812*. Ed. F. J. Billeskov Jansen. Copenhagen: Oehlenschläger Selskabet, 1980.

Poulsen, Vagn. 'Herman Ernst Freund'. *Dansk kunsthistorie*. Vol. 3. Copenhagen: Politikens Forlag, 1972. 311-319.

Welhaven, Johan Sebastian. *Samlede Skrifter*. Vols. 1-8. Copenhagen: Den Gyldendalske Boghandel (F. Hegel), 1867-1868.

Willoch, Sigurd. 'Heimdal kaller gudene til kamp: Et maleri av Knud Baade'. *By og bygd*, 1943. 49-56.

Wilson, David M. *Vikinger og guder i europæisk kunst*. Aarhus: Moesgård Museum, 1997.

Notes

My interest in this topic theme derives from my research for my book on Norwegian history painting in the 19th century, *Historien fremstilt i bilder* (Oslo: Pax, 2011). The book's focus is on Norwegian art history, a perspective that is also evident in this article. However, I have also attempted to include examples from Danish and Swedish art, as well as to demonstrate the background in contemporary Scandinavian literature. Further references can be found in this book.

1 The Ossian poems were originally published in three different volumes: *Fragments of Ancient Poetry* (1760), *Fingal* (1761-62), and *Temora* (1763). In 1765, they were published together in an edition entitled *The Works of Ossian*. The authenticity of the poems was discussed both at the time of their publishing and by later generations. Today, the general opinion seems to be that the poems are based on old sources, edited and given literary form by Macpherson.

2 Henrik Wergeland was so fascinated by the Ossian poems that he even took for one of his alter egos Siful Sifadda, a derivation of Sulin Sifadda, one of the hero Chuchullin's horses.

3 Fuseli's drawing belongs to the collections of the Nationalmuseum, Stockholm.

4 A reception piece was a work of art that an artist made as a sort of application to become a member of an Art Academy.

5 Adam Oehlenschläger, 'Forsøg til Besvarelse af det ved Kiøbenhavns Universitets fremsatte Priis-spørsmaal: "Var det gavnligt for Nordens skiønne Litteratur, om den gamle, nordiske Mythologi blev indført og almindelig antaget, istedet for den Grædske?"' (1801).

6 P. A. Munch, *Nordens gamle Gude- og Heltesagn* (1840). Reissued in several later editions under the title *Norrøne gude- og heltesagn*.

7 *The Ragnarok Frieze* was unfortunately lost in a fire at Christansborg Palace in 1884.

8 Knud Baade, letter to Thorvald Christensen, dated Munich March 29, 1872 This letter consists mainly of an autobiographical note. A sketch of the note is found in the National Library, Oslo. The latter is published in Didrik Grønvold, ed., 'Av Knud Baades papirer'. *Kunst og Kultur*, 1926.

9 Koop's painting belongs to the collections of the Royal Academy of Arts, Copenhagen.

10 There are two large verisons of Arbo's *The Valkyrie*. The 1865 version belongs to the Nationalmuseum, Stockholm, while the 1869 painting illustrated here belongs to the National Museum of Art, Architecture and Design, Oslo. *The Wild Hunt of Odin* was also executed in two versions; the 1868 painting illustrated here belongs to Drammens Museum and is on long-term loan to the Art Museum of Northern Norway, Tromsø, while the 1872 version belongs to the National Museum in Oslo.

Reviews

Constructions of German Romanticism

Six Studies

Ed. Mattias Pirholt. Uppsala:
Uppsala Universitet, 2011. 190 pp.
ISBN 978 915 54 8152 0

From the earliest critical receptions into the 21st century, critical and creative responses to German Romanticism have been embroiled in the dominant ideologies of the epochs in which they were written. This is the central thesis of Uppsala University's recently published collection of essays: *Constructions of German Romanticism: Six Studies*. Including four essays in English and two in German, the collection begins with an introduction that acknowledges the importance of Hans Robert Jauss' 1970 thesis that 'the critic is in no way able to independently present a unique perspective, standing apart in relation to the process of reception and production' (9). As such, the collection begins with a clear acknowledgement of critical pluralism and the role it has played in the last forty years of literary scholarship in general, and in scholarship on German Romanticism in particular. However, while its introduction hails Jauss' thesis as foundational, it challenges its pure aestheticism, recognizing that 'how we choose to construct literary history is inevitably an ideological act, which gives literature purpose and meaning in a much larger context' (9).

Thus, Jauss' thesis is augmented by the suggestion that critical perspectives 'are all involved in a still ongoing ideological battle' (10): a battle which is pervaded by 'various hegemonic paradigms' such as, for example, Raymond Williams' notion of 'selective traditions' and Fredric Jameson's 'allegorical master narratives' (10). The introduction goes on to observe that 'more than any other epoch in literary history, Romanticism is defined by the ideological view that is dominant' (11). The history of its critical reception is, then, one of competing critical paradigms.

Appropriately, in the opening essay, Anna Culled engages in a re-examination of Frederick Beiser's definitions of *Frühromantik*. In a scholarly and well-balanced discussion, Culled enumerates Beiser's seminal insights into the Jena Circle, while raising concerns about his 'division of labor' (38) between early German Romantic poets and philosophers. Culled argues that Beiser does not pay heed to the 'overlaps' (40) that occurred between these disciplines, which involve moral philosophy, politics, theology and rhetoric. She concludes that although Beiser's work is insightful, it does not

fully appreciate how 'the pathways' of poetics and philosophy 'meander toward a new kind of knowledge' (41).

Andreas Kubik's essay provides the collection with an investigation of Novalis' posthumously published 'Die Christenheit oder Europa' [Christendom or Europe] (1799, 1826). Observing that Novalis' interpretation of the Christian Middle Ages is not based upon historical accounts as much as it is upon his utopian ideal, Kubik interprets 'Die Christenheit oder Europa' as a visionary ideological work about Christianity. Thus, while 'Die Christenheit oder Europa' has generally been regarded as a historical or political work, Kubik points to how Novalis' aims entail the Romanticizing of Christianity so as to restore 'a culture of religious feeling' (77).

In the third essay, Roland Lysell explores the dramatic criticism of Madame de Staël, charting how Staël's appreciations of German drama in the second volume of De l'Allemagne (1810) are filtered through the ideologies of French aesthetics. Concentrating mainly on Staël's discussions of Lessing, Schiller and Goethe, Lysell enumerates the way that Staël praised German drama for its 'naturalism', 'imagination' and 'the many-sidedness' of its actors (91), and criticized it for its lack of unity. As Lysell observes, Stael uses these appreciations to criticize French drama for being 'superficial' (91), even while she maintains it as the dominant source of her aesthetics.

In the second German essay, Gernot Müller traces the evolution of the reception of Heinrich von Kleist's work in Sweden and how his work was championed by Fredrik Böök.

Müller's discussion explains how Böök's re-figuration of Kleist involves an ideological turn. Documenting how 19th-century Swedish receptions of Kleist had been influenced by Goethe's rejection of him as an example of the 'pathology of romanticism' (124), Müller goes on to relate how Böök salvaged the poet's reputation, transforming him into a figure of patriotic nationalism. However, Böök's success positioned Kleist's work in a far more problematic paradigm, in that the poet became appropriated by the radical conservative movement that was centered on the so-called 'ideas of 1914', which were advocated by Rudolf Kjellén and subsequently became part of the foundations of National Socialism.

Todd Kontje contributes the collection's fifth essay, which discusses manifestations of German Romanticism in the work of Thomas Mann. In a section of the essay titled 'Romanticism's Double Legacy', Konjte succinctly identifies the way in which German Romanticism both embraces the ideals of cosmopolitanism and democracy and persistently maintains the idea of a German soul, which endorses 'a fervent German nationalism with a tendency toward violence, myth and anti-Semitism' (134). Kontje notes that it is this duality that Mann comes to inherit, and his essay elaborates on what this inheritance means for an interpretation of Mann's late novel Doktor Faustus (1947). The essay traces the development of this paradox, and so it provides the entire collection of essays with an impressive cultural and literary history. We return to Madame de Staël, Novalis and Kleist to view their work in terms

of a German ideal that begins with the writings of Tacitus and ends with Mann himself.

The breadth of Kontje's discussion is picked up in the sixth and final essay by Mattias Pirholt. Pirholt's ambitious task is an examination of 'the construction of Romanticism in criticism of today' (155). He begins by pointing out the contrast between Staël's notions of German Romanticism as an inventive progression toward modernity that resists the classical world (154) and Heinrich Heine's view that German Romanticism is, in fact, 'a reactionary and restorative movement' (155) that seeks to return to the literature of the Middle Ages. Thus, while he shows how these positions are inherently antithetical, Pirholt also describes them as being unified in a 'constellation' (155) which has become the inheritance of modernity. The essay then proceeds to explore how the paradox of this Staël-Heine constellation influences modernist aesthetics. With reference to the work of W. J. T. Mitchell, Pirholt uses the paradox to consider the problems of mimesis in modernism. His essay concludes by anticipating Pirholt's further work into what he terms 'met-amimesis' (175).

Constructions of German Romanticism is an excellent addition to the field of German Romantic studies specifically, and Romantic studies in general. Organized in such a way that it follows a literary history, the collection has both thematic and literary breadth that dignifies its diverse subjects. Furthermore the overall stance of the collection – its attention to the ideological bent of literary history and criticism – makes each essay something of a meta-text, in that these writers are conscious of their roles as critics participating within a climate of ideological conflicts even while they explore how such conflicts have been manifested in the past. The collection is, then, a testament to fine scholarship as well as an illustration of the role culturally conscious critics have in negotiating contemporary ideological paradigms.

Andrew Miller
Copenhagen University

Erindringens poetik

William Wordsworth, S. T. Coleridge, Thomas De Quincey

By Lis Møller. Aarhus:
Aarhus Universitetsforlag, 2011. 638 pp.
ISBN 978 87 7934 519 5

In her doctoral dissertation *Erindringens poetik: William Wordsworth, S. T. Coleridge, Thomas De Quincey*, Lis Møller finds a new, personal way into her authors through a study of 'the poetics of memory'. The Danish word 'erindring' corresponds to 'memory', but also to 'recollection', 'remembrance' and 'reminiscense'. Møller concentrates on the Romantic conception of personal memory and the representation of the faculty of memory in the poetic texts, including metaphors and other poetic images. Secondly, she studies memory as 'a rhetorical, structural, and narrative device' (585) – memory is understood as a principle of form and not only as a theme. Thirdly, she reflects upon the role memory is assigned in the aesthetic texts of her three authors.

The book starts with Georges Poulet's observation that the phenomenon of subjective individual memory is a discovery of the 18th century. She connects this new conception of memory with the English empirical tradition, starting with John Locke's *Essay Concerning Human Understanding* (1700). Locke is, according to Paul Ricoeur, the inventor of the complex 'identity-consciousness-self' (70).

Locke founds his theory of the *tabula rasa* on an Aristotelian approach: sense perceptions are the prerequisites of memory. He rejects any notion of 'innate ideas'.

Focusing on infinity and the eternal, the Romantics revive Platonic theories that emphasizes innate ideas and the ontological priority of memory over sensation. In spite of their Platonic turn, however, the English Romantics try to amalgamate Platonic thought and empirical epistemology.

There are two main traditions of conceptualizing memory: the spatial metaphor, which represents memory in the form of a 'container' with a 'content', and the graphical metaphor, which views memory as a stamp, a mark or an inscription. The Romantics tend to merge spatial and graphic metaphors.

The Romantic conception of the child is different from Rousseau's, as it emphasizes both the experience of continuity and that of discontinuity concerning the adult's relation to his childhood. Wordsworth distinguishes them as 'two consciousnesses' in *The Prelude*; the Romantic child is above all a remembered child, an inner child.

In the chapter 'William Words-

worth: The Landscape of Memory', Møller concentrates on Wordsworth's poetry between 1798 and 1806, above all *The Prelude*. She is counters William Blake's statement that Wordsworth's faithfulness to memory prevented him from becoming a great poet. Geoffrey H. Hartman also declared that an 'unresolved opposition between Imagination and Nature prevents him [Wordsworth] from becoming a visionary poet' (110). In contrast, Møller sympathizes with the position of Charles Altieri and argues that Wordsworth uses the idea of memory to construct a bridge between associationism and idealism. Wordsworth's conception of the child seems to differ from text to text. Sometimes, as in 'Tintern Abbey', we can trace the humanizing of the pre-symbolic animalistic child of nature, and sometimes – especially in 'Ode: Intimations of Immortality from Reflections of Early Childhood' – the child's proximity to divinity is underlined. Møller is right in criticizing M. H. Abrams and emphasizing the difference between the two poems.

According to Møller, Wordsworth's poetics of memory – he evolves from a descriptive poet in the 1790s to a poet of memory in *The Prelude* – is most distinctly expressed in his depiction of landscape. Especially interesting is Møller's passage about landscape and sign inscription (177–179).

Møller is an extremely well-read scholar and her knowledge of Kierkegaard and Freud gives her a route into Romanticism that sometimes differs from the more biographical approach common among British scholars. She finds Kierkegaard's definition of

memory as a means of enhancement ('Forøgelses-Middel') fruitful, together with his description of forgetting as a pair of scissors cutting off what is not essential.

James Heffernan has compared Wordsworth's poetry to the paintings of Constable and Turner, but Møller considers Wordsworth's poetic method as more strikingly similar to the work of Caspar David Friedrich, especially his painting *Der Wanderer über dem Nebelmeer* (1828). In both cases the natural object depicted is simultaneously a realistic thing and a sign with hieroglyphic qualities, pointing beyond itself; in both cases, too, perception is mediated through memory. According to Friedrich, landscape paintings should not depict the natural scene but the reminiscence of it. Møller discusses several famous works of Friedrich but curiously enough not *Blick aus dem Atelier des Künstlers*, in which you see the painter's eye in a mirror – a consideration of this painting would have strengthened her argument.

Møller makes much of the well-known 'spots of time', i.e. poignant early memories with a visionary quality to the adult mind. Representing the indestructible memory traces as inscribed on the landscape itself, Wordsworth's metaphors are endowed with a graphic quality.

In the chapter 'S. T. Coleridge: The Book of Memory', Møller looks for fragments of a theory of memory in Coleridge's prose works. With the publication of his notebooks the impressive character of Coleridge's non-literary work became clear to most scholars. The distinction in *Biographia Literaria* between primary and second-

ary imagination on the one hand and fancy on the other is basic. The imagination concept is founded on Schelling's definition of 'Einbildungskraft', but the concept of fancy corresponds to Kant's 'reproductive imagination', which is subject to the law of association. Concerning the importance of Hartley, scholars are unanimous: some, however, have asserted that Coleridge denounces Hartley in the early 19th century, but according to Møller, revised and modified versions of Hartley's psychology are still important in the exposition of fancy, dream and delirium in *Biographia Literaria* and other late texts.

Although Coleridge discusses the creative potential of the dream in the preface to 'Kubla Khan' he seems skeptical and maintains that 'artistic Dreams form a *distinct* Kind – and ought not to have been confounded with those of proper Sleep' (600). A poem may be considered as a dream, but only a waking dream. Coleridge believes in a memory independent of the will and the conscious mind. A fundamental thought concerns the existence of a latent memory: 'the dread book of judgement, in whose mysterious hieroglyphics every idle word is recorded!' (601). In her classic work *Coleridge, Opium and Kubla Khan* (1953), Elizabeth Schneider relates Coleridge's theory of dreaming particularly to Erasmus Darwin. Møller proposes other possible frameworks for Coleridge's hypothesis of this full recording in memory: Leibnitz, animal magnetism and Swedenborg.

The most daring hypothesis in Møller's dissertation is that Wordsworth's memory as an act of giving meaning as well as reminiscing and Coleridge's idea about a complete recording in memory merge into one in Thomas De Quincey's autobiographical writings *Confessions of an English Opium-Eater* (1821), *Suspiria de Profundis* (1845) and *The English Mail-Coach* (1849).

To De Quincey, the memories of the child, which are also the objects of memory to the narrator, are enigmatic signs. The adult is an interpreter and retrospection is an act of reading. Møller also explains how the memories of De Quincey's reaction as a child to the death of his sister remained latent until he started to take opium as a student at Oxford.

Møller's reading of De Quincey centers on three crucial figures: the hieroglyph, the arabesque and the palimpsest. The hieroglyph is the nodal point in a network of signs, but this network is not static. It is 'open to altered valuations' (605). The hieroglyph is 'involute', a De Quincey term, i.e. it contains a juxtaposition of antagonist qualities. Møller's argument for using the concept of the arabesque is that De Quincey tried to imitate the structure of memory itself in his writings and that he emphasizes the dynamic aspect of memory. The graphic metaphor of the palimpsest, used by De Quincey himself when writing about 'the deep memorial palimpsest of the brain' (607), is the perfect image of how memory traces appear and disappear in the mind.

To Møller, the autobiographical work of De Quincey may be seen as the culmination of the Romantic conception of memory. But is there not a difference between, for instance, the calm resignation of Wordsworth's reflective protagonist in 'The Two April

Mornings' and De Quincey's autobiographical subject being harassed by the dead?

Does Møller succeed in her project of bringing the three authors together? On the surface, the chapters might seem disparate and in the De Quincey chapter purely literary analysis dominates. Møller refers to Georges Poulet before beginning her study, however, and after an attentive reading it is clear that just as Poulet – always considering both aesthetics and the history of ideas in *Ëtudes sur le temps humain* – studies aspects of the treatment of memory in important passages in the works of different authors, Møller succeeds using the same method.

In her concluding remarks, Møller compares William James, Sigmund Freud and Henri Bergson to the Romantics. I would add that there are also affinities with the phenomenological tradition from Husserl and onwards and when reading Møller's dissertation one constantly thinks of related (but strangely different) passages in the works of Rilke, Proust and Virginia Woolf.

Thanks to her concentration on selected texts and crucial questions in literary criticism about the Romantics, as well as her eminent talent for elucidating complicated issues, Møller can be proud of having written a dissertation which stands out as a magnificent work on three English Romantic authors.

Roland Lysell
Stockholm University

CONFERENCE REVIEW

Romantic Intermediality

Helsinki November 2011

The international conference *Romantic Intermediality* took place in Helsinki 24-25 November 2011 and was convened by Leena Eilittä (U. of Helsinki) with Henry Bacon (U. of Helsinki) and Lauri Suurpää (Sibelius Academy). Eilittä's opening remarks outlined the conference's three broad areas of investigation: 1) how concepts developed in 19th-century Romanticism might be reinterpreted from the perspective of cultural and media studies and applied to figures such as Blake, Keats, Tieck, the Schlegels and Hoffmann; 2) how Romantic discourse has been consciously deployed by post- or neo-Romantic movements and artists, poets, film makers and composers, both within and beyond Europe, and often as a medium for doing politics via culture; and 3) how Romantic intermedial approaches continue to generate experimentation in present-day culture and aesthetics. A conference volume, *Afterlives of Romantic Intermediality*, is forthcoming.

Hans-Peter Wagner (U. of Koblenz-Landau) opened the conference with a plenary talk on William Blake and text/image relations. More than a mere elaboration of the verbal poems, Blake's poem-etchings function as Derridean supplements, visual commentaries that perform as counter-texts referring to that which otherwise remains out of sight (the obscene, the taboo); Wagner noted that this is the grounding condition of writing itself, which seeks to stand in for the absent object. Wagner compared Blake's strategy with illuminated manuscripts, Japanese prints and Hogarth's 18th-century satirical prints, in which text and image work together to produce a morally didactic 'reading' of visual signs.

A second plenary by James Cisneros (U. de Montréal) introduced a geographical and historical dimension to considerations of Romanticism and intermediality. Cisneros used the delay which structures ekphrastic description of absent and temporally distant art objects as a figure for the relationship of Argentine to European Romanticism. The Argentinian River Plate Romantics, in political exile in the 1830s following the Rosas dictatorship in Buenos Aires, self-consciously adopted British Romantic discourse as a model for political subjectivity. However, there was one notable difference in their cultural borrowing, namely a refusal of ekphrasis. Whereas the English Romantics deploy ekphrastic description of monuments and artworks to highlight the uncertain

limits of subjective knowledge and thus to question Enlightenment privileging of reason, the River Plate Romantics consciously rejected ekphrasis. For them, ekphrasis becomes a lack – a sign of a turning away from European models – introducing a negation that destabilises subject/object hierarchies and creates an opening for different types of knowledge, ones which might include haunting and the historicity it implies.

Re-Reading Romanticism from an Intermedial Perspective

Klara Franz (HU, Berlin) addressed an implicit Romantic engagement with the 18th-century notion of the picturesque in Keats, proposing that his ekphrastic poems could be seen as an extension of poetic negative capability. Whereas distance between (ego-filled) subject and object structures Wordsworth's texts, Keats empties out the poetic 'I' to produce an encounter in which Otherness is always proximate to the self, overcoming the problem of the Wordsworthian *egotistical sublime*. Keats replaces the picture frame with poetic imagination, in which image and verbal representation merge to form a perceptual framework.

Asko Nivala (U. of Turku) and Helmut Grugger (U. of Innsbruck) both addressed Friedrich Schlegel's concept of *Universalpoesie*. Nivala argued that Schlegel was an early theorist of intermediality, who proposed *progressive Universalpoesie* as something that could unite all forms of opposition by acting as 'a mirror of the whole circumambient world'. However, the dialectical dynamic of progressive universal poetry can lead to a 'bad infinity' in which there is infinite regression, and no progression. Nivala thus drew on Walter Benjamin's concept of a *Reflexionsmedium* in which art is not *Vermittlung* (mediation) but *Mitteilung* (communication), or the bringing together of community through the letter. The form for this was the journal edited by Schlegel and his brother, a Romantic medium in which a heterogeneous mix of texts could be widely circulated, encompassing both Romanticism and Classicism.

Helmut Grugger (U. of Innsbruck) started off by playing a clip from the Rolling Stones' 'Sympathy for the Devil', which adapts the Mephistopheles figure in Mikhail Bulgakov's modernist novel *Master and Margarita*, which in turn borrows from Goethe's 19th-century *Faust*, itself drawing on Christopher Marlowe's Renaissance play. This introduced the complex intermedial network that goes by the name of Faust. Thinking about the many ways in which Faust/Goethe signify, Grugger suggested that the reflecting mirror of Schlegel's *Poesie* should not be thought of in terms of copy and original, but rather as a radical extension of the original that transgresses generic boundaries and disciplinary categories. Examining the use of Mephistopheles by Bulgakov, and Faust as a role split among seven actors in Werner Schwab's *Faust :: Mein Brustkorb : Mein Helm*, Grugger thus suggested that Goethe's *Faust* could be understood as not only a Romantic work but also as a reflection on the Romantic incorporation and re-assemblage of Renaissance and Enlightenment philosophy.

Taking up the problem and/or potential of language, Norman Kasper (U. of Halle-Wittenberg) suggested that poetic language in von Eichendorff and Tieck is not about translating the visual, but rather a means for negotiating the viewing experience. Tieck's 'Die Töne', for example, attempts to convey not color but the effect of color on the reader's sensorium. Tieck can also be understood in the cultural context of Goethe's investigation of light as physical sensation. These two Romantic poets can be read as forging a new, intermedial concept of metaphor, in which poetry both creates and serves as a bridge – between subjective and objective, internal psychological effect and external physiological sensation.

Tobias Hermans (U. of Ghent) suggested, in an excellent paper, that Mahler's late 19th-century *Lieder eines fahrenden Gesellen* comprise an aesthetic negotiation of the Romantic legacy. In his song cycle, Mahler draws on the earlier Romantic *lieder* tradition of Wilhelm Müller, thus establishing a temporal distance from his own work. This temporal distance, Hermans suggested, is a form of 'autarchic intermediality'. Mahler's compositions are post-Romantic, according to Hermans, since they engage with Romantic culture as a form of nostalgia, a longing for a past in which the arts were institutionalized. Thus, Romantic poetic motifs are not secondary to Mahler's *Lieder* but the very means by which he can situate his work in relation to Romanticism – by foregrounding his innovations of that tradition.

Jarkko Toikkanen (U. of Tampere) analysed Hoffmann's 'The Sandman' to set forth a theory that merges Romantic skepticism about language's ability to produce stable meaning with a concept of reading as a process not of establishing sense but rather of uncovering something that does not belong within the order of things. Reading is thus, Toikkanen proposed, intimately connected to the experience of horror as a specific (mis)functioning of word and image. The uncanny feeling of horror which arises in Hoffmann's story does not so much evoke a Freudian blurring of home and the unhomely as subtly work to undermine a completely coherent thematic reading.

Romantic Discourse Crossing Genres, Disciplines and National Borders

Martina Moeller's (U. de Provence) paper on Romantic tropes in post-war German cinema analysed how certain films draw on Romantic tropes to create a visual language that counters the classical Hollywood film style. Moeller challenged the conventional critical opinion that certain so-called 'rubble films' are expressionistic. She argued that the aim of the films is affective: to show defeat in German citizens – and the subjectivity evoked by the ruins is meant to initiate a critical discourse on German responsibility for acts committed under National Socialism.

Robert Neiser (U. of Chicago) addressed the use of media in Romanticism and Modernism. Neiser examined literary depictions of 19th- and early 20th-century mass media as engagements with the new phenomenon of crowds and

the new ways of seeing, hearing and moving offered by changing social and cultural conditions. Neiser argued, through a comparison of Hoffmann's 'Des Vetters Eckfenster' (1822) and Alfred Döblin's Modernist text *Berlin Alexanderplatz*, that a change takes place in the ways in which seeing and other senses are conceptualised by Romantic versus Modernist writers. Hoffmann's painterly framing of the marketplace crowd is replaced in Döblin by the crowd as a mass of energy dispersed throughout the city. Thus, Neiser suggested, the attempt to depict crowds gave rise to a new figure that encapsulated this modern understanding of the individual: the man of the crowd.

Several papers engaged the transfer, transmission or translation of Romantic concepts outside of literary discourse. In her paper on architect Louis Sullivan, traditionally considered a pioneer of stripped-down, 'form follows function' Modernism, Lauren S. Weingarden (Florida State) proposed reclaiming Sullivan as an organic expressionist who translated the literary and semiotic philosophies of American Romantics Ralph Waldo Emerson and Walt Whitman into architectural design as a metaphysical practice. Weingarden suggested that Sullivan's use of architectural ornamentation can be understood as a Romantic 'picture language' blending the natural and the man-made.

Miika Pölkki (U. of Helsinki) discussed 1930s and 40s Japanese Romanticism and the many ways in which it was entangled in questions of translation. Focusing on how Japanese Romantics used European Romantic discourse to critique utilitarianism and Western cultural imperialism, Pölkki suggested that translating cultural concepts is as much about reshaping material in quasi-performative ways as about transferring semantic meaning. The Japanese Romantics of this time used their own journal to circulate translations of European Romanticism; however, translations were accompanied by extensive commentary in Japanese, highlighting doubt about the possibility of, and perhaps also thereby the motivations for, importing the Western terms and their conceptual apparatus.

Antonio J. Jiménez-Muñoz (U. of Oviedo) investigated continuity between Romantic and 21st-century poetry. Challenging announcements of the death of poetry, Jiménez suggested that poetic form is not exhausted but shifting between media. Visual interactive poetry by Cia Rinne ('archives zaroum') and various video art installations by Bill Viola demonstrated his point. Jiménez suggested that Viola's video works function in many of the same ways as Romantic poetry: through fragment and synecdoche; through ekphrasis as the production of an image of something that is not present to the senses; and most importantly, through shrinking the distance between artwork and audience by situating the viewer within the frame of the video.

Teemu Ikonen (U. of Helsinki) discussed what happens when a literary text, conventionally theorised as stable and permanent, is animated in film or video. In the spirit of Duchamp's notion of words set free, text animation is a transliteration that both enables and highlights 'foreign' elements introduced from 'outside'. In Gary Hill's *URA ARU*, for instance, words move across space, colliding or breaking apart into new words, at the same time as an actor dressed in Noh theatrical costume seems to prepare to go on stage; he looks into a mirror

which is on the same plane as the screen we are watching/looking through. Text animation thus brings together theories of film and media to 'animate' theories of literature.

London-based artist Laura Kuch (Slade School of Fine Art) outlined the stakes of a post-Romantic dualism in current conceptual art. Kuch proposed that the Jena Romantics' concept of *Schweben* ('hovering') captures the intermedial function of bridging opposing concepts and thus overcomes the conventional problem of the tension between form and content. Kuch opened her paper with a conceptual work of her own, claiming (not knowing to what extent this was carried out is part of the conceptual game) that she had asked her parents to send air enclosed in plastic bags from her hometown in Germany to London, where she used it to try to inflate a rubber boat to row across the English Channel.

In the closing paper, Jacinto Fombona Ibarren (U. Caracas) examined Spanish American travel chronicles as intermedial bridges between European Romanticism and *modernismo*. The *modernismo* chronicle, characterized by a first-person narrator who constantly uncovers surprising phenomena, mediates the new Spanish American spaces and social encounters of urban modernity, making them 'understandable' via reference to European cultural spaces. *Modernismo* functions like an imagined epoch, placing history and literature in dialogue to compose an infinite text. The irony is that Nicaraguan poet Rubén Darío, the patriarch of Classicism, would end up writing better Romantic poetry than the River Plate Romantics – and the Romantics would not be able to free themselves from the Classics.

<div align="right">

Sabine Kim
University of Mainz

</div>

ABOUT THE AUTHORS

Heinrich Detering is Professor of German and Comparative Literature, Göttingen University. He is a member of the Academy of Sciences and Humanities, Göttingen; the Royal Danish Academy of Sciences and Letters, Copenhagen; the Academy of Sciences and Literature, Mainz, and President, German Academy for Language and Poetry. He has won Preis der Kritik (2003), Wissenschaftspreis Kiel (2007), Leibniz-Preis (2009), Heisenberg Award (2011), H. C. Andersen Prisen (2012), and was awarded an honorary doctorate by Aarhus University in 2008. His publications include *Das offene Geheimnis* (rev. edn. 2002), *Bertolt Brecht und Laotse* (2008), *Bob Dylan* (3rd rev. edn. 2009), *Der Antichrist und der Gekreuzigte: Nietzsches letzte Texte* (3rd rev. edn. 2010), *Kindheitsspuren: Theodor Storm* (2011), *Thomas Manns amerikanische Religion* (2012), as well as many articles on and translations of Hans Christian Andersen.

Knut Ljøgodt is Director of the Art Museum of Northern Norway, where he has also been curating exhibitions. He has also worked as curator at the National Gallery in Oslo. Ljøgodt has specialized in Scandinavian and European 19th century art, and is the author of several publications and curator of a number of exhibitions within this field. Among his latest publications is a book on Norwegian history painting, *Historien fremstilt i bilder* (2011) and a monograph on the painter Knud Baade, *Moonlight Romantic* (2012).

Lone Kølle Martinsen received her Ph.D. in 2010 from the Department of History and Civilization at the Europen University Institute, Florence. Her academic interests include Danish history and literature and their interaction, particularly in the 19th century. An educated historian, she approaches in her research works of fiction as historical documents. As of 2013, she will be a postdoctoral fellow at Syddansk Universitet, Odense.

Gertrud Oelsner is an art historian, researcher and, since 2000, a curator at Fuglsang Art Museum. The exhibitions she has curated have focused on Danish paintings from the 18th-20th century, including landscape paintings and separate exhibitions of the works of P. C. Skovgaard, Vilhelm Kyhn and Thorald Brendstrup. She has contributed to and co-edited *The Spirit of Vitalism: Health, Beauty and Strength in Danish Art, 1890-1940* (2011).

Alan Richardson is Professor of English at Boston College. His books include *British Romanticism and the Science of the Mind* (2001) and *The Neural Sublime: Cognitive Theories and Romantic Texts* (2011). He is co-editor, with Francis Steen, of a special issue of *Poetics Today* on Literature and the Cognitive Revolution (2002) and, with Ellen Spolsky, of *The Work of Fiction: Cognition, Culture, and Complexity* (2004).

His current research concerns literary and scientific conceptions of imagination from the Romantic era to the present.

Karin Sanders is Professor of Scandinavian at the Department of Scandinavian at University of California, Berkeley. Her publications include *Konturer. Skulptur og dødsbilleder i guldalderliteraturen* (1997) and *Bodies in the Bog and the Archaeological Imagination* (2009, paperback 2012). She has also published numerous articles on the relationship between words and images, material culture and literature, archaeology and modernity, romanticism, gender and aesthetics, art and ethics. Her work is featured in *The History of Nordic Women's Literature*, and she is co-editor of the forthcoming *A Comparative History of Nordic Literary Cultures*. Member of the *Royal Danish Academy of Sciences and Letters*. She is currently working on a book-length study on the subject of Hans Christian Andersen's 'material imagination' and the lives of things in his work.

Joachim Schiedermair was appointed to the chair of Modern Scandinavian Literature at the University of Greifswald in 2009. Before then he worked as an Assistant Professor at the Ludwig Maximilian University of Munich. Since 2009 he has also been in charge of the annual cultural festival "Nordischer Klang" [Northern Sound]. His research interests include relationships between text and image, gender studies, Scandinavian Romantic and Realist literature, and literary studies as cultural studies. He has published studies on Verner von Heidenstam, Peter Høeg and Henrik Wergeland and is the co-editor, with Wilhelm Heizmann, of *(V)erklärte Gesichter. Der Porträtdiskurs in der Literatur des dänisch-norwegischen Idealismus* (2009). He is the author of the monograph *Hoch, Ebenhoch, der Dritte. Elite als Thema skandinavistischer Literatur- und Kulturwissenschaft* (2012).

Romantik: Journal for the Study of Romanticisms
Issue 01, 2012
© The authors and Aarhus University Press
Cover/bookdesign and typesetting by Jørgen Sparre
Cover illustration: Knud Baade,
Scene from the Era of Norwegian Sagas, 1850
Oil on canvas, 87.5 x 119.5 cm
Collection of Asbjørn Lunde, New York,
photo Nordnorsk Kunstmuseum, Tromsø

Printed by Narayana Press, Denmark
Printed in Denmark 2012
ISBN 978 87 7124 086 3
ISSN 2245-599x

Aarhus University Press
Aarhus
Langelandsgade 177
DK - 8200 Aarhus N
Copenhagen
Tuborgvej 164
DK - 2400 Copenhagen NV
www.unipress.dk

INTERNATIONAL DISTRIBUTORS
Gazelle Book Services Ltd.
White Cross Mills
Hightown, Lancaster, LA1 4XS
United Kingdom
www.gazellebookservices.co.uk

ISD
70 Enterprise Drive
Bristol, CT 06010
USA
www.isdistribution.com

The publication is supported by the Nordic Board for Periodicals
in the Humanities and Social Sciences NOP-HS and by AU Ideas.